The Human Form

TECHNIQUES FOR DRAWING AND PAINTING THE NUDE

GIOVANNI CIVARDI

First published in Great Britain 2011 by
Search Press Limited, Wellwood, North Farm Road,
Tunbridge Wells, Kent TN2 3DR

Originally published in Italy by Il Castello s.r.l. Collane
Tecniche, Milano

Copyright © Il Castello S.r.l., via Milano 73/75 - 20010
Cornaredo (Milano), Italy

First published in 2000 as *Studi di Nudo: Tecniche di
disegno e di pittura della figura umana*

English translation by Cicero Translations

Illustrations by the author

ISBN 978-1-84448-601-4

The drawings reproduced in this book were created
with the collaboration of professional models and
consenting individuals. Any likeness to other people
is coincidental.

As a token of gratitude, admiration and friendship I
dedicate this book to Mario Uggeri, a great illustrator.

I would like to thank the visitors – whether regular or occasional
– to Nice's 'Plage Publique du Sporting'. Over many summers I
have availed myself of the opportunity they offered to observe
the bodies (souls, as we know, are harder to discern) of men
and women of all ages, statures, builds and races in a great
variety of poses and, not infrequently, unclothed. Particular
thanks go to those among these 'models' who patiently and
very obligingly allowed me to continue with the life study in
private and over a greater length of time: I like to think each
one of them will have preserved the occasion in their memory.

Printed in Malaysia

CONTENTS

INTRODUCTION

Le corps humain c'est sourtout le miroir de l' àme et de là vient sa plus grande beauté.

The human body is above all the mirror of the soul, from which comes its greatest beauty. August Rodin

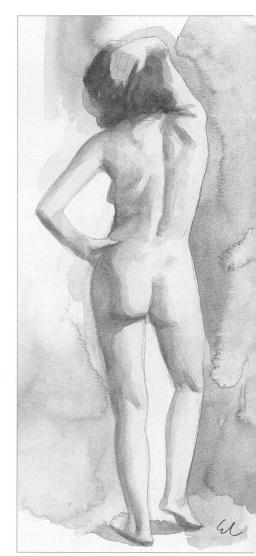

The representation of the human body has always been – albeit through successive vicissitudes – one of the most widespread and enduring subjects in art, to the extent that 'the nude' has come to be recognised as an art form rather than just another subject matter for the artist*. Rarely, however, has the image of the body been depicted with absolute objective fidelity. This fact has, to a large extent, reflected the changing orientations of civilisation, of culture and of religion. A break with past artistic traditions is especially conspicuous in 20th century Western art, which has created a clear opposition between the figurative and the non-figurative (or abstracted), and withdrawn from referring to natural models and from the principle of realism, or the imitation of nature. This makes my task, that of assessing the role played by artistic portrayal of the nude in recent modern and contemporary art, a rather difficult one.

On the one hand, the evocative and suggestive power of the naked human form appears to be waning as the place it once occupied is usurped or undermined by displays of the naked body which have today become a habitual part of our way of life and social communication. In many of its contemporary exhibitions, the body takes on mediocre or demeaning overtones, oscillating ambiguously between a cult of physical appearance and fitness and a contempt for the body as an object or as an implement used for commercial ends**. Yet it is also perhaps true today that the human body seems to have lost its enduring physical dimension and to have become a site of transformations or even a 'virtual object', immersed in a culture of images in which few artists are interested in the naturalistic representation of the body. This is in contrast to periods in the not-so-distant past when the natural model was of great, even fundamental, importance to the artist.

On the other hand, it is possible to discern a promising reappearance of the nude in painting and sculpture as well as its reaffirmation in other art forms. This reappearance almost amounts to a reconnecting with the natural person via a discourse that is both modern and purified of the deceptive contaminations of electronic art or the drift towards artificial embodiment.

* Kenneth Clark, The Nude (1956).
**Giovanni Civardi, 'Anatomia e Forma', Lecture Notes for Unitre University of Milan. Academic Year 1998–1999, p. 15.

The nude, then, is starting to reappear in the mainstream after years of non-figurative art; it has also maintained its important and unique place in the technical training of artists (independently of the aesthetic choices they will later make), which allows artists in training to engage with the human body in all its various emotional and morphological aspects and enables them to take hold of the basic tools of their craft through the practice of drawing, painting and sculpting it. The saying about music holds more than a grain of truth in this regard when it comes to art: only those in full possession of the rules are capable of improvising.

It therefore seemed useful to summarise in this book some information concerning the materials and implements most commonly used in drawing and painting the human form and to supplement it with some practical suggestions about how to approach life studies. Instead of going into exhaustive detail with each medium, as details can in any case be found in every treatise on artistic technique, I have opted to dedicate more space to commenting on the execution of the various studies I have made using the different techniques. The intention is not to propose a definitive working method, (which is my personal one and cannot be shared), but to point the way towards some hard-and-fast procedures and observations that the reader can take as points of departure for developing their own style of interpreting the human figure. With a few highly gifted exceptions, this development will take place through a lengthy period of attentive and precise objective observation and only once the main techniques of painting and drawing have been learned.

In the final section of the book, in which I have gathered a repertoire of nude studies and my comments relating to them, I focus on those aspects of morphological and anatomical analysis which are thrown into relief by the poses that the different models adopt. These studies should serve as a guide for actual observation when – should circumstances allow – the reader has access to a male or female model adopting the same pose as is suggested in my drawing. I have, in many of my books, repeatedly insisted that readers should not limit themselves to copying my drawings. Rather my work should inspire you to go and check for yourself, using a live model (or using yourself); to see whether you also find the details and the morphological-anatomical characteristics I have pointed out, and, if possible, to discover more. There are, in any case, no inviolable 'rules' when it comes to artistic training: the authentic and mature artist will overturn them, or, even better, will overshoot them to create rules of their own. And for this reason, even your own original life study may be qualified (though not contradicted) by the opinion of Gian Lorenzo Bernini, who thought that placing young artists in front of the 'naked truth' was injurious because 'it robbed them of their imaginations'. Be that as it may, the path laid down by this book does not lead to the destination of becoming 'an artist'; our destination is a more concrete one: learning to observe the human body attentively and with intelligence – the rest may well depend on your personal talent.

Giovanni Civardi, Milan, December 1999.

SOME DRAWING & PAINTING TECHNIQUES

Pourquoi une belle esquisse nous plait-elle plus q'un beau tableau? C'est q'il y a plus de vie et moins de forme. A mesure q'on introduit les formes, la vie diparait.
Why does a fine sketch appeal to us more than a painting? Because there is more of life in it, and less of form. As forms are introduced, so life disappears. Denis Diderot, 'Salon de 1797'

Acrylics

CHARACTERISTICS

Acrylics are painting materials made out of pigments bound in synthetic resins – the acrylic polymers. They are emulsions and so can be thinned by adding water or, to attain special effects, by using purpose-made additives. When completely dry, however, acrylic paint forms a surface film which is uniform, quite opaque, flexible, hard-wearing and waterproof. The drying process may take just a few minutes or several hours, depending on the amount and thickness of paint applied and on whether an acrylic retarder has been used.

Acrylics enable you to use a very flexible painting technique since when dry they take on the typical qualities of other painting mediums: oil for example, gouache or watercolour. Undiluted acrylic paint can, indeed, be applied with a painting knife and in considerable thickness over large surfaces. If you add a little water, you can paint as with oil paint; by adding more water, you can paint as if using gouache and if, finally, you add a lot of water the results are very similar to those of watercolour or coloured inks.

Acrylic resin's strong adhesive properties enable the paint to bind to practically any support provided that the surface is not too smooth or oily: canvas, wood, paper and cardboard, some types of plastic, acetate sheet, wall plaster, textiles, etc. are all suitable. Binding will take place even without any sizing of the background, although it is advisable to apply a light priming coat of acrylic gesso. Their adhesive properties make acrylics particularly suitable for collage and for accepting the addition of 'found items' such as sand, sawdust, pieces of wood or crushed stone.

NOTES ON TECHNIQUE

Mediums

The specific properties of acrylic paints can be altered if they are used in combination with the appropriate additives. These may either be added once the work has been finished (for example, varnishes, which give the painting a uniformly matt or gloss appearance), or may be mixed directly into the paint. Among the most commonly used additives are gels that either retard or speed up the drying process; you can also find gels that have the effect of thinning down the painting medium to make it more fluid without actually changing its consistency. One important supplementary material is acrylic gesso. This is normally white, but it may be given any suitable tint for preparing the 'background'–providing a sizing coat on the surface

*PLATE I▷

I traced the outline of the figure using a pen and sepia-coloured Indian ink. The choice of a fine nib with a slightly rounded point ensured a good fluency of line across quite rough paper. Sepia Indian ink is liable to dissolve a little on contact with water or thinned-down paint and for that reason I let the sketch dry thoroughly for a few minutes before continuing. I avoided going into more detail than just a simple outline, which shows through the acrylic paint at some points. A light and perfunctory pencil line provided a guideline to help minimise uncertainties or later revisions to the bodily proportions or anatomical structure.

Then, using a soft-haired round brush of medium size, I laid down the background colour over the top part of the composition only, using a fairly thin mix of raw umber and burnt sienna.

The support on which the figure is lying was coloured using yellow ochre, to which I added a little raw sienna to pick out the shaded areas. The most highly lit surfaces were subsequently brightened to a lighter shade using yellow ochre and titanium white.

The figure was painted using a highly diluted glaze of yellow ochre and burnt sienna to which I added more burnt sienna for the shaded areas (on the thighs, forearm, face and neck, for example).

The parts of the body under strongest illumination were then painted in using a quite opaque mix of titanium white, yellow ochre and medium cadmium yellow. To this mix I added a touch of medium cadmium red to pick out the lips and nipples.

The hair on the head and pubic area were barely hinted at in a simplified way, using burnt umber with the barest touch of Verona green earth (terre verte).

Acrylic colours I find useful for painting skin are: yellow ochre, cadmium yellow medium, cadmium red medium, burnt sienna, burnt umber, ultramarine blue, cobalt blue, terre verte and titanium white. Different mixes, with more red, yellow or brown are chosen as needed, depending on each model's particular coloration. These should be mixed in suitable proportions while avoiding the use of more than three or four colours in a composition (see: 'Colouring the Skin' on page 48).

*All the plates relating to examples of technique have been executed using the implements and materials indicated, on sheets of Fabriano 200g/m² textured paper measuring 24 x 33cm/9½ x 13in. At the base of each plate some test applications of paint, some colour combinations or some strokes of the technical medium concerned have been applied, even if they do not necessarily feature as shown in the picture above them.

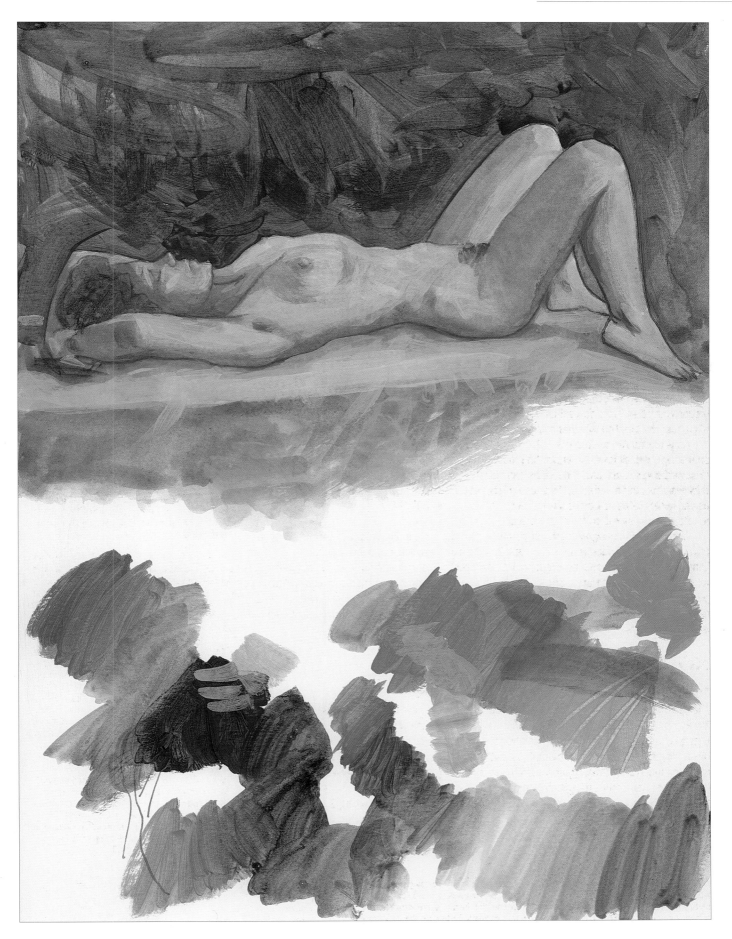

of the support material – especially if this is some type of canvas, cardboard or a board made of wood or Masonite. Another ancillary material is modelling clay (which can also be used for creating a 'granitura' or 'dotted' effect); this enables the artist to use thickness to create complex textures or high relief without needing excessive amounts of paint.

Equipment

The equipment needed for painting with acrylics (painting knives, palettes, easels, etc.) are the same as those used with other mediums (oils, gouache, watercolours, etc.) but these will sometimes have to be adapted to suit the qualities of acrylic polymers. For example, when working with acrylics it is advisable to use a palette made by laying a piece of glass on a sheet of white paper, or simply to use a china plate; either is preferable to a palette made of wood, as acrylic paint sticks only too well to a wooden surface. Alternatively, use disposable palettes – pads of paper impervious to acrylic paint.

Brushes

These can be flat or rounded, soft-haired or natural bristle and should be cleaned frequently and with a great deal of care using clean water (which should preferably be warm). This is because the paint that gets in among the bristles dries very quickly, rendering the brush useless. Should this happen, you can try to re-soften and clean brushes by immersing them in methyl alcohol for some time. It is advisable to use synthetic-fibre brushes rather than ones made using natural fibres, not just because the synthetic ones are just as good and cheaper, but also because they are better able to withstand exposure to solvents and the hard wear and tear that comes especially from painting on rough surfaces.

Paints

Acrylic paints suitable for artistic work are available packaged in tubes of various formats and they come in a very wide range of colours. For work requiring a very large amount of paint medium they are also available in larger-sized tins, although the choice of colours is more limited. As these paints tend to dry very quickly on contact with air, tubes will be kept functional if they are closed soon after use, taking care to exclude any air. Paint left on your palette can be kept damp for some time by covering it with a sheet of transparent plastic or by immersing the palette in water.

Other paint types

Three other types of commercially available paint, PVA, alkyd and vinyl, are comparable to acrylics. Their low cost and less-refined properties make these paints suitable for decorative work, illustrations, preparatory painting and for paintings covering very large surfaces. PVA paints are produced using a more limited range of pigments that are bonded to polyvinyl acetate; they are used in exactly the same way as acrylics. Alkyd paints have properties similar to those of oil paint, are thinned using turpentine (instead of water) and are fast-drying. Vinyl paint is manufactured using pigments of not very high quality but it is suitable for covering very large areas, when painting a mural, for example.

Techniques

The techniques for using acrylic paints are analogous to those traditionally used with oils, watercolours or gouache, but can also be very innovative due to the versatility of the medium, which allows the use of mixed media in which acrylics are used at the same time as other associated mediums: oil, gouache, graphite, charcoal, inks, etc.

Brushes and supports

Choose brushes and a support that correspond with the style of painting you intend to adopt. For example, if you are using acrylics in the way that you use watercolours, it would obviously be a good idea to select soft brushes with natural or synthetic bristles, and strong, thick paper or board with a white, not over-smooth surface. If you are using them like gouache, you would again use soft brushes but card or board with a semi-rough or smooth surface, which may be tinted, or wood-based panels such as Masonite or Faesite, which have been primed with one or two layers of acrylic gesso. If you are using acrylics as you use oils, it would be better to opt for brushes with slightly stiffer bristles or a painting knife, and to use canvas or wood-based board, again primed with acrylic gesso.

Oils

CHARACTERISTICS

Oil paints are produced using a mixture of finely ground coloured pigments in an oil-based binding agent, which may be linseed or poppy oil. This confers on them chromatic characteristics of luminosity and depth unequalled by other painting mediums, justifying the pre-eminent position that oils have occupied in traditional painting ever since the 15th century when their use first became widespread.

Oil paint can be applied in thin layers of transparent colour (glazes) or in thicker, denser, opaque layers (impasto). The fact that the pigment has been mixed in oil offers the option of a very slow drying time, allowing you scope to build up special, nuanced effects of colour gradation if so desired. Once dry, colours undergo no change in chromatic hue or tone; their appearance becomes neither lighter nor darker than when the paint was still wet, as happens, for example, with gouache or – to a lesser degree – with watercolours. Oil paint can be applied to any non-vitreous or over-glossy support (if need be, surfaces can be roughened, using sandpaper for example) which has preferably been primed beforehand using a suitable chalky primer or acrylic gesso. Traditional supports offering the surest guarantees of a good technical result are canvases (usually mounted on a stretching frame or on paperboard backing), wooden panels, cardboards or reasonably heavy-duty paper.

Paint can be applied directly from the tube: that is, spread on to the support using a brush or painting knife, although the somewhat pasty texture of the paint limits its flow characteristics. Smoothness of spread can be attained through every degree up to the liquidity required for applying glazes by adding suitable thinners when mixing and applying. The most suitable thinners are linseed oil, turpentine essence, petroleum spirit or, more commonly, a mixture of equal parts of linseed oil and turpentine. Each of these thinners has its own side-effect on the pigment: generally, oil will keep colours bright, improve flow and sufficiently lengthen the time-window during which colours can be mixed; turpentine or petroleum oil removes some of the gloss from the final sheen and speeds up the drying process.

One of the most important properties of oil paint is its opacity: indeed, if the paint is spread as impasto over another colour that has already dried, even a moderate thickness of colour will be enough to cancel out the underlying colour, or will at least be only partly affected by it.

Lighter tones of a colour can be attained by adding some white to the mix or, if possible, by adding another colour of the same chromatic hue but lighter in tone; darker shades are obtained through combinations of complementary colours or by adding colours alike in hue but darker in tone or, in some cases, by adding black.

Complementing their covering abilities, oils also have the opposite property of being able to spread a colour thinly in fine layers rendered almost transparent by plentiful thinning with linseed oil. The final chromatic effect is therefore modified by the underlying colours that have been laid down previously and left to dry. This is a very slow working method, but it may be combined to various degrees with the use of impasto, with an eye to attaining highly expressive chromatic effects, attainable – in their fullest force – only when painting with oils.

NOTES ON TECHNIQUE

Paints

It is quite unusual these days to find painters who prepare their own oil paints, even though the necessary ingredients are fairly easily available and the procedure is described in a host of manuals. This is because you can find ready-made paints of excellent quality, which come packaged in small, medium and large-sized tubes (the bigger tubes are reserved for white, as it is used in large amounts, black and the so-called students' colours). The colour range, the intensity of individual colours and, sometimes, even the names by which colours are designated may vary from one maker to another according to artistic tradition and the manufacturing process used.

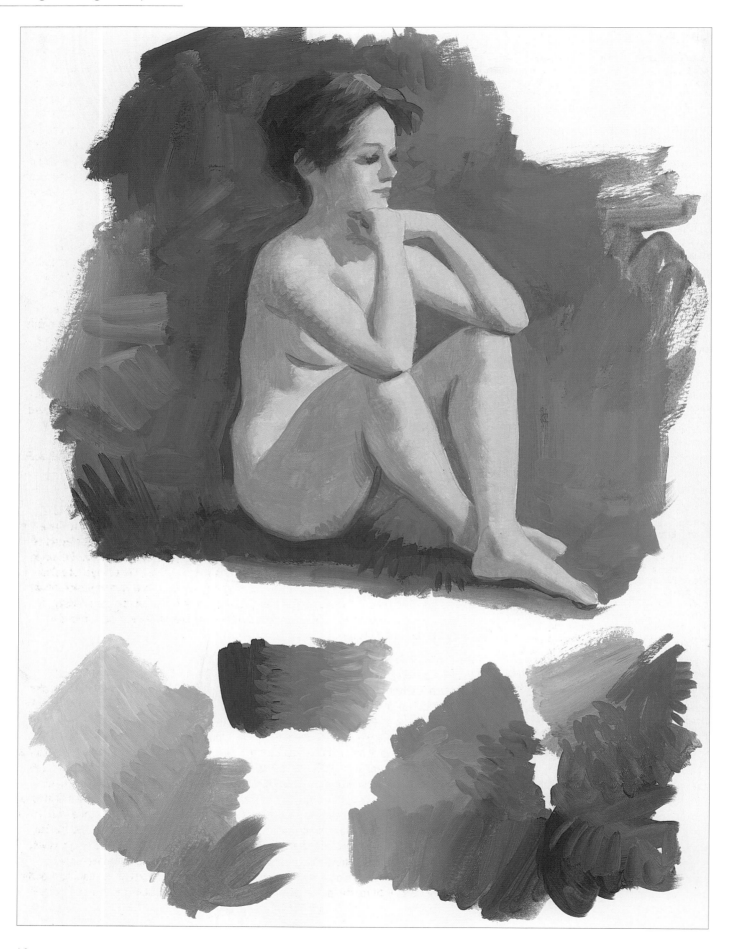

◁PLATE 2

I roughly traced the main lines of the figure's 'structure', paying close attention to the way the limbs counterbalance each other and assessing the proportional relationships between the different parts of the body. I chose a fairly hard HB pencil for this outlining stage so that the paint would not later smudge up any graphite powder.

Using a small, flat, natural-hair brush, I applied a fairly thinned-down coat to mark out those large areas where the figure is in shade, as well as the mass of hair. The colour mixes I used for this were medium cadmium yellow, raw umber, yellow ochre and Prussian blue for the skin and burnt sienna with Prussian blue for the hair. Soon afterwards, using some larger flat brushes, I put down the background colour surrounding the figure, which is very dark and cool compared to the figure's fleshy tones. Mixing randomly, thinning with turpentine and blending colours into each other a little on the paper, I added yellow ochre, raw sienna, burnt sienna, cobalt blue and some green tones.

It is always advisable, right at the start during the sketching out phase, to juxtapose the various colours and tones of the whole composition as – especially with the nude or with portraits – the colours and tonal subtleties of the complexion are influenced to a great extent by their contrasts or similarities to the neighbouring colours on the canvas. When painting from life, you should also take care to consider the influence of the type of illumination, and the effect that any reflected colour from the surroundings, including drapes, may have on the colours visible in the model's skin.

Finally, using a small, pointed natural-hair brush I applied the paint more thickly (using a mix of medium cadmium yellow, medium cadmium red and titanium white) for the lighter areas of the body, shading off the transition between the tones using a light crosshatching movement across the forms. For the final touches I sharpened the colour and tonal contrasts in some parts of the sketch, for example in the area between the feet and buttocks, the point of contact between elbow and knee, in the fold under the breast, etc.

The colour of skin (see page 48) is not easy to define and is rich in chromatic subtlety, influenced by the surroundings and by the biology and the lifestyle of each individual. For these reasons, it demands close observation from life as well as planning ahead of the overall chromatic accent you wish to give the painting. This is especially true when working in oils as it is a medium that lends itself well to attaining rich and fascinating chromatic effects through its employment of glaze and impasto. In a very general way, one can begin by experimenting with mixes of various proportions of some of the following colours: medium cadmium red, yellow ochre, medium cadmium yellow, Naples yellow, burnt sienna, raw sienna, Prussian blue, cobalt blue and zinc white.

Brushes

For laying the oils on to the support, soft brushes of animal hair (marten etc.) are suitable for applying glazes, for shading tones into each other or for fine retouching work, while stiffer animal bristle brushes (hog etc.) are more suitable for a vigorous, immediate and direct style. Alternatively, you may use the less expensive synthetic-fibre brushes. There is also the angle-gripped painting knife, which may be used to apply paint directly, providing interesting, bold, structural effects. Brushes come in various shapes and sizes (rounded or pointed end, flat, fanned, filbert, etc.) to be selected according to the work in hand and the amount of surface to cover, while individual preferences and the painter's habitual style will also play their part in brush choice. After use, brushes should always be cleaned using turpentine, then washed with soap and water and left to dry, heads upwards and bristles carefully 'coiffured', to avoid them becoming irreversibly misshapen.

Equipment

Additional equipment may comprise such useful objects as the studio easel, palette and painting knife. An easel is almost indispensable – above all for this type of painting – as the canvas or other support, when set on it, is slightly inclined forwards or backwards from the vertical is such a way as to avoid glaring light reflecting back from the painted surface and enabling the artist to work effortlessly and at just the right distance to see the work as a whole. Wooden or laminated plastic palettes provide a surface on which to set out your paints and mix them; painting knives can be used for painting or scraping back the paint, and there are also receptacles for holding thinners etc.

Mediums

To speed up drying time it helps, in some circumstances, to use linseed or poppy oil, suitably treated to accelerate drying, instead of mixing the colours with the usual thinners. If you want to resume work on layers of colour that are still touch dry, re-touching varnish can be used. Once your work has been completed, you can protect it from dust or damp and confer a uniform patina to its surface by a careful application of a 'final varnish'. This is a resin that adds a moderately glossy film.

Techniques

When painting in oils, various techniques for applying the paint can be pursued, singly or in combination, to achieve different coloration effects. The painting knife can be used to place the paint on the surface or to scrape it back: brushes can be used to apply 'lean' or thin layers of paint, almost without any body, or very thick impasto (very thick paint). Colours can be mixed directly wet-on-wet either on the palette or directly on to the support, or one layer of colour can be applied over another that has already dried (wet-on-dry); colours can be broken down, inviting the observer's eye to recombine them, as is the case in the Pointilist and Divisionist styles, or partial overpainting may be employed so that the final colour emerges from the interaction of overlaid glazes.

Approaches

Broadly speaking, however, oil-painting techniques can be divided into two fundamental approaches which stand, to some degree, in opposition to each other, although they can also be combined to good effect. The first of these is the direct technique, (also called alla prima), in which opaque layers are applied quickly, working the paint wet-on-wet. This technique requires the artist to work in order from the darkest tones to the lightest, meaning that the darker colours have to be put down first during the initial sketching stage, thinning them quite a lot with turpentine and then gradually adding the lighter tones in slightly thicker consistencies. The most highly illuminated areas on the subject are painted last of all, using thick-bodied paint, following the recipe of 'fat over lean'. Of course, this procedure means that the final tonal quality of the composition needs to be envisaged right from the start. This precept applies even more to the second of the two fundamental approaches, that of building up the colour using thin layers of glaze. This indirect technique allows the artist to arrive slowly and progressively at the desired qualities of tone and colour by placing successive layers of thinned-down translucent paint over previous ones that have been left to dry. This technique requires that the artist work from light to dark proceeding in a similar way to watercolour technique.

Working with oils in three colours

In the academies and schools of art of the not-too-distant past, and perhaps also in present-day schools where the technical foundations of drawing, painting and sculpting are still taught, the study of coloration would be preceded by that of those two other essential elements of figurative artistic expression, namely form and tone. By form was meant the representation, using pictorial and drawing methods, of the profiles presented by the subject as well as of its appearance of solidity: the study of tone consisted of the analysis of the relationships between light and dark, using a colour scheme gradually merging from minimum intensity of white to a maximum intensity of black. A most relevant learning technique was therefore to use black and white oil paint in exercises exploring tonal relationships. The resulting works demonstrate tonal gradations effectively enough, but have a rather sparse and unattractive feel. However, by adding even just one more oil colour, choosing, for example, between yellow ochre, raw umber, or burnt sienna, a rich range of suggestively warm-tone combinations can be attained, which suitably represent the full range of tones between the two extremities of black and white, in a way that suits this type of exercise.

Similar effects have been attained in drawing ever since the 16th century through the use of the technique that came to be known as aux trois crayons. This combines the use of the sanguine crayon with black chalk or charcoal and white chalk, using slightly tinted paper. It produces 'academic' studies of the naked human figure which are particularly effective and rich in tonal subtleties.

PLATE 3 ▷

Using a fairly hard graphite pencil (H), I quickly sketched out the figure's outline without dwelling on any details. The underlying drawing should serve as no more than a guide for the work to follow, which should be executed entirely using painterly means (tone, colour, etc.). It is also advisable to carry out a separate preliminary study of the figure – perhaps a simple thumbnail sketch in pencil or in charcoal – to sort out the main structural and tonal issues in your mind beforehand, thus freeing you up to make a more spontaneous and complex interpretation in paint.

I selected yellow ochre plus zinc white and ivory black. Using a small, soft-haired round brush, I marked out the shaded areas of the body in a blend of ochre, white and the barest touch of black, thinning the paint down with rectified turpentine (unrectified turpentine can stain the paper and leave a messy halo-ring effect).

I laid down the background colour and the colour for the support the model is sitting on, mixing the ochre with a little black, quite thinned down, and using a medium-sized flat brush.

Keeping an eye on the tonal contrasts thus created, I then laid down the paint for those parts of the figure that caught the light most strongly, using ochre with a great deal of white. When it is dry and illuminated by natural light, human skin rarely gives off highly intense or bright reflections, which is why it is best to avoid adding accents of pure white, but to use instead lighter blends of the colours mixes that have been used for the overall tone or for the less-directly illuminated areas.

Finally, I indicated the accents of intense shadow (in the hair, in the fold of the abdomen, by the right knee, along the sides of the left leg) using a lot of black mixed with a little ochre.

When oil paint is applied to paper, especially when thinned with turpentine, it dries out and becomes opaque quite rapidly, making it quite difficult to control the blending between tones. This nonetheless remains an excellent choice of technique for your preliminary studies and sketches worked directly from life.

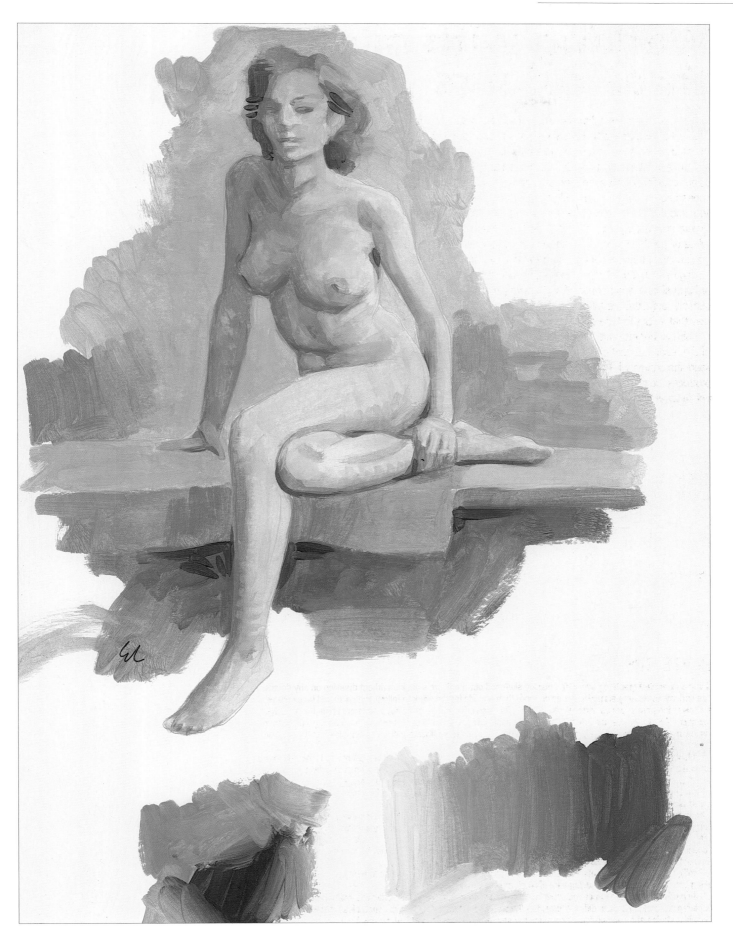

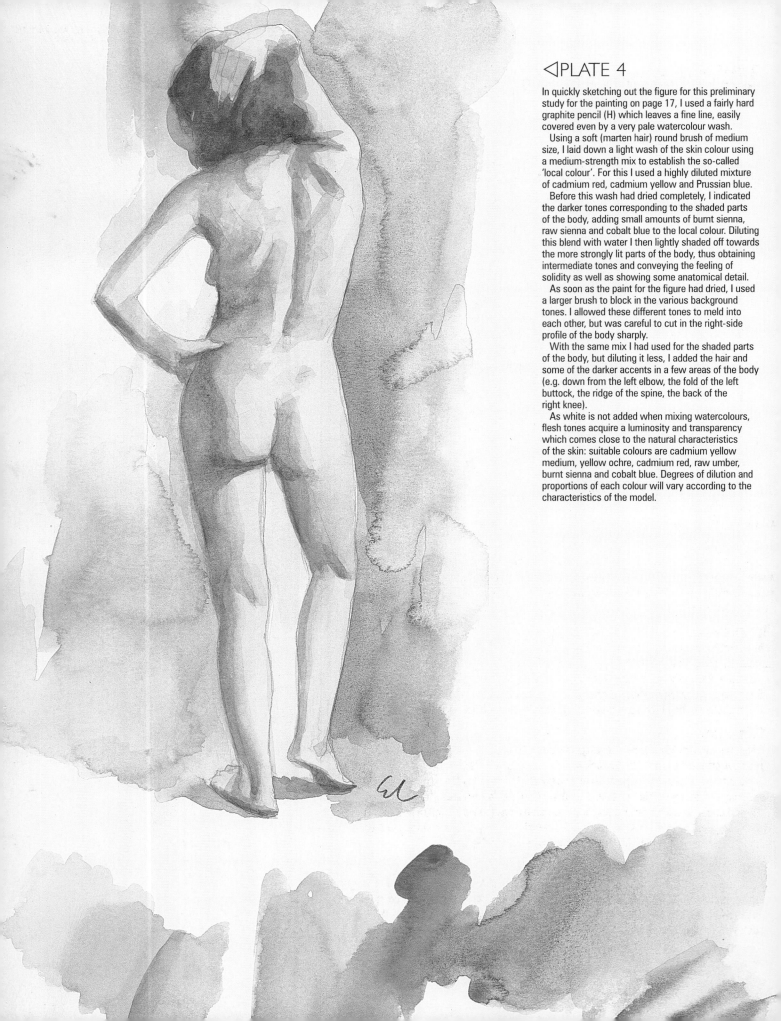

◁PLATE 4

In quickly sketching out the figure for this preliminary study for the painting on page 17, I used a fairly hard graphite pencil (H) which leaves a fine line, easily covered even by a very pale watercolour wash.

Using a soft (marten hair) round brush of medium size, I laid down a light wash of the skin colour using a medium-strength mix to establish the so-called 'local colour'. For this I used a highly diluted mixture of cadmium red, cadmium yellow and Prussian blue.

Before this wash had dried completely, I indicated the darker tones corresponding to the shaded parts of the body, adding small amounts of burnt sienna, raw sienna and cobalt blue to the local colour. Diluting this blend with water I then lightly shaded off towards the more strongly lit parts of the body, thus obtaining intermediate tones and conveying the feeling of solidity as well as showing some anatomical detail.

As soon as the paint for the figure had dried, I used a larger brush to block in the various background tones. I allowed these different tones to meld into each other, but was careful to cut in the right-side profile of the body sharply.

With the same mix I had used for the shaded parts of the body, but diluting it less, I added the hair and some of the darker accents in a few areas of the body (e.g. down from the left elbow, the fold of the left buttock, the ridge of the spine, the back of the right knee).

As white is not added when mixing watercolours, flesh tones acquire a luminosity and transparency which comes close to the natural characteristics of the skin: suitable colours are cadmium yellow medium, yellow ochre, cadmium red, raw umber, burnt sienna and cobalt blue. Degrees of dilution and proportions of each colour will vary according to the characteristics of the model.

Watercolours

CHARACTERISTICS

Watercolours are made of very finely ground pure pigment combined with gum Arabic, resulting in a paint that dissolves when any amount of water is added to it. The characteristic and most fascinating quality of these paints is their transparency, which confers a crucial role on the whiteness of the support – usually paper – in creating the highly luminous hues that typify this medium. The paint is laid down in a diluted form, using either the direct technique or through the build up of successive washes.

Colour composition is achieved not just through mixing the pigments with each other directly but also through the 'optical mixing' of colours which comes about when one layer of colourwash is laid over another (as in oil painting with successive glazes) until the desired effect is achieved. Unlike when painting in gouache, oil or acrylic, white pigment is only used in exceptional circumstances when mixing watercolours. This means that the whiteness of the background becomes a resource to be exploited and the paint has to be laid down working from lighter to darker tones, enabling you to attain the final chromatic and tonal coloration directly, applying the paint with the required strength of colour and not touching it again, or by using a succession of progressively darker washes.

NOTES ON TECHNIQUE

Paint types

Watercolours are available in a wide choice of colours and come in a variety of formats and consistencies: hard in tablet-form; semi-hard in pans; semi-liquid in tubes; liquid and concentrates in bottles. The first two of these formats are suited to smaller-scale compositions executed outdoors; the latter two lend themselves well to covering large surfaces when working in the studio.

Lightfastness

The paints are lightfast to varying degrees: some of them tend to fade over time but most watercolours have sufficiently good permanence and colour stability. Nonetheless, it is advisable to protect the finished work with a sheet of glass and not to leave it exposed to direct sunlight.

Mediums

Watercolours are dissolved by the addition of water; it is better to use distilled water in order to avoid any colour-altering effects. An essential tip is to use two distinct water dispensers: one for thinning the paint and the other for washing your brushes. The problem of large washes drying out too quickly in hot weather can be solved by adding a drop or two of glycerine to the water, while drying times can be accelerated with the addition of a little alcohol.

Colours

Even though there is a wide spectrum of colours to choose from, it is preferable to limit your palette to a dozen or so colours. In this way you will acquire the habits of keeping your colour mixes 'clean' and of painting in a sparser but more effective style. Subject to individual preferences and possible additional colours which may be required by the subject genre (whether you intend to paint a portrait, a life study, a landscape, etc.), a useful basic palette will comprise: cadmium red, yellow ochre, cadmium yellow, burnt sienna, raw sienna, emerald green, terre verte, ultramarine blue, cobalt blue and ivory black.

Brushes

The best results can be obtained using very soft round or flat brushes made of animal hair (pine marten or sable). Suitable sizes will depend on the dimensions of the composition to be tackled, but it is always better to avoid using undersized brushes because this will tend to detract from the spontaneity and sureness of stroke typical of watercolour work.

Brush care

Brushes made of natural animal hair are very expensive and require careful handling, but they should last a long time if you take care to clean them thoroughly with soap and water after each painting session and leave them to dry in the air, with the bristles well shaped. They should be protected in storage in a case, wallet or holder.

Supports

The support of choice for working in watercolours is a fairly heavy and somewhat textured handmade rag paper. This can be found in single sheets or mounted in pads or blocks, the latter being glued along each edge to hold the paper and stop the wetness of washes from causing buckling (or cockling) while you are working. To the same end, separate sheets of paper can be laid on a wooden board and fixed along the margins with gummed tape. Other supports that serve as suitable alternatives to expensive handmade paper include machine-made papers (usually with a smoother surface), cardboard, or lightly tinted paper – which lends itself well to life studies of the human form.

Equipment

Watercolour painting does not call for a lot of elaborate equipment – you can use the inside of the lid of a metal paint-box as a mixing palette, or a china plate will do just as well – some painters prefer to use a set of small bowls. A studio easel is not an absolute must, unless you are working indoors on a fairly large composition; much more practical for working outdoors is a portable box easel which will allow you to tilt the support at different angles, although a table easel will often suffice. Experience of working with watercolours will soon make it clear what other supplementary tools of the trade best suit the needs of each individual painter: wipes, blades, sponges, masking fluid, etc.

Drawing techniques

Using watercolours for life studies demands accurate – if simple – drawings, an eye for the essentials and lightness of touch. Drawing can be done using a pencil that is not too soft on completely dry paper, or with a small round brush in a neutral colour, such as highly diluted sepia or raw umber. Medium-hard pencils (H or HB) won't leave excess deposits of powder which might later dirty the watercolours, but they still need to be used with care, drawing with a light touch to avoid damaging the paper.

Corrections

One should avoid the use of erasers or putty erasers to lighten or correct pencil marks. These lines should be no more than a clean, delicate, essential guide. A eraser can leave unforeseeable areas of resistance to paint absorption: the paint may slide across them instead of lying, leaving displeasing streaks or halo rings in the final result.

Wet or dry

Watercolour paint can be applied to dry paper or to pre-wetted paper using what is known as the wet-on-wet technique. When laid on dry paper, the paint takes on clean, sharp outlines and the colours are sometimes more intense. On wet paper, the paint spreads out to varying degrees, making the contours appear blurred and indistinct; the blending of colours has a nebulous effect which may lend itself very well to creating delicate, nuanced effects. The paper may be wetted using a sponge or a large brush just before the paint is applied, or to keep it damp for longer and to spread the moisture more evenly, it may be dipped into water for a few moments and then laid on to a backing of other sheets of clean, wetted paper.

Techniques

The most effective technique to use with watercolours is the so-called alla prima or direct method in which each colour and tone is laid down as it is to stay, without any subsequent changes of mind or processes of retouching. But there are many other ways of laying the paint and these techniques may sometimes be combined in the same composition: the building up of layers of glazes, shaded-off or graduated washes, laying the paint on with a nearly dry brush (scumbling), flicking or dabbing the brush, spraying, scraping, etc. Even though these techniques may find only limited applications in studies of the human form, it is a good idea to experiment with them. Methods for working with watercolours are fairly intuitive, and you may find them described in every elementary manual on the subject.

PLATE 5▷

'Nude Study' (1998)
Watercolour on paper (36 x 48cm/14 x 19in)

The procedure I followed in this study of a naked female figure largely parallels that described for the preliminary study in plate 4. I began by tracing the complete outline of the figure using an H pencil, taking care not to score into the paper's surface. Doing so would otherwise have left a furrow behind into which, even if it were a very slight impression, the paint would have run to form a sharp contour effect, not always desirable in a life study.

I then sponge-wetted the entire paper surface. This was done only to make it more receptive to the paint, and I left the paper to dry once more before continuing. If I had worked on the still-damp paper surface, it would have been difficult to control the blending of colours and attain the clear anatomical effect I was after. The wetted paper underwent no cockling or buckling as it was fixed along its edges in a block.

Working quickly, (this study was done from life), I laid down the middle-tone of the skin colour in a fairly uniform way. On the more highly lit parts of the figure – e.g. the right arm and shoulder, the lumbar area of the spine and the right foot – I watered this colour down, lifting it off in some places using a clean cloth, to let the whiteness of the paper shine through.

Having let the colour on the body dry, I used a very large round brush to block out the background colour around the figure, putting down blotches of very watery paint.

I let these patches of colour run into each other, helping them do so and 'steering' their progress by tilting the block in my hands.

I observed the model's anatomical structure very carefully, but without dwelling on minor details. In this case, the essential elements for portraying the body's posture and the external forms that display the influences of the pose are focused mainly on the model's back. For example: the sideways curve of the spine, the way some groups of back muscles are raised, the angle and protrusion of the right shoulder blade, the contraction of the left buttock. Added to this, the bend of the right leg (accentuated by the shading on the thigh) and the outward thrust of the left elbow (emphasised by the shading on the forearm) convey a sense of the figure's unstable balance and twisted stance. Being a medium that requires speed of execution, watercolour is well suited to studies of the human form when you wish to convey a sense of movement.

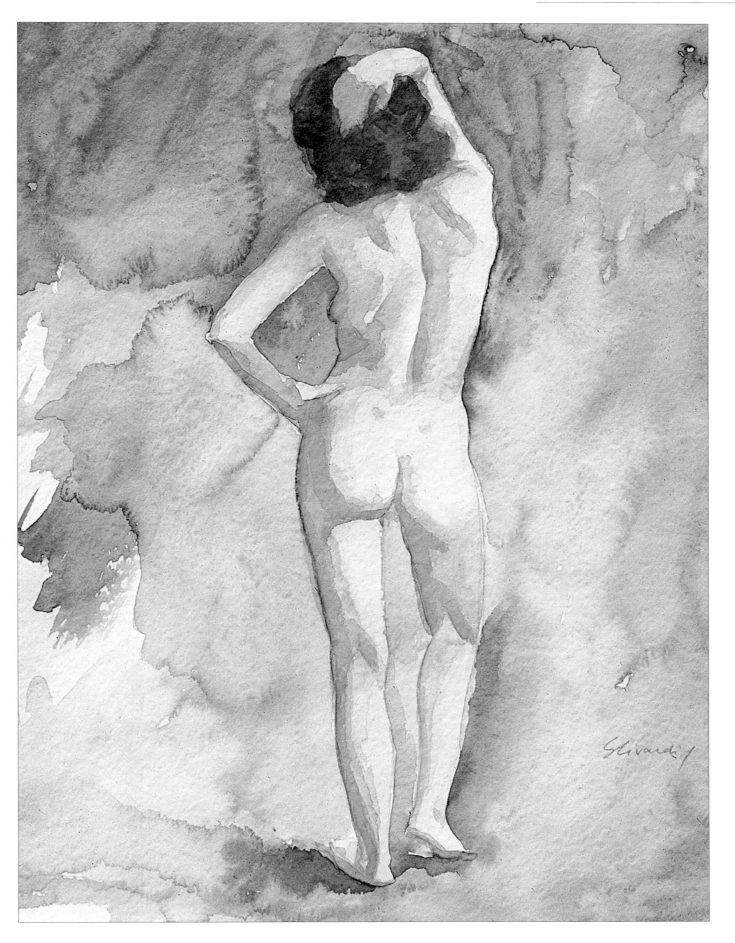

Gouache (modern tempera)

CHARACTERISTICS

Traditional tempera goes back to ancient times and involves mixing pigment with egg yolk and then thinning with distilled water. But in more recent times the term tempera has come to be used to refer to modern tempera or gouache. This painting medium has similar properties to watercolour, but differs in being thicker and more opaque, requiring the addition of larger amounts of white in the colour mixes. As with watercolour paints, pigment powders (less finely ground than those used for watercolour) are combined with gum Arabic and subsequently diluted with water. White is added to lighten the colours and to some extent enables them to cover previously laid colour without being influenced by it, giving the composition a uniform opacity and velour finish. Colours may tend to lighten slightly on drying.

Gouache is a very versatile medium: the paint dries quickly and can be laid in covering layers (which must not, however, be too thick as this can result in crazing and flaking) or it can be watered down to near transparency, although without achieving the luminous quality of watercolour. Gouache lends itself to combination with other painting and artistic methods in so-called mixed media: examples of compatible mediums are watercolour, inks, pastels, coloured pencils, graphite and charcoal. Gouache paint requires a fairly rigid support such as card or heavy paper with a non-greasy surface, which must not be too smooth.

When using gouache, it may become especially difficult to convey the colours of the skin effectively (see page 48) if you use white in an uncontrolled or over-generous way as this will make the paint mix appear chalky and unnatural. Fair approximations of skin tones can be achieved by choosing among the following colours and adjusting their proportions to suit the skin tones of individual models: yellow ochre, cadmium yellow medium, cadmium red medium, raw sienna, burnt sienna, cobalt blue and white. It is also worth bearing in mind that colours lightened simply by diluting them with water differ greatly from colours that are given a lighter tone through the addition of white.

NOTES ON TECHNIQUE

Gouache comes in a wide range of colours and in tubes and containers of varying sizes, up to those for large-scale works. They have the same characteristics as watercolours, although they are somewhat less refined.

Working implements

These are similar to those used for working with watercolours or acrylics. So the best brushes to use are those made of soft animal hair, although synthetic-bristle or hog-bristle brushes can be used to good effect, for example when covering large areas or for creating special effects. Brushes should be washed thoroughly and frequently with warm water and soap to keep them in good condition and prolong their working life. The range of supports suitable for gouache are many and varied as the medium will hold well on any support with a non-greasy, toothed surface. Painting in highly diluted colour can be done on fairly heavy paper, which may be white or coloured, smooth or textured, while card, canvas panels and wooden panels in MDF or Masonite as well as canvas on stretchers are the ideal supports when applying gouache in more substantial layers. To guarantee long-lasting adhesion of the paint, these last four supports require sizing with acrylic gesso, best applied in thin layers. Thick layers of heavily diluted gesso would run the risk of rejecting the paint, particularly if it has been well diluted.

Techniques

When applying a thin wash, the principle to follow is usually similar to that used with watercolour: of progressing from lighter to darker tones. In this case, the paint should be laid down with a light hand, with strokes of thicker or thinner consistency, in order to avoid the risk of dissolving and picking up the underlying layers of paint. Unlike watercolours, however, gouache leaves open the option of later adding lighter tones and highlighting, using a thicker, covering mix of paint to which white has been added. When painting in thicker mixes, it is possible to progress in the opposite direction: from dark up to light, using the same strategies

PLATE 6 ▷

Over a preparatory sketch, using the minimum of lines in HB pencil to indicate the overall proportions, I laid down a watery mix of burnt sienna with a small, round synthetic brush to provide an outline of the figure and to block in the shaded areas of the body and background.

Using a larger brush, I then laid down the local colour of the skin (the middle tone), trying not to cancel out the reddish brown tones of the burnt sienna, but to let it show through a little, distinguishing the parts of the body catching the light and those in shadow. The background colours and those of the sofa were laid down almost at the same time.

Adding a little burnt umber, yellow ochre, Prussian blue and a tiny amount of white to the local colour, I strengthened the areas of the body where the shadows seemed deepest. Then, using a blend of Prussian blue and burnt sienna, I established the colour of the hair on the head and the pubic area.

After that, adding white and medium cadmium yellow to the local colour for the skin, I applied a fairly thick impasto and used light shading movements to paint in the most highly lit parts of the body, trying to tie them in tonally with the surrounding areas.

Finally, using a few short, clear lines of bunt sienna, some much darker accents were picked out in the shaded areas (e.g. the fold of the abdomen, under the breast, in the shadow of the arm down the side of the torso).

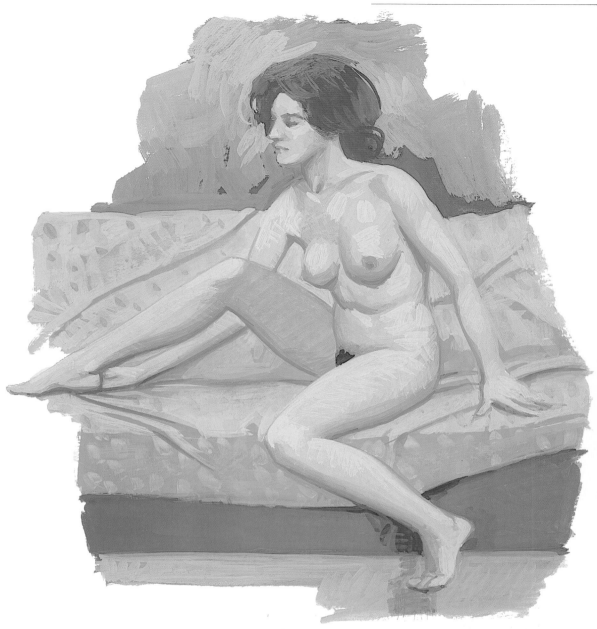

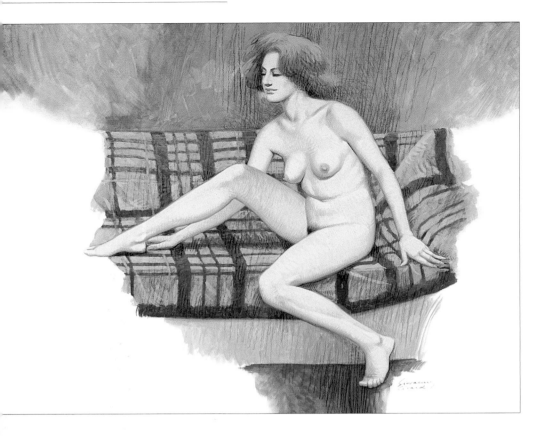

◁ PLATE 7

'Nude Study: Myriam on a Couch' (1998)
Gouache and coloured pencil on medium-toothed card
(36 x 51cm/14 x 20in)

After making an accurate drawing in HB pencil, concentrating more on the outline than on aspects of shading, I made the essential lines indelible by going over them with a pen nib loaded with sepia-coloured Indian ink. A preliminary drawing made in this way is not completely obscured by succeeding layers of thinned-down gouache. Indeed, it will show through enough to serve as a guide, allowing you to proceed with confidence when laying down the colour, without having to worry about losing track of those essential aspects for portraying the human form: the figure's proportions and pose. Furthermore, sepia is a colour which blends well with skin tones.

The local colour for the figure was mixed from white, yellow ochre, burnt sienna, cadmium red and cobalt blue. Soon after laying the middle colour on the body, I painted in the background, drape and sofa, using very dilute gouache, partly mixing the colours directly on the card using a flat brush, with the brushstrokes going every which way, to create energetic, irregular and random brush marks. Then, using the mixture for the body made darker by adding burnt sienna and raw sienna, I placed the shaded areas of the figure and the intermediate tones (the half-tones).

After this, adding white, cadmium yellow and Prussian blue to the mix for the local colour, I built up the more strongly illuminated parts of the body. For this, I used a medium-sized, soft-haired brush and applied the paint in a moderately diluted state, with repeated parallel brushstrokes going across the form (see page 53).

To complete the painting, I blocked in the mass of hair with a few brushstrokes (the mix was burnt sienna, yellow ochre, white and cadmium red); accentuated the nipples (cadmium red and yellow ochre) and emphasised the lines of shade on some parts of the body (the iliac lines at the hips, the fold of the abdomen, facial features, the pubic hair, etc). Using suitable colour mixes, I strengthened some of the areas around the figure, deepening the shadows, for example, on the throw and on the floor. In these areas, as well as on some areas of the body, I varied the 'weave' of the hatching by tracing some loose parallel lines, working with coloured pencils on the surface of the gouache (burnt sienna, burnt umber and black).

and caution with regard to the underlying layers. It is normal practice to mix these two approaches, combining one with the other as work progresses. When painting the nude in gouache, one normally starts by laying down the middle tone of the skin (the local colour) and then working in both directions to add the darker and lighter tones.

Mixed media
Gouache lends itself to mixed media, combining well with other mediums to attain more interesting and complex effects. Examples of complementary mediums are charcoal, soft graphite, coloured pencils, pastels, inks, acrylics and collage.

Special effects
Paint may be applied in small areas using a painting knife or diluted with egg-white to create effects of variegation and colour-fragmentation. The paint can also be treated in various ways: scraped, sprayed, dripped, scumbled, etc.

Protection
Gouache paintings do not need to be coated with varnish, which has the effect of darkening the colours somewhat and neutralising the delicate velour finish, but they do need to be looked after using the same provisions as suggest for conserving watercolours: do not expose them for long periods to direct sunlight, and it may be advisable to protect their surfaces by framing them behind glass.

Underpaintings
A piece of work that has been begun using gouache may be resumed and completed in oils (this was, indeed, common practice in past centuries); it is, however, not possible to work in gouache on oil as the paint will soon flake off. A similar problem exists with acrylic paints that have been applied in thick layers, although acrylics that have been well thinned down have no problem in accepting gouache.

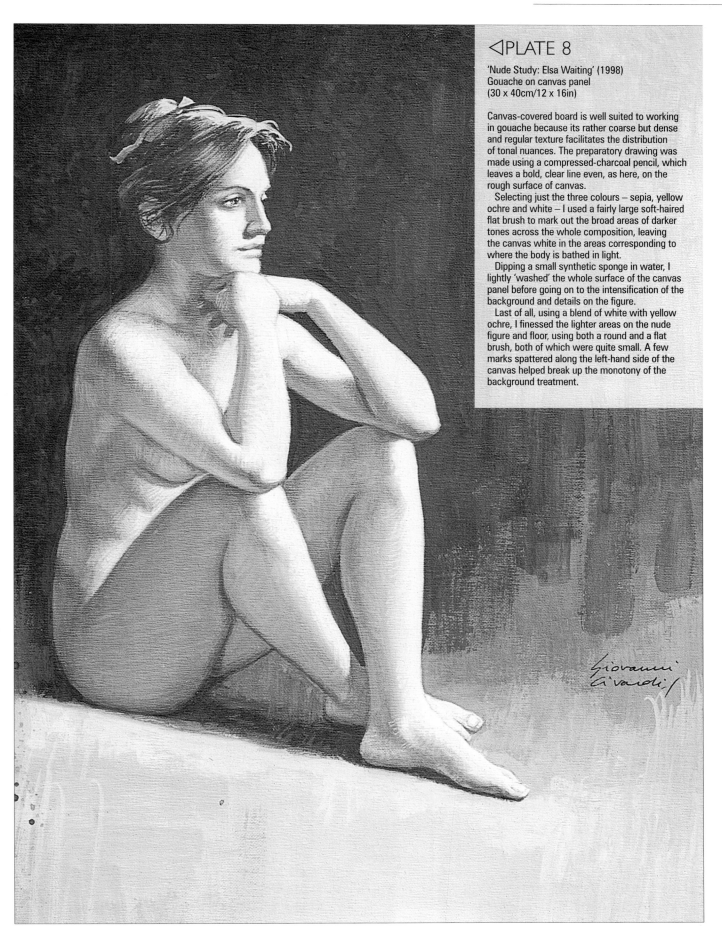

◁PLATE 8

'Nude Study: Elsa Waiting' (1998)
Gouache on canvas panel
(30 x 40cm/12 x 16in)

Canvas-covered board is well suited to working in gouache because its rather coarse but dense and regular texture facilitates the distribution of tonal nuances. The preparatory drawing was made using a compressed-charcoal pencil, which leaves a bold, clear line even, as here, on the rough surface of canvas.

Selecting just the three colours – sepia, yellow ochre and white – I used a fairly large soft-haired flat brush to mark out the broad areas of darker tones across the whole composition, leaving the canvas white in the areas corresponding to where the body is bathed in light.

Dipping a small synthetic sponge in water, I lightly 'washed' the whole surface of the canvas panel before going on to the intensification of the background and details on the figure.

Last of all, using a blend of white with yellow ochre, I finessed the lighter areas on the nude figure and floor, using both a round and a flat brush, both of which were quite small. A few marks spattered along the left-hand side of the canvas helped break up the monotony of the background treatment.

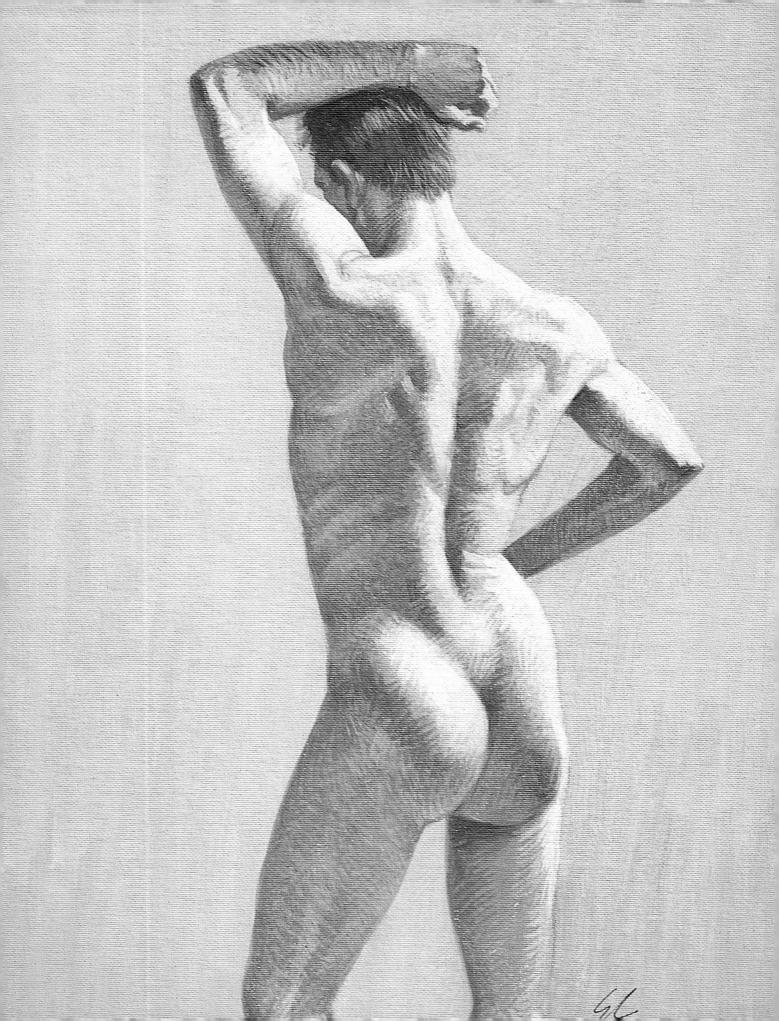

◁ PLATE 9

'Nude Study: Salvatore in Pose' (1998)
Gouache on canvas panel (25 x 35cm/10 x 14in)

The bright, side-on light source throws the body surface into high relief: this is a particularly effective way of highlighting the anatomical aspects of some masculine forms, lending them a sculptural quality.

The colour for the background was mixed from cobalt blue, white and yellow ochre, over which a few uneven and mainly vertical brushstrokes of raw umber and of burnt sienna were added.

Having made a cursory brushstroke outline of the body using a fairly thin dilution of burnt sienna, I then proceeded from 'darker to lighter', that is, putting down the colour in the vast areas of shadow first of all. I then colour-washed the whole of the body using a blend of yellow ochre, cadmium yellow, raw umber and burnt sienna with touches of white and Prussian blue. I marked out the muscles, but had the foresight to lighten the paint by diluting it further when laying down the strongly lit areas. I then coloured in the brighter parts of the body using a pale mix of burnt sienna, cadmium yellow and yellow ochre.

The brushstroke method used in this study harks back to the classic way that painting in traditional tempera was taught: that of using closely spaced parallel brushstrokes which both graduate between the tones and evoke the form at the same time. To do this, the paint has to be fairly well diluted and laid with a delicate touch to avoid dissolving the underlying layers.

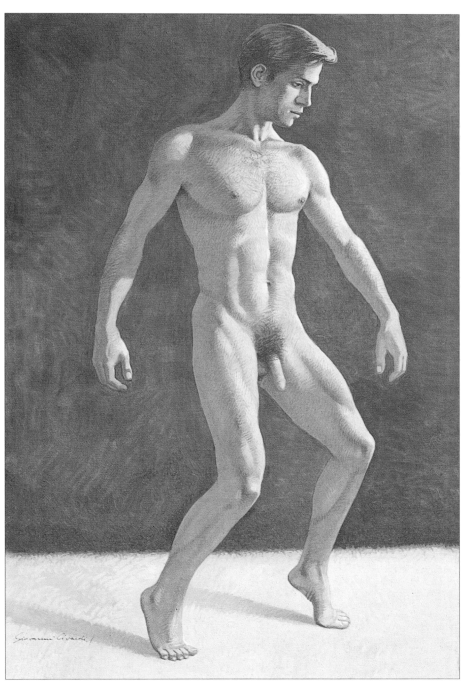

PLATE 10 ▷

'Nude Study: Salvatore Performing a Dance Step' (1998)
Gouache on canvas panel (40 x 60cm/16 x 24in)

For this study of a male nude I used the same technique as is described for plate 8 (see page 21), exploiting the sculptural effects attainable with monochrome treatments of the human form. The larger dimensions of this support, however, argued against a full-brush application of the paint. To avoid the problem of lifting the underlying layers and to model the forms presented in a more controlled way, I adopted a more systematic use of contour lines: parallel in some areas and crosshatched in others. I used a highly diluted paint mix in the areas where the body is in shade, while the addition of white contributed to making a stiffer mix when I came to paint in the strongly lit areas.

Graphite pencils

CHARACTERISTICS

A variety of crystalline carbon, graphite has been known as a natural product since the 15th century, although it was not used by artists until much later, at around the end of the 18th century. The first pencils appeared when a mix of graphite and clay shaped into sticks (the pencil lead), was enclosed in a wooden casing. The varying proportions of ingredients between graphite and clay, as well as the extent of thermal treatment during manufacture, produce gradations in the degree of hardness or softness along a scale extending from 8B – the softest graphite, whose dark lines may require protection using a fixative – up to 8H, the hardest, which leaves a fine light silvery line on the paper. H and HB represent the medium part of this scale.

The paper used may be white or slightly tinted, of varying weights, both textured and smooth; other commonly used supports are card or board (Bristol board) or pasteboard for more complex work.

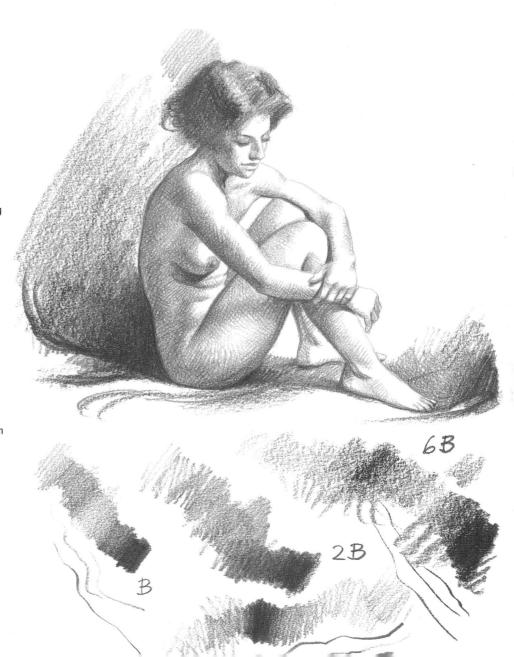

PLATE 11 ▷

I used a 2B lead to draw the figure, working almost simultaneously on the profile lines with the point and on the middle-tone areas with the side of the graphite lead.

When working in graphite, I prefer to indicate shadows by applying thicker lines of hatching and gradually tapering them off, without spacing them closely enough to cancel out the grain of the paper. Thus, even the lines representing the deepest areas of shadow retain (with some deliberate exceptions) a degree of transparency.

Last of all, I added some especially bold strokes using 6B graphite: in the hair, for example, beneath the model's left hand and in the shadow on the floor. However, in general it is good advice to stay with one grade of hardness of graphite in any one drawing, or at least to limit changes of leads to those of neighbouring grades of hardness, and to use nothing but hand pressure to vary tonal depth; this will confer a unified consistency to the resulting work.

There are no rules to be followed in drawing with a pencil: the sequence of steps between each stage of the drawing is left to the discretion of the individual artist. That said, with nude studies, unless it is a rapid, vibrant study done 'in one throw', it is usual to proceed through successively darker tones: from an outline executed with the lightest of touches, through the medium tones to the boldest marks of deep shadow. But for those parts of the body in the strongest light, we make use of the paper's whiteness.

Apart from round-leaded or flattened (carpenter's) pencils in their wooden sheathing, which have the drawback of needing to be sharpened with a penknife or pencil-sharpener, mechanical pencils with retractable leads are now in widespread use. Superfine mechanical leads offer the option of creating miles of thin, regular lines without having to reach for the sharpener. Held directly in the hand, cylindrical graphite sticks with much greater cross-sections may be very soft and provide a very versatile medium, ideally suited to making lively studies from life. Nebulous shading effects can be achieved using graphite powder, which may be applied with a cloth, a brush or directly with your fingers; powder is also useful for creating large volumes of tone.

Marks left by graphite, especially if fairly light, can be erased – or lightened at least – using a putty eraser (which is to be preferred to plastic-rubber erasers). But it is hand pressure that provides the main modulator of darkness or lightness of line.

PLATE 12▽

'Nude Study: Corinna in Sunlight' (1998)
H, HB and B graphite on semi-textured card (51 x 73cm/20 x 29in)

The rather large scale of the support and the meticulous style I had in mind resulted in this work progressing slowly through the building up of successive layers until I attained the tonality desired.

Using grade H graphite, I traced a fine, precise outline of the figure. I then worked on the dark area at the top of the picture, hatching in the surface with short, light, densely spaced lines in several directions. The final intensity of tone was achieved by hatching across previously drawn layers of lines, using a technique analogous to that traditionally used in etching with acid. The definitive tone was then accentuated at some points, for example around the model's knees.

A great deal of care is called for when handling the finished drawing because it is all too easy to leave ugly – and indelible – thumbprints behind: the drawing was not 'fixed', but simply placed inside a protective sleeve of fine transparent plastic. You can reduce the risk of accidentally damaging the picture during the latter stages of work by placing a sheet of smooth paper between the drawing hand and the support.

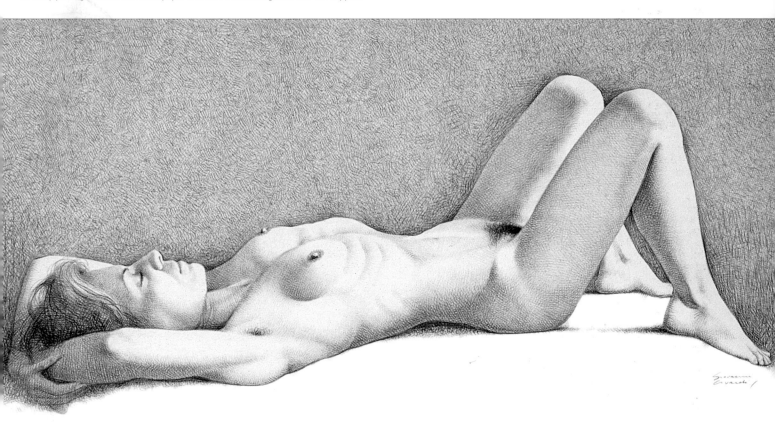

Coloured pencils

CHARACTERISTICS

The lead of a coloured pencil consists of the coloured material (the pigment), an inert substance and the binder: as with the graphite pencil, these are sheathed inside a casing of wood. The range of colours available is a vast one as each chromatic hue comes in a range of tones graduating from light to dark. The final colour is then arrived at via a patient technique of parallel or cross hatching of one colour over another, adjusting the amount of hand pressure applied until the varying strengths of different hues combine to the desired colour blend. This method of blending colours in superimposed transparent layers begins with the lightest shades, over which the darker ones are gradually laid. All the while, you should be careful to ensure that the surface-colour of the paper (usually white) retains its important function as a source of luminosity. Compositions made using soft textured coloured pencils require protection against smudging either with a light coating of fixative or using a sheet of transparent paper.

NOTES ON TECHNIQUE

Colours

Coloured pencils, as a rule, are not labelled with the name of their colour (cobalt blue, cadmium red, yellow ochre, burnt sienna, etc.) because each chromatic hue comes in a range of lighter or darker shades. But with experience, you will come to recognise colours at a glance and a lot of time can be saved in locating them as needed if you develop a habit of arraying your pencils in a set order. The pencils frequently bear an order number, and this usually corresponds to a colour chart supplied by the manufacturer in which it may be useful to look up the colour names.

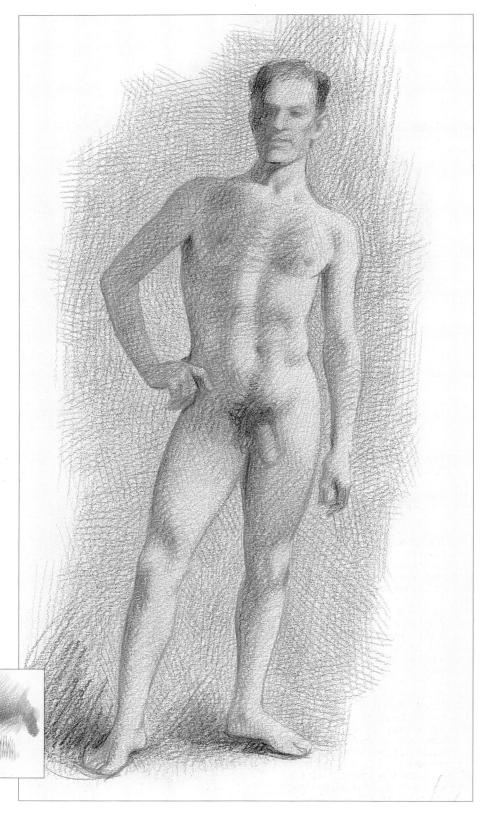

Working in layers

The final colour and tone is obtained through the juxtaposition of colours and by building up successive layers of component colours. Superimposed layers of colour should be laid down lightly to avoid saturating the paper and thus forming a glossy film that will not take any further layers. It is advisable to work towards the desired coloration by proceeding from lighter to darker colours as light-coloured pencils are not very opaque and it is difficult for them to assert themselves against a background of stronger, darker colours.

Achieving unity

Given the slow pace of progress when working with coloured pencils, it is better to apply colour across the whole of the composition right from the start and then seek to maintain overall chromatic unity as you work. When you complete separate areas of the drawing individually, you surrender overall control and you may in the end be faced with the difficult task of having to lighten or darken other areas of the composition. That said, it is possible to complete small details without running any great risks, and a colour that is too dark or one that has been applied too heavily can later be lightened by touching it with a putty eraser or scraping it back with a blade or scalpel.

Good practice

Even more so than graphite, coloured leads are quite brittle (some particular colours more than others) and leave fragments and dust in their wake that may cause accidental damage to the drawing. It is therefore advisable to incline the drawing surface at a steep angle and to protect it from the resting hand using a piece of smooth or absorbent paper.

Retouching

It is a mistake to attempt to retouch a drawing made in coloured pencil using other media: gouache or watercolour, for example, would jar and look out of place. It is possible, though, to work in the opposite direction; using coloured pencil to enhance watercolour, gouache or soft crayon, or mingling them with graphiteto create interesting colour and texture effects. Having said that, in situations where it is necessary to highlight intense reflections of light (in the pupils, for example) when it is no longer possible to correct a drawing by scraping carefully back to the white of the paper, a drop of opaque watercolour or gouache may do the trick.

◁PLATE 13

Using an H graphite pencil I drew, very lightly, the basic outline of the figure in its essentials, after which I switched to using coloured pencil alone. Pink and yellow ochre supplied the local colour for the skin, while at the same time I used green, pink, blue and brown to build up the colour of the background.

The areas of shade on the body were coloured using a range of browns that could be described as burnt sienna, raw umber and sepia. Blue was used to cool down some of the tones and a few strokes of red and dark brown lent clearer definition to the forms of muscles and the outlines of body features.

PLATE 14▷

'Nude Study: Alexandra' (1998)
Watercolour and coloured pencil on semi-textured card (36 x 51cm/14 x 20in)

A quick sketch taken from life preparatory to this figure study helped me judge and place the broad shadows cast by the oblique light shining across the model's body. The sketch will also come in useful later, as an example of pastel technique (see plate 16, page 31).

I used an H pencil to make a careful drawing of the essential contours of the figure. Then, using a sponge soaked in clean water, I lightly washed the whole of the card's surface, wetting the back at the same time to prevent it from buckling.

Before the surface had dried completely, I laid down flat, even washes of watercolour without modulations of tone for the background, the floor and the figure in order to establish the local colours.

Using well-sharpened non-water-soluble coloured pencils, I meticulously built up the different areas of the composition, varying the thickness of hatching line, sometimes using regular crosshatching, sometimes using irregular strokes in several directions, but keeping a light pressure of line throughout in order to let the local colour shine through to some degree in the final coloration.

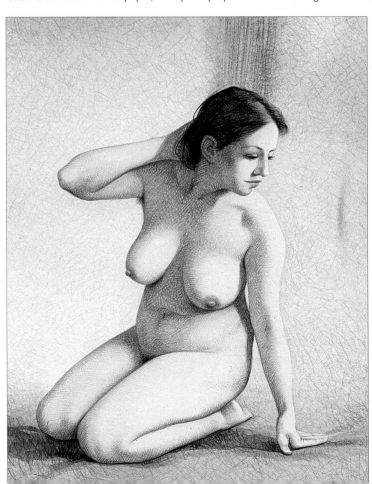

Watercolour pencils

CHARACTERISTICS

Although most coloured pencils can be dissolved to some extent in water or in spirits, some types of pencil are manufactured with a view to being used in conjunction with water and are for this reason called aquarelle or watercolour pencils. The technique for using these pencils is an intermediate one between drawing and painting as pencil lines can be fused together or extended using a wet brush or drawn/painted directly on to pre-wetted paper. Effects very similar to watercolour can be achieved using these watercolour pencils, although they lack the luminosity of watercolour and its other characteristic properties.

NOTES ON TECHNIQUE

A watercolour effect can be achieved in a variety of ways with water-soluble coloured pencils. A brush dipped in water can be run over pencil lines made by dry pencils on dry paper to blend the colours, or a similar outcome can be achieved working with dry pencils on pre-moistened or thoroughly wetted paper. Both these techniques require a relatively heavy paper (at least 400g/m²), which should be quite smooth in texture, and it is necessary to bear in mind that the moistened surface is very tender and may be torn by the point of your pencil. This type of work normally calls for stiff card.

In some situations, for example when working on fine details, you can dampen the pencil's tip directly by dipping it in water. As an alternative to water, rectified turpentine essence is sometimes used as the solvent, because this will dissolve the binder carrying the pigment, creating concentrations of colour and interesting transitions between shades. Turpentine also has the advantage of drying rapidly and leaving the paper unwrinkled. The incompatibility between turpentine (which is quite oily) and water will yield unforeseeable results and so it is not advisable to combine these two techniques, unless you begin by working in turpentine and, once this has completely evaporated, switch to water.

PLATE 15▷

Instead of using graphite to draw the essential lines of the figure, I made direct use of a dark yellow watercolour pencil, thus avoiding any risk of dirtying the later colours with graphite powder when they were dissolved in water.

I used short, parallel hatching and crosshatching strokes in an array of colours (brown, ochre, blue, green, yellow, red), not seeking to simulate the real colour of the skin, but to portray the spreading areas of shade on the body by creating a colour contrast between warm areas – those tending towards yellow and red – and cool areas – those ranging towards blue and green. The areas where the body was bathed in the strongest light, I left perfectly white.

Then, with a medium-sized soft-haired round brush dipped in clean water, I worked across large areas of the picture, blending the colours into each other.

At some points, where this tonal wash weakened the bodily contours (for example on the face, the chest, along the outline of the model's left leg, etc.) I freshened up and redefined the colour relationships using dry pencil lines in the appropriate colour.

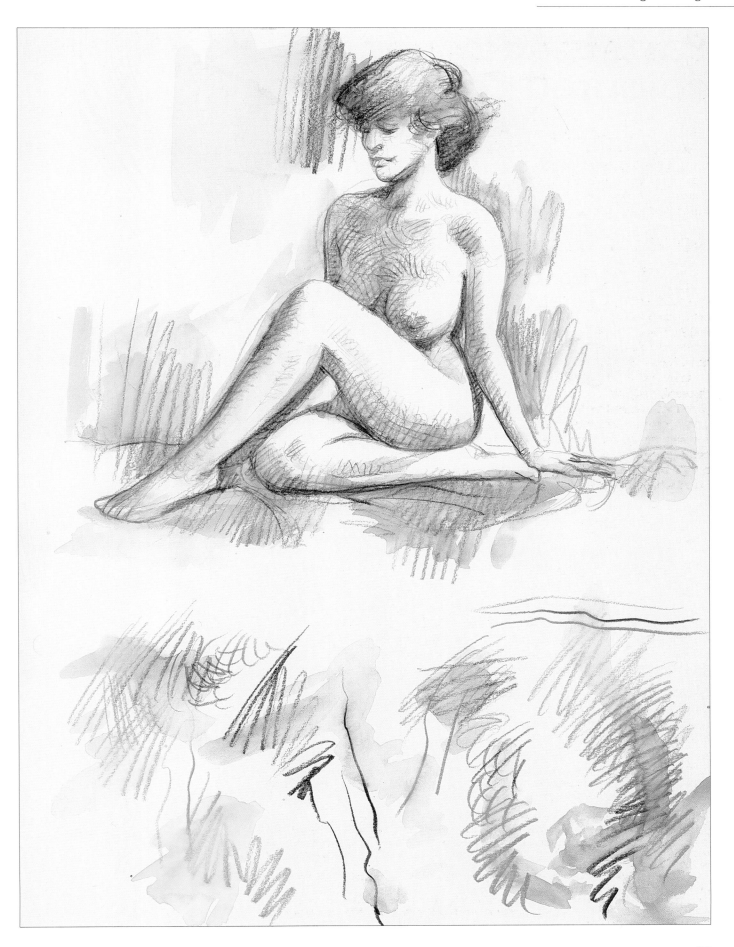

Pastels and coloured crayons

CHARACTERISTICS

Soft pastels are made solely of powdered earths and pigments weakly bound in a solution of gum (usually gum tragacanth) and formed into bars or sticks of various sizes. Pastels come in a truly vast range of colours and shades. This is because, as with coloured pencils, the final colour-cast is obtained directly on the support through juxtaposition or blending of the individual colours required for making up the overall chromatic composition. Pastel colours have the property of covering well, allowing lighter colours to be mixed or drawn over darker ones. Colours can be hatched together using parallel or crossing lines of varying density or shaded into each other using a brush, a purpose-made paper torchon, or simply with your fingers.

The most suitable support for bringing out the velvety texture of a composition made in pastels is robust, lightly tinted paper with a fairly well 'toothed' surface.

The finished work is very vulnerable and needs protecting as the grains of colour can be smudged off easily. There are various schools of thought about the best method of protection, but common consent advises against applying fixative to the final surface: instead, the finished work should be covered with a sheet of glass and stored out of direct sunlight. Pastels can also be mixed with other coloured mediums: coloured pencils, watercolour, gouache, coloured inks, etc.

NOTES ON TECHNIQUE

Depending on the amount of binder needed to hold the pigment, pastels are manufactured in varying consistencies: hard, medium and soft (the most popular) and in various shapes and sizes, although, given their tendency to crumble, they are usually fairly chunky. There are also wood-encased pastel pencils, which look just like coloured pencils and are more suitable for small-scale and fine-detailed work. The more common wax-based (encaustic) and oil-based pastels use wax and oil binders. The latter kind are especially versatile: they cover well, can be blended with the fingertip or thinned using turpentine; they are quite pliable and are an ideal medium for a preliminary sketch to be continued as an oil painting or when using mixed media.

Paper
The paper, used in loose sheets, should be quite robust and textured to hold the pigment. It is best mounted on a stiff backing support – cardboard for example, or a wooden board – and set perpendicular on the easel to allow the plentiful amount of surplus powder from the fragile pastels to fall away before it can interfere with your work or cause any accidental damage to the composition.

Shading off
This can be done to best effect using your fingers or a clean cloth. The purpose-made torchon is handy for working on small-scale areas, but should be deployed lightly and being careful not to overfill the tooth of the paper's surface. If need be, corrections can be made by pressing a putty eraser lightly on to the colour or by carefully dusting with a cloth. If you are using oil pastels, corrections have to be made by delicately scraping the colour back using a penknife or scalpel.

Sharpening
Pastel pencils should only be sharpened with a knife, while the soft pastels themselves cannot actually be sharpened with a sharpener: for drawing fine, sharp lines, use the edge of the pastel face which is worn down as it abrades against the paper during the drawing process; make broad strokes using the pastel, or a broken piece of pastel, side-on. If you need a fine-pointed tip, one can be fashioned using sandpaper, or by carefully breaking a jagged fragment off a pastel.

Portraiture and life drawing

Pastels lend themselves wonderfully to portraits and studies of the naked human form. Such studies were indeed once done regularly by students in art academies, alternating with studies in charcoal or in sanguine. The paper used, as a rule, is of a near-flesh tint (ochre, brown, etc.) or a slightly contrasting colour (grey, blue, etc.) and the usual procedure is to lay on the full area of local colour for the skin first of all, then to work on the areas in deepest shadow and finally, having suitably blended the tones and harmonised the colours with that of the paper, to add in the lighter tones and highlights.

Studio management

Painting in pastels — especially when the subject is the human figure — calls for good management of studio space and working implements: the pastels, for example, should be laid out carefully with similar chromatic hues grouped together and sorted according to strength of tone so that they come to hand easily, even when you have managed to lose the strip of paper identifying the particular colours by name.

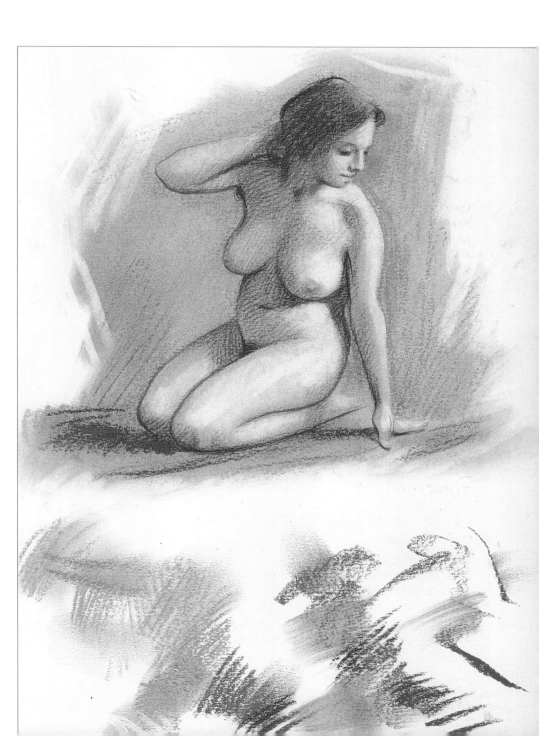

PLATE 16▷

I used a coloured pencil of a brown similar to burnt sienna to draw in lightly the bare contours of the figure, paying especial attention to the ratios between the parts and the proportions of each volume.

Selecting ochre, red and light yellow pastels, I laid down a light shading for the local colour of the body and, at the same time, used ochre, blue, emerald green and purple to map out the surrounding background colours. I used my fingers to shade the pastel lines delicately into each other.

Working with the edges of two crayons, burnt sienna and sepia, I strengthened the areas of shade in some areas and sharpened the body's outlines. Then I used a cadmium red pastel pencil to warm up the shadows and to indicate the nipples.

Using pastels on edge once more, I traced out some parallel contour lines on the body's surface and added hatching to the background. These lines I left visible with the aim of counteracting the chocolate-box effect evoked by the unbroken merging of soft tones. Finally, I used a putty eraser to highlight the most strongly illuminated parts of the body, letting the paper's whiteness break through on the model's left shoulder, the thigh, the knees, etc.

As this drawing is just a quick little study for a more carefully worked portrait, to be kept in an album as a record more than as a work of art in itself, I opted to fix it with a spray fixative, although this has the drawback of intensifying the colours, and the characteristic dustiness of pastels is lost.

Charcoal

CHARACTERISTICS

Charcoal is the most ancient of drawing materials: traces of drawings made using burnt wood have been found on the walls of caves inhabited in prehistoric times. It is a particularly versatile medium as its black marks have great strength and intensity, offer very bold and precise lines, but at the same time can easily be shaded using a rag or simply with your fingers, or even erased almost completely. Various types of drawing charcoal are obtainable, each with its own characteristics. Charcoal made from willow twigs, for example, is very delicate and leaves silvery grey marks on the paper, which are capable of yielding rich depths of shading. Compressed charcoal, on the other hand, made from lamp black combined with a binding agent and then compressed under great pressure, produces a denser, more compact

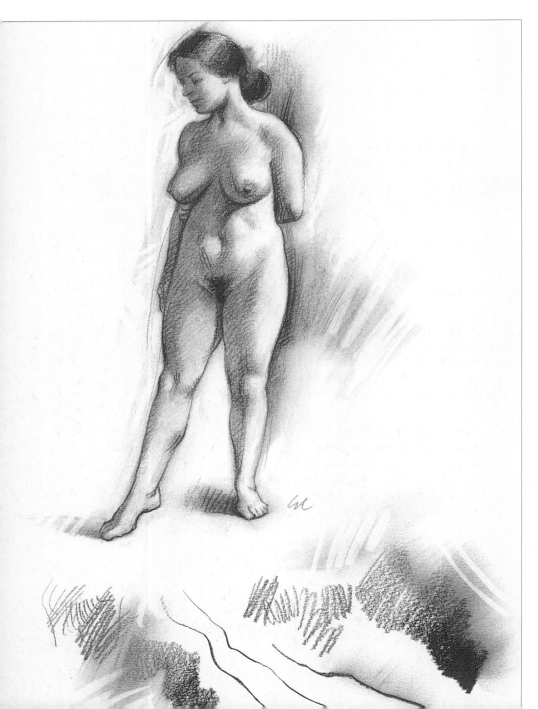

◁PLATE 17

Soft graphite, which is somewhat greasy, may repel charcoal and prevent it from adhering to the paper, so for this small-scale study I limited myself to no more than a few lines made using a hard pencil (2H), just to set out the correct overall proportions of the figure and general positioning of the pose.

Then I used parallel contour lines, drawn with a fairly soft charcoal pencil and working always across the form (see page 56), to depict the areas of shadow on the body, which I soon after softened as required by rubbing them with my fingertip. When it comes to shading, the pressure exerted has to be light, as it is better to glide the charcoal powder across the paper's surface than to work it in, thus filling up the tooth of the support.

At this point I had a rather indistinct and blurry impression of the figure, based solely on its tonal masses and so I used a well-sharpened charcoal pencil of slightly harder consistency to outline the contours of the model's body and used hatching and thickening of lines to give more substance to the shadows, leaving some of these lines visible in the finished drawing. Lastly, I used a putty eraser to lift some of the tone from the more illuminated parts of the body, such as the left cheek, the side of the neck and the left breast, and added a few stripes of shade to break up the background.

mark, suitable for bold, dark delineations. Wooden-clad charcoal pencils come in a range of hardnesses and can be indispensible for detailed work or for giving definition to areas of shade. Any composition made using charcoal, especially if executed in natural vine or willow charcoal, will be extremely delicate and liable to smudging, for which reason a suitable liquid fixative should be applied and the surface protected with a sheet of flimsy or tracing paper.

NOTES ON TECHNIQUE

Supports
The most suitable support for a charcoal drawing is fairly robust paper, preferably with a highly toothed surface for holding the charcoal powder. Very smooth paper would only be used for sharply detailed, precise work. Faintly tinted paper is sometimes used (grey, yellow or blue) to provide a middle tone better suited to studies of the nude. In this case, charcoal would provide the darker tonal areas and chalk or white pastel would be used for the lighter ones. Art colleges often use cheap lining paper for life-drawing classes; this comes in large rolls and has a yellowish tinge.

Details
As with pastels, there is no need to sharpen charcoal sticks because finer lines can be drawn using the edges of the bevelled face that is normally formed in the course of working. Should a very fine, sharp point be required, you can form one by rubbing the charcoal on sandpaper or by using a scalpel blade. The tip of the stick of charcoal is normally used for parallel or crosshatching lines or finer line-work, while the side of a broken or whole piece is used for making broad, uniform strokes.

The torchon
This instrument, made of tightly wrapped paper fashioned to a tapered point, is used for melding dark tones into lighter ones: it is to be used sparingly as it may easily give your work a showy or affected feel. It is better employed for drawing soft, subtle strokes by placing its tip in the charcoal dust and pressing down as you draw it across the paper's surface. Shading off between tones can be done more effectively using your fingers or a small piece of rag.

Erasing
Excessively heavy marks or mistakes made using natural charcoal may be removed almost completely by dusting down with a cloth, wielded using controlled, light strokes. Mistakes made when using compressed charcoal require the delicate deployment of a putty eraser, which will also come in handy for removing the inevitable fingerprints.

Mixed media
Charcoal is sometimes combined with other media (graphite, pastel, gouache, sanguine, acrylics, inks, etc.), resulting in some very effective mixed-media effects. A very atmospheric feel can be given to a life study by painting carefully along the charcoal lines with a soft brush that has been dipped in water. Similar results can be achieved by spreading the charcoal dust in broad swathes using a brush or rag and then fine-tuning the shading using a putty eraser.

Fixative
Fixative is a must if you want to keep a life study that has been worked in charcoal, especially if it was executed on a large scale: smaller drawings can, however, be protected using sheets of flimsy or tissue paper. The fixative should be sprayed on to the picture from a distance of around 50cm (20in), holding the applicator upright and moving your arm slowly and evenly to avoid creating patches of concentrated liquid. More than one application is preferable, and it is better to choose a draught-free space for fixing pictures, although it is important to avoid inhaling the spray as it is potentially toxic.

Sanguine

CHARACTERISTICS

Like pastels and other coloured crayons, red chalk, or sanguine is composed of a mixture of clay, pigment and adhesive gum formed into sticks or bars. These are usually square in cross-section and are sold as Conté crayons or sticks. Colours traditionally range from reddish brown through terracotta to a dark brown similar to sepia or bistre.

Alongside natural charcoals, and its forebears, red ochre and yellow ochre, sanguine can claim to have been used by artists back into the distant past, as it is a material often found in cave paintings. More accurately speaking, sanguine in its modern form has been in use since the beginning of the 16th century when it emerged as a favourite medium for drawings of the naked human form. Its soft, warm tones reflect those of the flesh, especially when used on paper with a light brown or ochre tint. Many artists have used sanguine in combination with charcoal and white chalk on a yellowish background, evolving a technique well adapted to depicting the human form which has come to be known as aux trois crayons.

As the pigment can easily break up and detach itself from its support, pictures drawn in sanguine need to be protected with a layer of fixative, which should be applied in the way described for protecting charcoal drawings (see previous page). Fixative should, however, be applied sparingly as it darkens sanguine, shifting its hue towards the brownish tones.

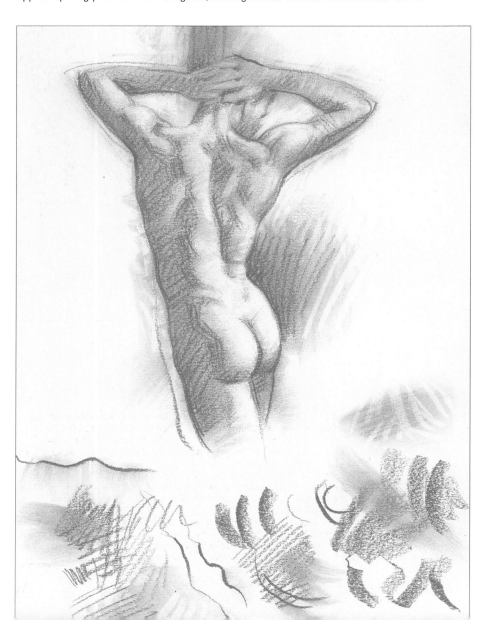

◁PLATE 18

The methods and strategies used in drawing this study in sanguine of a masculine torso were the same as those described in the preceding study (see plate 17), executed using charcoal. The techniques for using sanguine differ from those for using charcoal only in so far as the medium has a different colour; this is particularly true with respect to compressed charcoal.

NOTES ON TECHNIQUE

Getting started

It is a good idea to make the preliminary drawing using the stick of sanguine straight off or, if preferred, to use one of the earth colours offered by Conté crayons in pencil format. Graphite has the drawback of acting against the warm, sunny feel of sanguine's reddish pigment. Furthermore, a hard pencil point runs the risk of scratching the paper's surface, while the greasiness of softer leads may interfere with the even application of a charcoal line, or with the spread of charcoal dust to create shading.

Scoring

The possibility of incising the paper may be deliberately sought after as a desirable effect. By scoring lines on the paper before starting work, with the tip of a fine-pointed implement, (which should have a rounded nose to prevent tearing the paper's surface), a clear, fine tracery of white will be left behind in any shading applied to the area as the pigment glides over without filling in the furrows. These interesting effects of brilliant lightness can be created in shading done with sanguine or with other similar mediums such as charcoal, or coloured pencil.

Working loosely

Shading added in sanguine should not be finicky, over-elaborate, or pushed beyond its initial effect. When overworked, this medium tends to fill in the pores of the paper's surface so that any further application becomes uniform in tone, cancelling out nuances of shading and creating a lacklustre effect. Better, instead, having drawn the figure using loose lines, modulating the pressure of your hand as you work, to then indicate some of the tonal subtleties in selected areas, going back over your lines with quick, light finger-flicks (the thumb is usually used for this) until the shading and the crayon lines begin to reinforce each other and the lines appear to take on vibrancy. Chiaroscuro effects (characterised by strong contrasts between light and dark) suggested in this way both endow the figure drawing with solidity and preserve its freshness and immediacy.

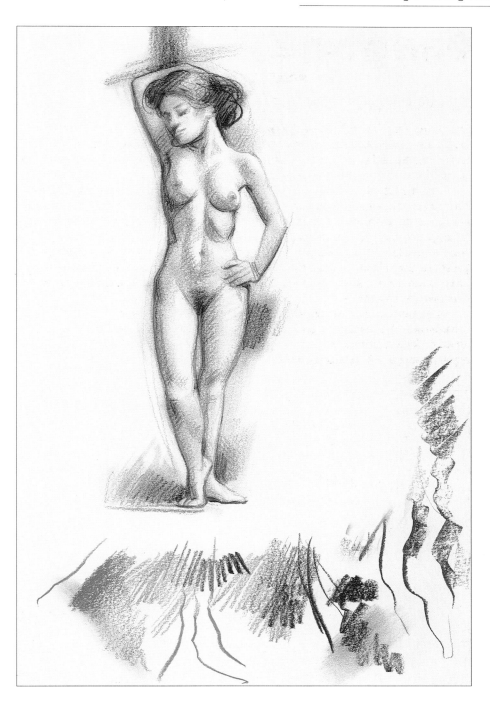

PLATE 19△

Using a 2H graphite lead, I drew the outline of the figure and traced the pattern made on her body by the areas of shade to establish some guidelines. Hard graphite is perfectly compatible with charcoal and sanguine as it leaves a light, fine line that will neither repel the powder of the charcoal nor the dust of the pigment. It is not advisable to use softer pencils (softer than B, for example) for the preliminary sketch because the broad, greasy lines they leave on the paper will show through charcoal.

Using a stick of sanguine, I then worked through the main areas of shade, starting with the areas of deepest shadow and shading off the crayon lines with a fingertip as I went along. Staying with the same areas of shade, I applied a few light lines of sepia; this colour harmonises well with sanguine and dampens down its warm tone, evoking a convincing suggestion of shadow on skin.

The charcoal pencil then came in to accentuate the very darkest areas of shadow on and around the figure: the hair on the head and pubic area, the outline of the model's left forearm, etc.

Those areas on the model's body that were in the strongest light were left unshaded and, to finish off, I went over them with a putty eraser, lifting off traces of sanguine to reveal the paper's whiteness once again.

Pen and ink

CHARACTERISTICS

Drawing with pen and ink is one of the most ancient of drawing techniques, with roots reaching back to Asia, to ancient Egypt and Greece, and through its widespread use in Europe from the early Middle Ages for illustrating manuscripts. But it is also one of the most difficult techniques to master because once a mark has been made on the paper it must stand definitively as the finished product. Correcting or erasing a line is difficult and, even if done well, it runs the risk of spoiling the impression of spontaneity, immediacy and regularity of line. Pen marks can be fluent and free, of varying width and boldness depending on the pressure applied to the nib, or they may be evenly spaced to build up thickened shading in places using parallel or crossed lines of hatching.

The ideal support is fairly smooth paper, which should not be too absorbent and which allows the pen to run easily and smoothly, leaving a sharp, continuous line.

Implements for drawing with inks are many and varied: the traditional quill (made from a goose feather, for example), dip pens with a wide array of detachable steel nibs of various forms to insert in their holders, bamboo and reed pens, etc. Recent additions to add to this list are ballpoint and roller pens, calligraphic or technical reservoir pens, conical soft-haired brushes, etc. Of course, all of these instruments have to be cleaned carefully after as well as during use to avoid the formation of ink clots which would otherwise impede their fluidity and evenness of line.

There are several types of ink suitable for drawing with pen, available in black and other colours. Many of these are water-soluble, but the most popular ink type remains so-called China or Indian ink, a solution of lamp black and binders whose recipe can be traced back to the early inks manufactured in ancient China.

NOTES ON TECHNIQUE

Nibs

The type of nib and the amount of ink it can hold will determine the characteristics of the mark that is made. Steel nibs, for example, are highly flexible and permit the line width to be modulated between broad and fine; this is not possible with technical pens, which guarantee a line of unvarying width. Bamboo pens produce soft, variegated stokes, while the chisel-angled nib of the lettering pen or bullet-shaped nibs allow line thickness to be modified by the angle at which the pen is held against the paper.

Holding the support

When drawing with pen and ink, the support – paper or card – should be positioned horizontally or slightly inclined, just enough to make the hand feel comfortable and its movements easy to control.

Supports

Interesting effects can be attained by working on coloured paper, on paper that is textured, glossy or pre-moistened. It is a good idea to try out these and other techniques as a way of acquiring a breadth of experience, without which it is not possible fully to exploit the resources offered by this medium.

Line and dot

Drawings made using pen and ink are founded on two basic marks: the line and the dot. With varying combinations of these two elements all the many textures required for inflecting tone and indicating shadow can be created. These elements are exemplified in the classic line techniques: parallel and crosshatching, stippling, broken lines, scribbled hatching, etc. These can, through variations of width and direction of line, be employed to obtain an almost infinite number of combinations.

Mixed media

Recourse can be made to other media in order to build up the tone or to tone down areas of a pen-and-ink study: graphite, washes of watercolour (once the ink of the drawing is thoroughly dry) or of watered-down ink (see plate 22), charcoal, gouache, etc. Very interesting effects can be created by spraying the ink or by dabbing it on to the support with a sponge or a scrap of cloth.

Corrections

White gouache is useful as a correcting medium for touching up lines of ink to make them lighter. If the ink mark has to be removed completely, however, it is better to excise it delicately using a knife, a scalpel or a razor blade.

Thinning

If the ink bottle is left open for a long time, its contents tend to thicken and thus reduce the smooth flow of nib on paper. For this reason, during a slow and lengthy piece of work, it is better to add a drop of distilled water to the ink every so often. On the other hand, further thinning of the ink has the effect of reducing the blackness of the line. This leads to the technique of drawing using a selection of dilutions of the ink, graded from undiluted through progressively lighter shades. A row of three or four little bowls is usually set out for this, each containing a slightly greater proportion of water, with the pen nib alternating between them according to the desired boldness of line.

Drybrushing

One technique that is both interesting and effective for life studies is the dry-brush technique, which may be used to build up areas of shade in line drawings. It consists in rubbing a soft, almost dry brush across the surface of the paper, which for this technique should be quite well textured. In this way, veined or variegated strokes of varying shades of grey are obtained, their depth of tone depending on the amount of ink held by the brush and the degree of pressure applied. It is a simple procedure, but it needs to be carried through carefully, with practice runs on a piece of scrap paper beforehand. The brush is first dipped into the ink (at full strength), left to drip or squeezed out a little to remove the excess, before being dried out to the desired tone on fairly absorbent scrap paper (kitchen paper is ideal), during which process the brush hairs are fanned out. The stroke is then applied with a steady, unfaltering hand.

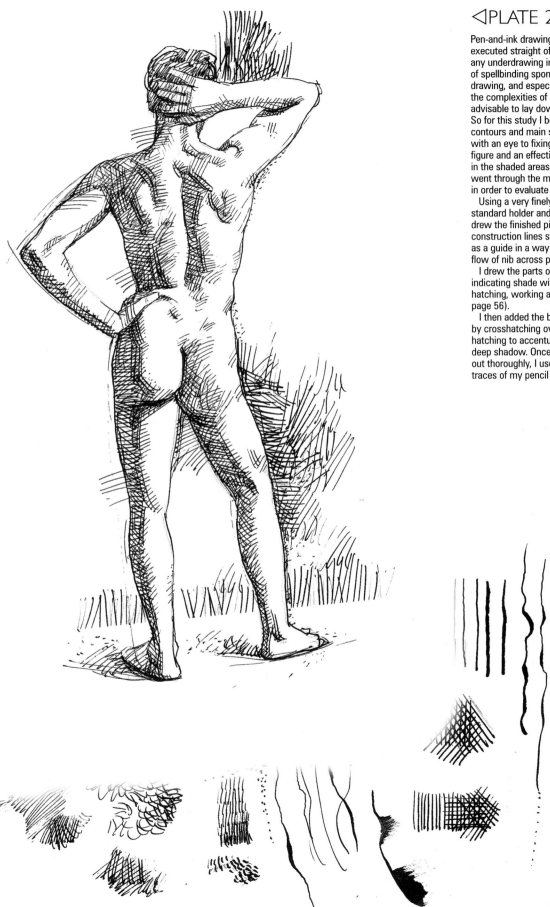

◁PLATE 20

Pen-and-ink drawings show their best qualities when executed straight off on the blank paper, without any underdrawing in pencil, keeping their character of spellbinding spontaneity. However, in figure drawing, and especially in the case of nude studies, the complexities of anatomical structure make it advisable to lay down a few guidelines beforehand. So for this study I began by outlining the figure's contours and main structural lines using a B pencil, with an eye to fixing the proportional relations of the figure and an effective rendering of the pose. Then, in the shaded areas, working the pencil very lightly, I went through the motions of filling in some hatching in order to evaluate direction and intensity.

Using a very finely pointed nib inserted in a standard holder and working in black Indian ink, I drew the finished picture, trying not to follow my construction lines slavishly, but to bear them in mind as a guide in a way that would maximise the free flow of nib across paper.

I drew the parts of the body in shadow first, indicating shade with parallel, but not overly regular hatching, working across the anatomical form (see page 56).

I then added the bodily contours and finished off by crosshatching over the previously drawn lines of hatching to accentuate some areas of particularly deep shadow. Once the ink had been allowed to dry out thoroughly, I used a putty eraser to remove all traces of my pencil lines.

Felt-tip and ballpoint pens

CHARACTERISTICS

Over the past few decades, various writing implements in everyday use have been taken up by artists: a vast array of easy-to-use ballpoint, rollerball, felt or fibre-tip pens in a variety of shapes and colour ranges, some of which are especially suited to line work, whether for highly finished drawings or quick sketches in colour. Ballpoint pens use a slow-drying type of ink which may be thinned and shaded off to some extent by the addition of solvents such as alcohol.

Fine-pointed felt-tip pens are often used for drawing single-line contours, for tracing finer areas of detail or for finely hatched shading. Broad-tipped felt markers are used for filling in larger areas of colour.

Depending on the solvent used (water or spirit based) the colours may be water-soluble or permanent. Staying within each type of ink, colours and tones combine well, providing a spectrum of hues and graduations of tones if applied in layers or juxtaposed. The same is not true if you attempt to mix colours of different solvent types by layering one over another.

In the case of markers, whether water or spirit based, as the colour is transparent, colour blends can best be obtained with layers of darker colour over lighter, and not the other way round.

The best support for ballpoint or rollerball pens is fairly robust and smooth white paper, while a heavier grade of smoother, non-absorbent paper should be used for felt tips, especially for markers. For studies and sketches intended to serve as illustrations, perhaps for advertising purposes, finer, purpose-made layout paper is used, or alternatively smooth Bristol board.

PLATE 21 ▷

Using an H pencil I made a quick, outline-only sketch of the figure, using the same approach as recommended for pen-and-ink studies (see plate 20).

I then used very fine fibre-tip pens in three colours. I selected red to draw the largest areas of medium-depth shade, varying the density of shading by controlling the spacing between the crosshatching strokes. Once these areas had been developed on the basis of the previously drawn pencil lines, I added part of the body's contours. I chose green to accentuate some of the deeper areas of shadow, using its optical combination with the underlying hatching done in its complementary colour, red. Finally, I used black fibre tip to define the precise 'seat' of the deeper shadows, e.g. in the hair and on the neck, beneath the fold of the breast, by the left knee, etc.

The same study could have been done following the same method – which is only one of many possible approaches – using ballpoint pen, also available in black, red and green. One difference, however, is that I would not then have made a preliminary sketch in graphite, as it would not have been possible to rub this out later using a standard or a putty eraser without running the risk of creating messy smudges and blotches of biro ink.

If I had used broad-tipped markers, over a lightly drawn outline of the body I would have put down quick, sweeping strokes of the lightest colour first of all, to establish the local colour, leaving the paper blank for those parts of the body reflecting the light most strongly. Then, while this first 'coat' was still tacky, I would have used a felt tip of a different, darker-toned colour to indicate the areas of intermediate shade. Lastly, choosing a marker of a colour or tone darker still, I would have laid down the deepest shadows. Executed in this way, a picture may take on an indistinct or 'frayed' look, rather like that of watercolour or of diluted ink. If you want sharper definition, details and outlines can be added using fine liners of a matching colour and tone. The light pencil lines disappear with each successive 'glaze' of marker ink.

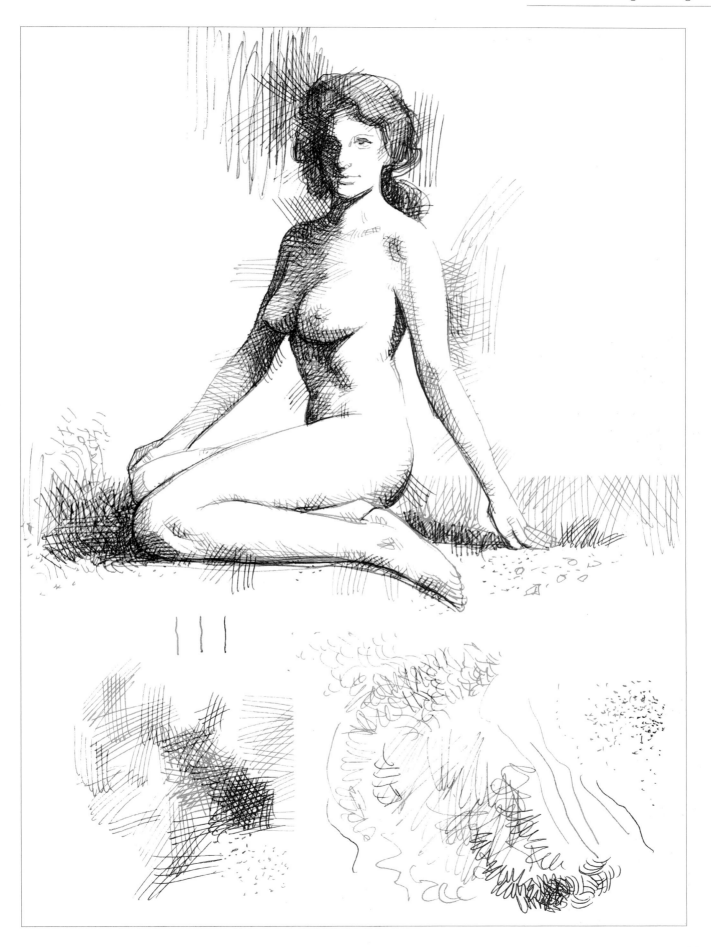

Working with pen and wash – the lavis technique

CHARACTERISTICS

The technique of lavis, which means 'colour wash', was very popular during the 16th and 17th centuries. It consists of adding areas of shading and of tonal transition to a finished picture made in pencil or pen and ink by using a brush to apply washes of ink that have been diluted to varying degrees. The effect achieved is similar to that of a monochrome watercolour study – especially if brown or sepia inks are used – conferring a painterly quality on the drawing.

The materials and implements used (brushes, pens, inks, graphite, paper) will be those used for watercolour or gouache and pen or pencil drawing, for which see the notes on the technique concerned.

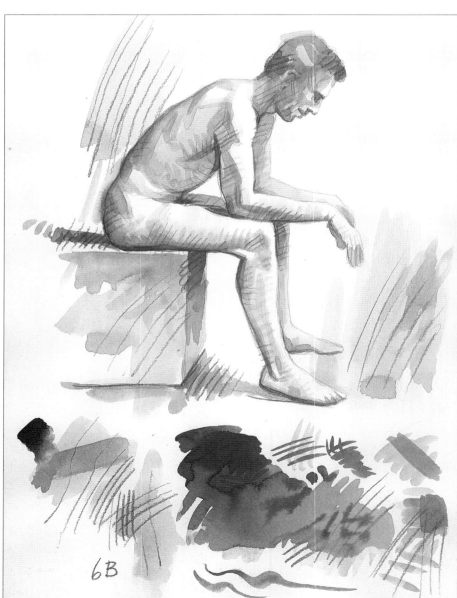

PLATE 22 ▷

I began with a lightly drawn, bare-bones sketch of the figure using a very fine lead (in a mechanical pencil), aiming at an effective overall portrayal of the pose and especially at fixing the relations of volume and the proportions between individual parts of the body.

Using a soft, cone-shaped synthetic brush of medium size, I laid some washes of various dilutions of ink according to the strength of shadow on the body. I let the brushstrokes blend into each other in places to create soft graduations of tone, while in other places I left clear, sharp brushstrokes to give this male nude its impression of sinewy robustness.

I used water-soluble black ink for this study but similar effects can be achieved by adding water to Indian ink, gouache, watercolour or acrylic paint: warm tones can be found using concentrated black coffee or tea. Any colour can be used, of course, although the most popular, perhaps because they are the most effective ones, are black and brown.

Having allowed the ink washes to dry thoroughly, with a loose, generous hand, I added some lines with a 4B pencil, aiming at strengthening some of the areas of shadow and at adding more solidity and definition to some of the body's volumes.

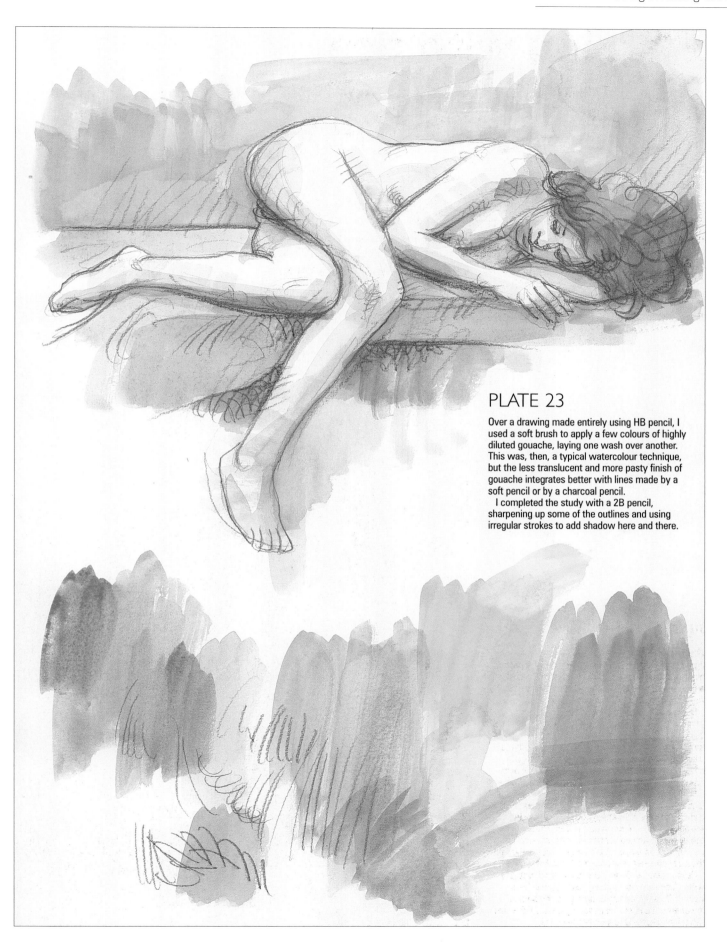

PLATE 23

Over a drawing made entirely using HB pencil, I used a soft brush to apply a few colours of highly diluted gouache, laying one wash over another. This was, then, a typical watercolour technique, but the less translucent and more pasty finish of gouache integrates better with lines made by a soft pencil or by a charcoal pencil.

I completed the study with a 2B pencil, sharpening up some of the outlines and using irregular strokes to add shadow here and there.

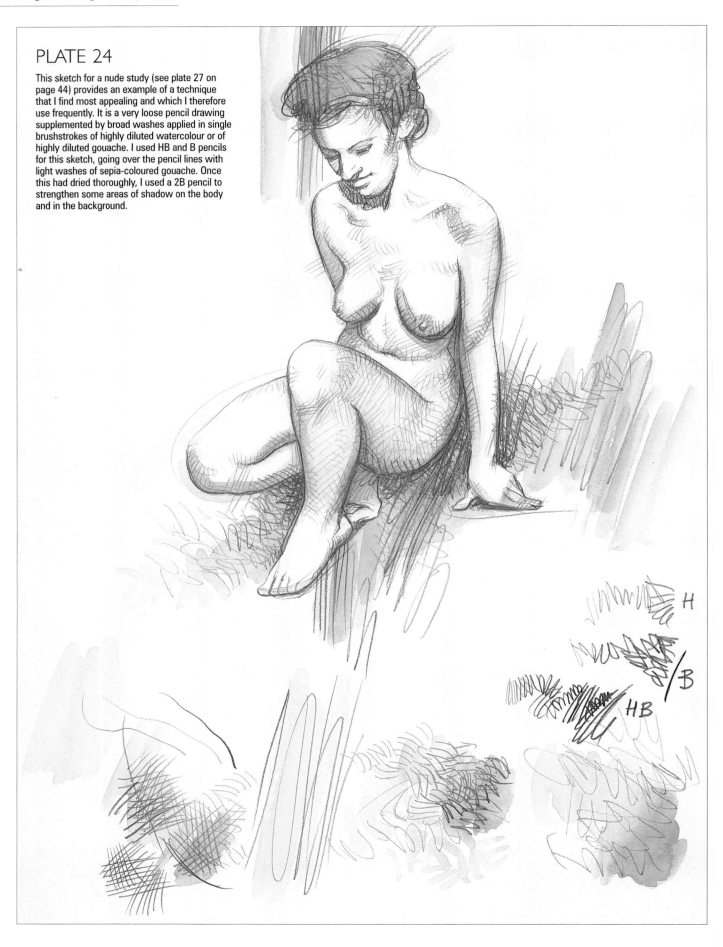

PLATE 24

This sketch for a nude study (see plate 27 on page 44) provides an example of a technique that I find most appealing and which I therefore use frequently. It is a very loose pencil drawing supplemented by broad washes applied in single brushstrokes of highly diluted watercolour or of highly diluted gouache. I used HB and B pencils for this sketch, going over the pencil lines with light washes of sepia-coloured gouache. Once this had dried thoroughly, I used a 2B pencil to strengthen some areas of shadow on the body and in the background.

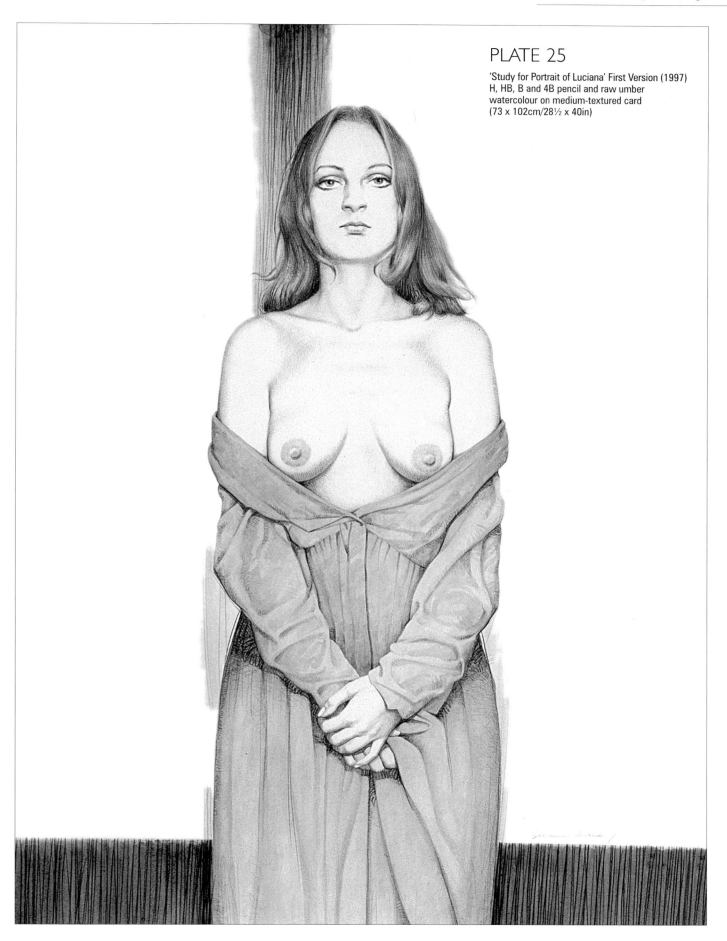

PLATE 25

'Study for Portrait of Luciana' First Version (1997)
H, HB, B and 4B pencil and raw umber
watercolour on medium-textured card
(73 x 102cm/28½ x 40in)

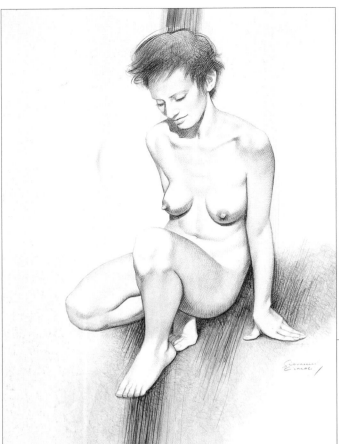

◁PLATE 26

'Nude Study of Cynthia' (1998)
H, HB, B and pencil and sepia watercolour on medium-textured card
(36 x 51cm/14 x 20in)

PLATE 27▷

'Study for Portrait of Luciana', Second Version (1997)
H, HB, B and 4B pencil and raw umber watercolour on
medium-textured card (73 x 102cm/28½ x 40in)

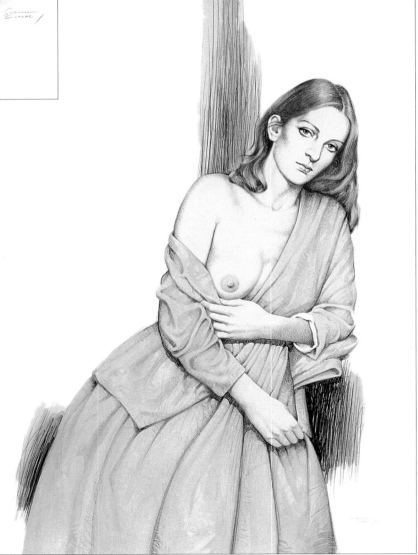

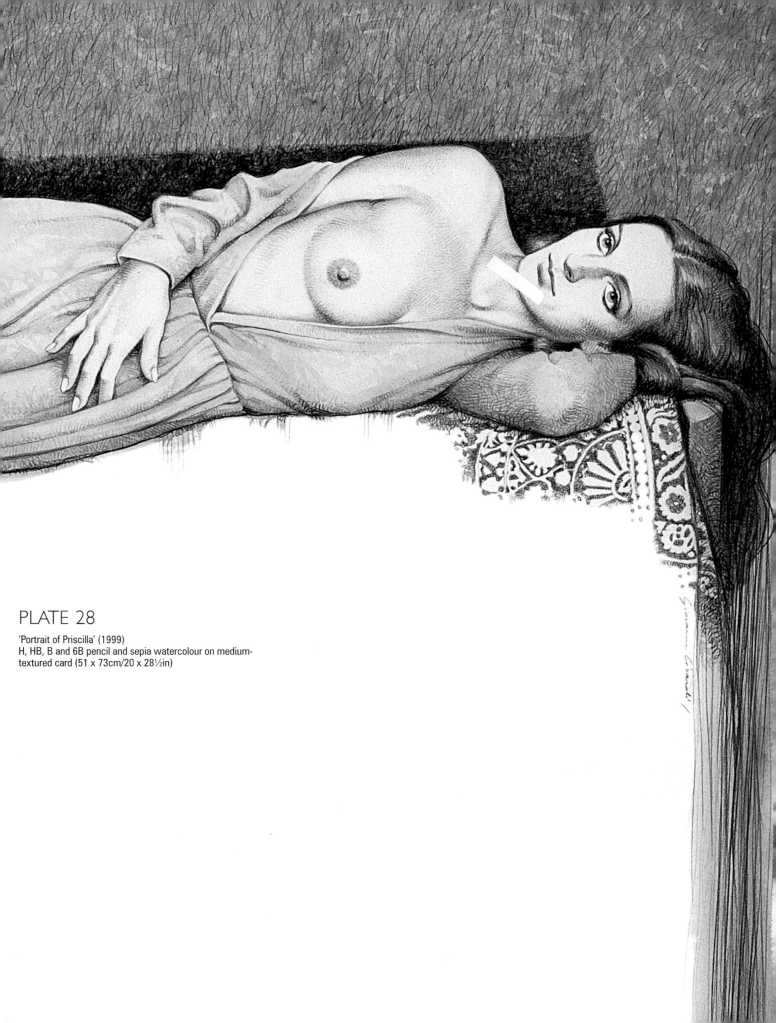

PLATE 28

'Portrait of Priscilla' (1999)
H, HB, B and 6B pencil and sepia watercolour on medium-
textured card (51 x 73cm/20 x 28½in)

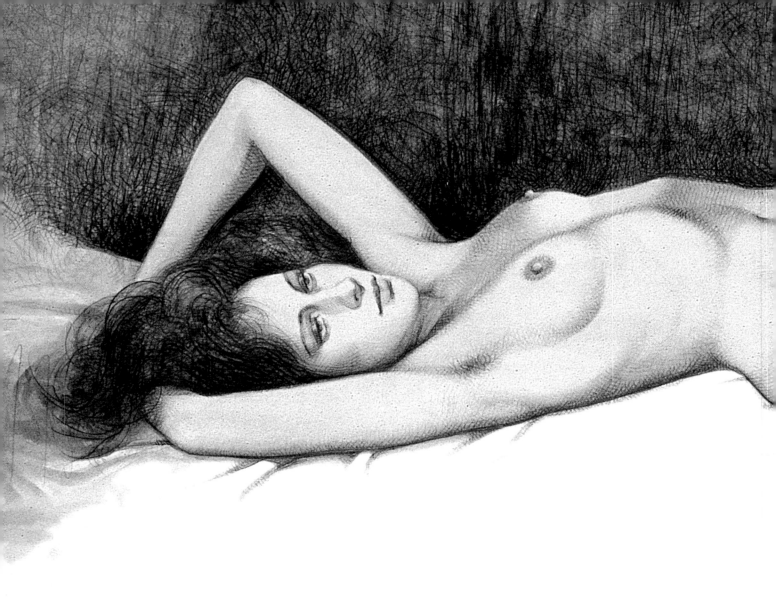

PLATE 29

'Nude Study Myriam in Nice' (1998)
H, HB and B, pencil and sepia watercolour on medium-textured card
(51 x 73cm/20 x 28½in)

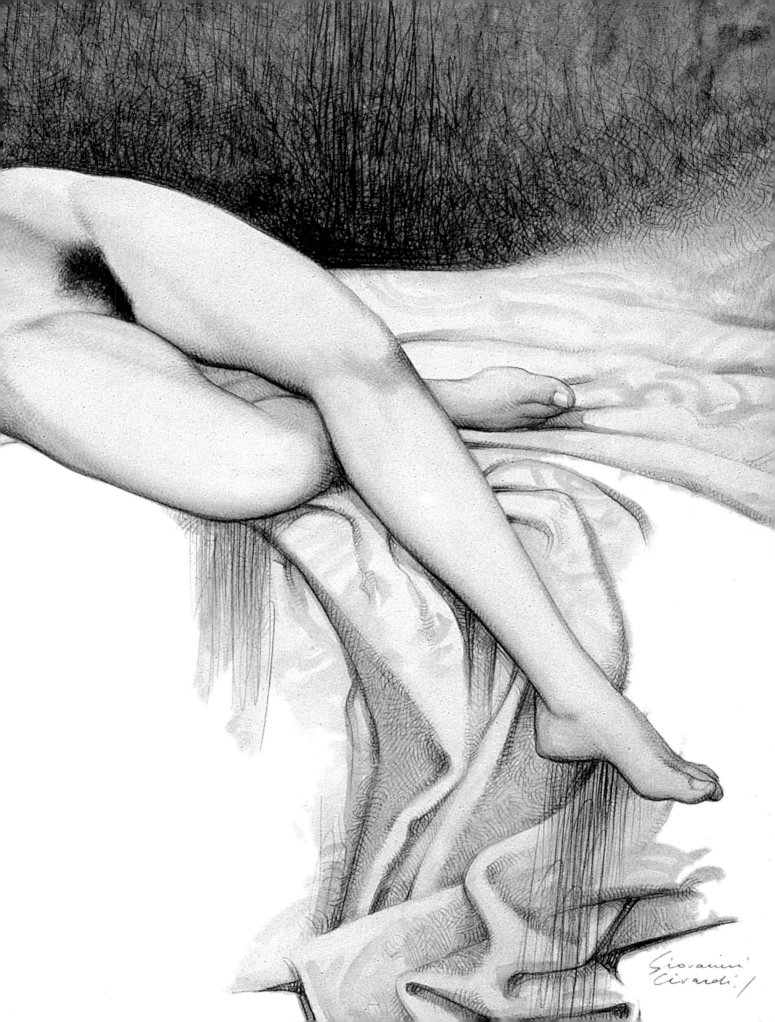

COLOURING THE SKIN

Considered from the anatomical and physiological points of view, human skin colours derive from a set of closely linked factors which you should bear in mind if you want to achieve an effective and convincing rendition of it in your painting.

The factor often considered first of all is the quantity of melanin, the brownish-black pigment present in the skin which – as pale-skinned sunbathers are aware – will intensify when stimulated by sunlight. The second factor is the reddish colour of the blood contained in the dense network of subcutaneous capillary vessels. From the coloration point of view, I have sub-divided skin types into the following inexact categories: pale-skinned, brown/black and golden, although both climatic and genetic influences ensure that each of these categories has to be broken down further to admit wide-ranging variations both on individual and group levels. We are all familiar with how skin colour can vary with such factors as changes in the skin's thickness, its tautness or looseness, our emotional state, ambient temperature, age, gender, lifestyle, etc. It is also a matter of everyday observance that some parts of the body typically have a slightly darker coloration (e.g. the face, the backs of the hands, the external genitalia, etc.) while other parts may be noticeably more pigmented (the nipple and its areola, the lips, etc.).

A third factor you should bear in mind is the muddy-whitish cast specific to skin tissue itself, which to some extent affects the coloration of the underlying muscles and the chromatic hue taken up by the blood vessels near the surface. When you come to paint a portrait or a nude study, you realise that there is no one flesh tone, meaning an easily mixable colour to be employed for every person of the same skin type. Rather, you come to realise that a great variety of colours may go into creating the skin's chromatic qualities. Once these have been toned to match their surroundings, the incident light and the colour spectrum chosen for the composition, they may be capable of simulating the colour seen in the skin of 'this particular model in this specific situation' in a convincing and vibrant way.

It is also necessary to bear in mind that, depending on the painting medium being used, differences in the way complexions are rendered will lead to differences in appearance, just as the way in which colours are mixed will also vary. Painting mediums with transparent colours (watercolour, acrylic, inks, etc.) can give a great measure of luminosity to skin hues. When blended or juxtaposed, this type of colour imposes a working sequence that proceeds from the lightest colours and warmest areas, towards the darker tones, the cooler areas or the blue end of the spectrum. Painting mediums with better covering properties (gouache, oil, pastel, etc.) allow one colour to be laid over another without dictating a technique of blending in situ, so that you can work from darker to lighter and obtain a much wider tonal range.

PLATE 30▷

The three portrait studies on pages 49 and 50 have been included as examples of three different skin colorations. They were painted in gouache on a single canvas panel measuring 30 x 40cm/12 x 16in.

When painting a portrait or a nude, it is not advisable to try to stick to colour formulas; nor should you limit yourself to vague approximations of what you see. Far better advice is that you carefully observe the wealth of bodily variations between one model and another and try to render these with sensitivity and intelligence. Nonetheless, some practical considerations regarding how to set about this task may be of assistance and help launch a project of research that should lead each artist to find his/her own personal style.

An approach that I have found useful when painting nude studies in gouache, (although it is, of course, only one among the many possible approaches), could be summed up in the following stages:

1. Simple pencil drawing of the figure.
2. Sketch, using a small round brush, of the essential contours in a highly diluted mix of burnt sienna.
3. Monochrome blocking in of the body areas in shadow, using burnt sienna.
4. Fairly diluted coat of the local colour (the overall prevailing tone for the skin) over the whole of the figure, being careful not to lift out the underlying monochrome layer. The local colour should do no more than wash over the underpainting, allowing it to show through, and exert an influence on tonality without blending in. When mixed, it is a good idea to put a little of the local colour aside to be used later in mixes for the shaded areas, and those in the strongest light.
5. Rather lean, diluted mix laid for the middle-depth shaded areas.
6. Accentuation of the areas of deepest shadow.
7. Fairly fat, dense layer of the lighter colours.
8. Accentuation of the brightest highlights and reflections on the skin.

PALE SKIN COLORATION

For the local colour I added the following colours to white: yellow ochre, cadmium yellow light, cadmium red light, cobalt blue and burnt sienna.
For the mid-depth shade I added the following colours to the local colour mix: yellow ochre, burnt umber and burnt sienna. For accentuating the deepest shadows I used burnt sienna and cobalt blue.
For the lighter areas I added cadmium yellow medium and white to the local colour.
For the reflections on the skin and the brightest highlights I used cadmium yellow light and white. Last of all, I laid a light wash of cobalt blue on the cheeks and chin, to suggest the tone of the shaven beard.

GOLDEN SKIN COLORATION

For the local colour I mixed yellow ochre, cadmium yellow medium, raw umber, burnt sienna and a small amount of white.
For the mid-depth shade I added the following colours to the local colour: yellow ochre, burnt sienna and raw sienna.
For accentuating the shadows I used burnt sienna and raw umber.
For the lighter areas I mixed the local colour with white, cadmium yellow medium and yellow ochre; for the reflections on the skin I added some white and cadmium yellow light.
This Asian skin colour has been exaggerated by the contrast with the hair colour (almost black), but most of all by the choice of background colour: pure yellow ochre.

BROWN/BLACK SKIN COLORATION

For the local colour I mixed burnt sienna, raw umber, yellow ochre, Prussian blue and a touch of white.

For the shadow I used a mixture of burnt sienna, burnt umber and cobalt blue. The darker accents were achieved with burnt sienna and Prussian blue.

The lighter areas, which are limited in extent, were added by mixing a little white with burnt sienna and yellow ochre.

The reflections, which can have a bluish hue on this skin coloration, were indicated using a mixture of raw sienna, cobalt blue and white.

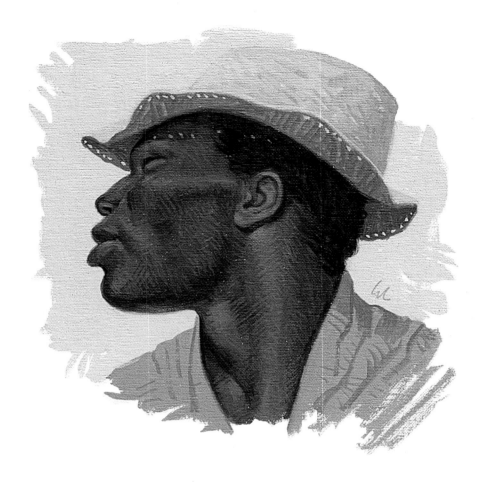

APPROACHES TO RENDERING THE HUMAN FORM

THE PRINCIPLES OF FORM

Combine careful observation with regular and committed practice of depicting what you see if you earnestly wish to pursue the figurative art of depicting the human form, whether through the mediums of drawing, painting or sculpture. This principle holds, with perhaps even more force, for those who intend to follow their imagination, because it is obvious that if you do not know how to depict what is in front of you, it is unlikely that you will be able to give a complete and convincing rendition of what you imagine. In other words, the study of nature – which in our case means the study of the human body – is neglected by artists at the expense of depleting or impoverishing the language in which they express themselves.

When we are drawing or painting, the visual elements we make use of are those of line, tone and colour. In the case of sculpture, these elements find their expression in surfaces and volumes. When we consider these three elements of expression and try to distinguish the various degrees to which each of them is engaged when we draw or paint, it becomes clear that we can roll them together under the heading of: 'the principle of form'. By this I mean the principle we follow when we represent form as it appears to us at a given moment in relation to the prevailing light, its structure and its surface, along with the relations these elements have with the surrounding environment. Whatever object we choose to study and whichever medium we use to depict it, this principle of form is the single foundation on which we base our realistic interpretation of nature.

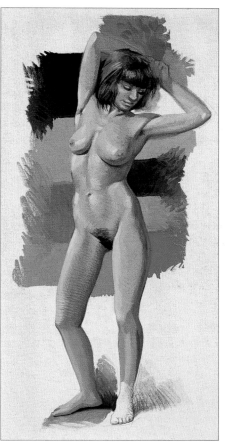

Line

Line, (which, in its most extended sense, refers to form), is used to describe the contours that separate spaces from each other as well as to define the form through its outlines. In so doing, lines mark out tonal divisions and partition the different areas of the composition. Apart from providing the outlines of objects, line also conveys the sense of volume, of sculptural relief, of depth; it does so by appealing to our sense of touch. When limited to the two-dimensional surfaces on which drawings or paintings are made, this appeal has to be an illusory one, while in the case of sculpture the temptation to run a hand over the form is real enough. Any drawing is the proportions between its parts: proportions may be rendered both by pure line and by light and shade as both these elements combine to evoke the object. There is an evolution in expressing proportion as the drawing evolves through the gradual transition from one stage of execution to the next: the drawing of the outline, the separation between light and shade, the articulation of planes, the addition of detail and the accentuation of the strongest tones*.

Tone

Tone refers to the values ranging between white and black, or the brightness or darkness of one value compared to another. More precisely, tone is the relationship between the masses that make up any visual image in terms of their relative positions on a value scale ranging from white to black. All objects can, in fact, be considered as arrangements of different masses of tone, used here to mean degrees of lightness or darkness and not the degree of a colour's chromatic strength in terms of how bright or subdued its hue is. Experience derived from careful observation will help you identify different properties of tone.

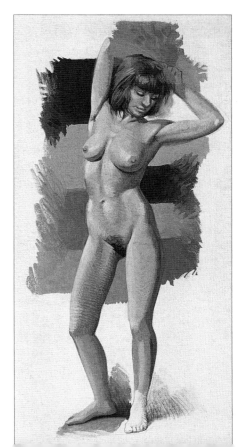

* One or two definitions of the terms being used here might be of assistance, even if they can only be approximations of the meanings usually given to them in texts about aesthetics:
Tone is the amount of light reflected by an object – it has been noted how the way in which an object reflects or absorbs light is influenced by its form, its material and its position relative to the light source.
Planes appear where areas of light and dark on an object subdivide into well-defined areas: when we see a gradual variation from light to shade on an object without a clear border being formed between them, we assume that we are looking at a regularly curved surface.
Form is represented by means of the graduation from light to dark tones.
A mass is an area of uniform tone.
The value is the degree of light or darkness of a tone, a mass or a plane.

For example:

1. The relationship between the intensity of light and shade: all areas of light and shade are correlated – the stronger the light, the more intense the contrasting shadow will appear.

2. The relationship of a tone to its adjacent tones: any tone will appear lighter or darker if it is surrounded by contrasting tones.

3. The relationship between the light's quality (natural or artificial) and its strength (direct or diffuse).

4. Variations in areas of shade due to ambient light or reflected light.

Colour

Colour refers to the actual hue, the chromatic value of the pigment, which has its own expressive vitality and emotive or suggestive undertones distinct from those of line or tone – even though linked to these to varying degrees. Colour is closely bound up with lighting and the quality and the characteristics of the light reveal the colour and endow it with its degree of tone (its lightness or darkness). As you will know, when painting a colour, the apparent tone can be lightened either by thinning or by adding white; similarly, it can be darkened through the addition of black or of its complementary colour. With colour too, careful observation can lead us to formulate some practical guidelines:

All colours reveal their maximum chromatic strength when illuminated most strongly or in the areas of mid-tone. When they pass into shade, colours reduce in strength and may come under the influence of other neighbouring hues.

The local colour should not lose its chromatic identity when it enters shade: if there are no other influences on colour cast, the shaded parts of an object should keep the same colour as the rest, although this colour will be darker and its strength subdued.

When in strong light, every colour becomes a source of reflected colour in that it will reflect a little of itself on to neighbouring objects; by the same token, all colours in shaded areas are receptors of their surrounding colours and are modified as a consequence.

Any colour will appear to be warmer and more luminous if it is laid as a transparent glaze over a light surface, while a cooler, less intense feeling is attained if you mix the colour with white.

Regarding the optical and emotional effects produced by colours, some closely interlinked principles have been identified. Examples of these are:

The principle of harmony: when a new note of colour is introduced to a painting, it will enhance and strengthen other similar or kindred colours present.

The principle of contrast: when a colour note is introduced to a painting, the colours adjacent to it are influenced by it in that either their intensity is lessened or they take on a complementary tonal nuance.

The principle of unity: any two colours will harmonise with each other as long as one of them contains a hint of colour from the other, (monochrome painting or a pencil drawing provides the extreme example of this principle).

The principle of variety: when colours roam freely across an extensive chromatic range, their rich reciprocal influences can spread themselves throughout the painting.

In practice, all of the above principles come into play in a soundly conceived composition which has been carried through to a good level of technical proficiency and which strives to portray nature honestly. Line and tone require variety within unity; colour requires contrast within harmony; while line is also contour, tone is at once form, space and volume.

USING TONAL MEDIUMS

In addition to the principles of composition, contrast, balance and the rendition of form through tone – all of which have a bearing on the content and the structural definition of a drawing, painting or sculpture – other elements come into play when we try to portray an object realistically. All of these principles will obviously apply to any technical medium we intend to use. Two aspects requiring particular attention are the way we handle profiles and outlines, and the treatment we give to detail.

The treatment of profiles concerns the prominence we choose to give to those lines which are conventionally used to delineate the forms of objects. If the object's profile is softened, its sharpness reduced and blurring introduced, this can have the effect of adding an element of vibrancy and articulation to the representation. The practice of adding an element of suggestiveness to a profile belongs to the concept of artistic treatment and does not correspond to anything in nature; nonetheless, it serves to endow the image with an illusion of space, volume and movement. The artist's subjective sensibility perceives and depicts a 'halo' around some parts of the profile, creating transitions that are precise despite being vague.

A soft, mellow, or 'lost' profile may, however, arise from natural causes: a bright reflection of light from a shiny surface, for example, or the fusion of equal tonal values at an object's perimeter (light against light, dark against dark, etc.). This may also occur where forms 'fray at the edges' (as with hair) or with rapid movement. However, technical or aesthetic considerations may recommend this type of treatment of profiles: for example, to convey atmospheric perspective or the fading into the distance at the intersections between lines or planes (a good tip here is to fade the line you want to appear further away around the point of intersection only).

The handling of details concerns the process of selecting and simplifying an image with the aim of subordinating particular minutiae to the picture as a whole, while being careful not to create an impression of inconsistency. In order to avoid a bland uniformity of soft tones, it is better to stress the distinction between a picture's principal planes and to strengthen the transition from one tone to another. Briefly put, form should come before detail: a sense of unity and structural coherence can only be achieved through the careful assigning of tonal values.

PLATE 31 ▷

Gouache on canvas panel, (35 x 45cm/14 x 18in)
I painted this picture to exemplify some of the methods described in this section.
Plate 32 is a key showing which techniques were used where.

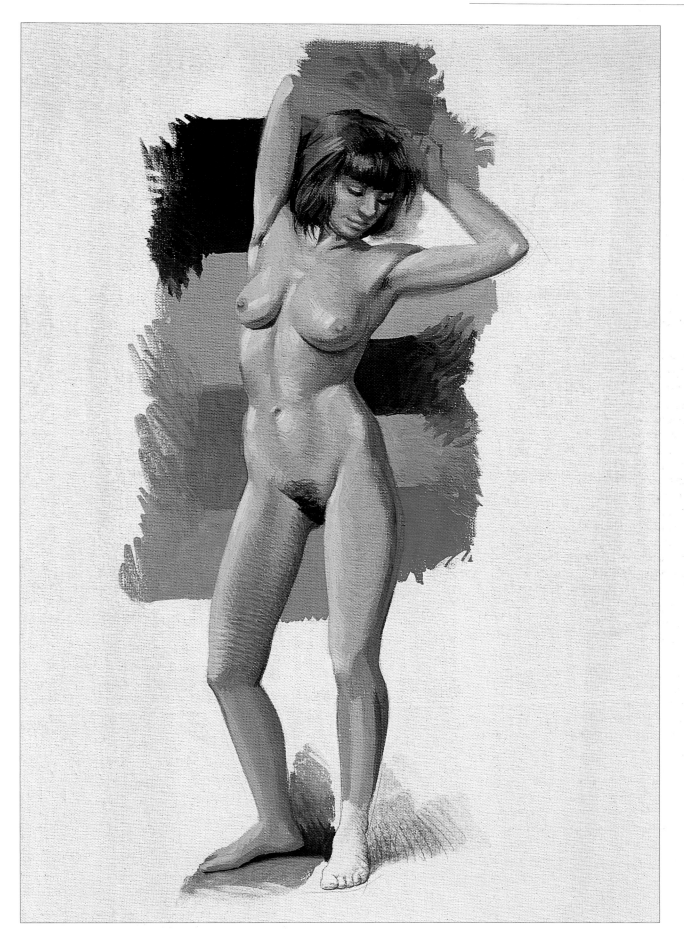

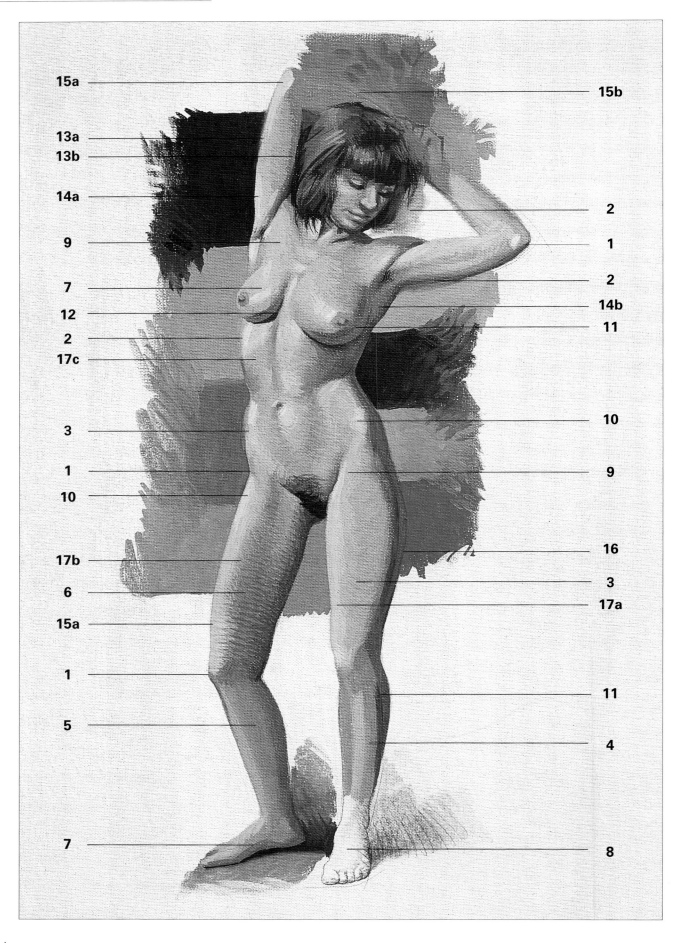

15a
13a
13b
14a
9
7
12
2
17c
3
1
10
17b
6
15a
1
5
7

15b
2
1
2
14b
11
10
9
16
3
17a
11
4
8

◁PLATE 32

1. Clear-cut (located) profile. The image in focus: a sharp, precise and clean outline is also well-suited for depicting anatomical structures of the human body that are hard in their outlines, or whose outlines have a firm consistency, such as the tendons or skeletal structures visible below the skin e.g. at the elbow, the knee, the knuckles and the ridge of the foot.

2. Blurred (lost) profile. The image is out of focus: in opposition to sharp outlines, blurred or indistinct contours are suited to those parts of the body that are soft in texture – areas of adipose tissue or those with a dense covering of hair, slackened muscles, etc.

3. Shaded-off tones: the blurred or sfumato method. In charcoal or soft graphite drawings, for example, a similar method to this is very useful where you do not wish to portray the naked body by reference to its outlines, but rather to let contours emerge by doing no more than varying the strengths of tones. Indistinct outlines can contribute to 'involving' the model in the surroundings.

4. Distinct and separate tones applied using the direct method or the structural method.

5. With the form method.

6. Against the form method.

7. Tonal masses: the direct method. The brightest parts of the figure are those positioned to meet the incident light at a right angle (or very close to one), while mid-tones are to be found on those planes angled obliquely to the light's direction. Shadow is found on those planes that do not receive any light directly from the main source.

8. Preliminary pencil drawing and monochrome layer in burnt sienna. One approach to drawing or painting the human form was mentioned on page 49. Another approach, which can be applied to any technique and which is especially useful for a thoughtful development of a nude study from life, is that of analysing the tonal values by making a monochrome study (see plate 8). For example, if you are using oils, the main working stages could map out as follows:
a) Use charcoal or graphite to block out the general, overall forms of the figure, assessing structure, pose and the broad masses of tone or volume.
b) Establish the extremes of the tonal scale you plan to use (this does not necessarily need to go all the way from black to white). Do this both for the model's skin tones and for the background.
c) Lay the background to attain its precise tone, but do not work too evenly. It is a good idea to use fairly well-thinned paint for this, a medium-sized or large flat brush, and to avoid using parallel or overly regular brushstrokes. Be careful to avoid depositing a thick ridge of paint along the figure's outline.
d) Paint in the elements in the foreground of the composition, as well as any shadows they project.
e) Determine, by simplifying as you go, what the figure's main tones are; decide which ones are indispensable and which ones may be omitted. Tones can here be graded into three strength groupings: light, medium and dark. Bearing in mind that the medium tones will appear to belong to – or at least tend towards – the light group, it is better to begin by making a marked differentiation between the lightest and the darkest tones – i.e. between light and shadow. You should then establish the exact relationships of the tones between these two extremes, painting in the larger masses first.
f) Evaluate how the contours are progressing as well as their quality – the alternation between sharp and blurred outlines. It helps if you let a little of the paint used to mark out the figure's edges run into the background colour.

9. Local colour (see page 49, step 4).

10. Highlight strong light and reflections.

11. Shadow on the body's dark side and ambient light. The 'self-shadow' or the shadow cast on itself by a figure is located on the opposite side to the light-source and can therefore receive no direct illumination. The darkest zone within this shadow is the part nearest the illuminated side, situated as it is in the area of contrast between the light tones and the mid-tones that are created by whatever fill light hits the body after being reflected from surrounding surfaces on to the shaded part. In painter's slang, this 'terminator' or dark halo of deepest shadow is known as the 'hump' or the 'bridge'. For ambient light, see point 16.

12. Cast shadows. Extended or projected shadows are those cast on to other planes by an object interrupting the stream of incident light. In conditions of diffused lighting, projected shadows are weak and blurred in contour, while shadows cast on to surrounding objects under conditions of strong direct lighting are deep and clear-edged.

13. Skin coloration: a) in light; b) in shade. Different types of illumination – natural or artificial light – have differing effects on the relationships between skin hues under full illumination (light tones) and those in shade (dark tones). A general rule-of-thumb that may often prove useful is light warm/dark cool – light cool/dark warm where by warm we mean a colour in the yellow/red part of the spectrum, and by cool we mean a colour tending towards blue or grey.

14. Tonal contrast: a) light (skin) against a dark (background); b) dark (skin in shadow) against a light (background).

15. Equivalent tonal values: a) light (skin) against a light (background); b) dark (skin in shadow) against a dark (background).

16. Colour cast of ambient or reflected light: any light source, especially if it is direct, will produce reflected light as it bounces on to the shaded parts of an object from surrounding surfaces. In these areas of self-shadow, this reflected light weakens the colours present or alters them in some way (see colour, page 52). The amount of reflected light will ultimately determine the tonal value of this ambient light in the shaded areas – it has a similar effect on tonal planes to that of direct light (see point 7). Reflected light is usually less intense than direct light and for this reason no area in the shade can be as bright as one in direct light.

17. 'Kindred colours' and 'contrasting colours': in this point I shall look at skin coloration when it is contrasted with a) a neutral background colour; b) a warm background colour; c) a cool background colour.

METHODS OF DEPICTION

For the study of the form (line, tone and colour) of any object, but particularly in the case of such a complex natural object as the human body, each of the possible painting techniques listed below offers its own interesting characteristics and will call for different methods in terms of observing, perceiving and expressing the object under study. You may opt faithfully to follow each of these methods individually in order to gain experience or to acquire proficiency in a particular painting technique, but in general most artists switch between techniques when a specific approach is prompted or imposed by the characteristics of the subject or the medium.

1. The broad planes method

This consists of simplifying the tonal planes and evaluating the figure as if it were made up of extensive areas of flat tone divided between light, dark and mid-intensity. Having drawn or painted these tones on the support, it is possible to modulate them a little, linking them with each other and adding accents for the areas of strongest light and for those in the deepest shade.

2. The direct method

This also consists of depicting the three basic tones (light, medium and dark), but this time working through the figure and laying down smaller amounts of each tone where it occurs on the body: working freely, first the light tones are put down, then the medium and then finally the dark ones to build up a mosaic of small blotches of tone, each one where it belongs. While similar in its inspiration, the broad planes approach differs from this method in that it simplifies the tonal areas more and makes them larger, juxtaposing them first and only later adjusting them or shading them off into each other if this is considered necessary in order to give particular parts of the figure their distinct tonal values.

3. The blurred or sfumato method

This method resembles that of broad planes, but instead of leaving clear divisions between each broad area of uniformly flat tone, and then shading them off into each other later on, they are blurred into each other as the paint is laid down. Then, working rapidly wet-on-wet, detail of ever-increasing sharpness is immediately built up on these areas of general tone before the underlying layer of paint has dried. The portrayed image thus emerges gradually from vagueness into clarity.

4. The sharply focused method

This method is suitable when strong, direct lighting is used, to emphasise the contrasts between light and dark. Each profile and plane is clearly distinguishable, although softening and shading may be used in order to convey a sense of volume more effectively, by modulating the transitions between tones in a more natural way.

5. The compact or structural method

This method is a good way of counteracting any tendency to make forms too soft, vague and rounded. It consists of blocking out the tonal planes distinctly and separately as if they were part of a group of solid geometrical forms, and then fusing them into each other, but without losing their clarity of construction in the process.

6. The across the form or against the form method

This consists of graduating the strength of tone or colour as it is laid in small, short brushstrokes or lines across the overriding direction of the form. For example, if you are drawing a forearm, you work from side to side across the width of the arm and not from elbow to wrist along its length. This method will always enhance the solidity, interconnectedness and structure of your forms and at the same time will soften the contours to some extent by breaking up the sharpness of their outlines.

7. The along the form or with the form method

This method is the opposite of the previous one both in its characteristics and in its aims. It consists of directing the brushstrokes or pencil lines along the prevailing direction of the form. For example, in painting the lower leg, your brushstrokes travel along the length, parallel to the sides, from the knee to the ankle. This has the effect of reducing the feeling of solidity given to the form and of mellowing the intermediate tones. Outlines appear sharper and the overall appearance of the figure is more svelte or slender.

MAKING A PAINTING INTERESTING

Two elements go into making a painting interesting: one is the subject depicted and the other is the rhythmical arrangement of line, tone and colour. In addition, colour or tonal contrasts produce emotional effects, and there is a commonly held idea that strong contrasts excite while soft contrasts have a calming effect on the beholder. The perfect example of tonal unity would be of flat, uniform tone (unity without variety), while the opposite extreme would be represented by the chaotic and fragmentary jumbling together of a large number of contrasting tones (variety without unity). Big, broad forms, then, give the figure a firmer, more simplified appearance than do a succession of small, shallow, haphazard forms. In fact, the unity of tone needed for a good painting or a good drawing is to be found in the broad, clear way in which forms are composed: the smaller masses are subordinate to and matched by the larger ones. One effective way of introducing tonal dynamism in a picture is to play on the contrast between the brightly lit areas on the model (the areas of light tone) and a darker background, or on an opposite contrast.

A REPERTOIRE OF BODY POSES

Non bisogna fare violenza alle forme dell'uomo e dell'anomale oltre un certo limite marcato dalla decenza e dalla verosimiglianza.
The violence you do to the forms of man or beast should not cross the line laid down by the demands of decency and verisimilitude. Arturo Martini

The study of anatomy directly from life, through practice in drawing the naked human form, is still by and large the most suitable and the most effective way to learn how to observe, how to understand correctly what you observe, and how to interpret (and therefore to express) what you derive from your gaze on another's body in the light of your emotions and personal style. Indeed, the ability to portray the human figure, not just accurately but in such a way that the image conveys a feeling of anatomical solidity, of movement, vitality and convincing realism, is without doubt a worthy objective. Once you are well versed in this skill, it may lead you on to true technical mastery and mature freedom of expression.

On the other hand, the choice of which anatomical details to portray and the degree of precision to which they should be observed and rendered will be matters for each artist to decide according to his/her culture and sensibility. It has often been noted how some life studies, for all their methodical execution and anatomical precision, may be devoid of any trace of feeling and are therefore little more than cold-blooded exercises in technical ability. Others, meanwhile, may merely hint at a correct rendition of anatomical form on their way to fulfilling overriding artistic aims and this makes them speak to us with great expressive strength.

In any case, the present artistic climate tends to consider it unnecessary to provide a wealth of detailed medico-anatomical analysis: more weight is given to predominantly visual artistic priorities concerning the form in terms of line, colour and volume as presented by the model who is posing for us.

The life drawings and drawings of partially clothed figures I have brought together in this section are quickly drawn studies carried out with the model before me. They provide an opportunity for me to make various remarks: some comments about anatomy; considerations about the model's pose; suggestions about approaches to observation and depiction.

The best way to use these pictures is not simply to look at them or to copy them, but – where circumstances and practical considerations allow – to work on a live model who is encouraged to adopt the same pose. It will then be possible to make the same observations from life, check up on my personal findings and build on them.*

Note: All of the studies reproduced on the following pages were drawn using pencil (HB, B and 2B graphite) and a wash of sepia gouache paint on coarse-grain (Rough) 200 g/m² Fabiano paper measuring 33 x 48cm (13 x 19in). This collection of pictures comes from a series of studies executed rapidly during life-model sittings over a period of a few months. They were made with a view to providing an anthology of more technically refined drawings and paintings specifically made to illustrate this book. Some of them were subsequently developed into more finished pictures, others were repeated several times using different media, while most have been left as they were at the 'study' stage. Left in this spontaneous, immediate state, they seemed to me more suited to their purpose than works that are more technically complete.

* A series of reflections on drawing the nude model is available on pages 46-49 of my book (see my bibliographical note), while for more strictly anatomical considerations I refer to my *Morfologia esterna del corpo umano,* Il Castello, Milan 1999.

DRAWING 1

When the adult body is in an upright, standing position, especially when it is in the text-book or 'anatomical' stance – with the lower limbs tensed and close together and the arms hanging parallel to the sides of the trunk, the centre of gravity is located inside the pelvis, slightly forward of the second sacral vertebra. The line of gravity (the perpendicular line connecting the centre of gravity to the ground) thus falls in the area comprising the feet and the space between them. Any shifting of the centre of gravity – in whichever direction – involves a compensatory movement of the different body segments as they are forced to reposition themselves in space, thus keeping the line of gravity over the supporting base and preventing the body from toppling to one side.

 The model in this drawing is standing in a variation of the text-book stance: a counterpoised (or 'one arm akimbo') position. In this case, the weight of the body is supported by one leg alone – the right – which is therefore tensed, pillar-like and load-bearing while the other is bent at a slight angle. The pose imparts a tilt to the pelvis, which is higher on the load-bearing side and lower on the side of the bent leg, while the spinal column is twisted in the other direction, bringing the chest, shoulders and head round to counterbalance the shifted weight and re-establish a stable balance. The tension in the load-bearing limb is very clear in the depression running down the thigh corresponding to the fascia lata, the tendon-like band running down the side of the thigh below the skin, forming part of its attachment at the knee.

 This counterpoised pose will crop up again in various guises in the drawings to come because, apart from being a very natural pose, it has been a standard feature in the artistic representation of the standing nude ever since it was 'discovered' by ancient Greek sculptors.

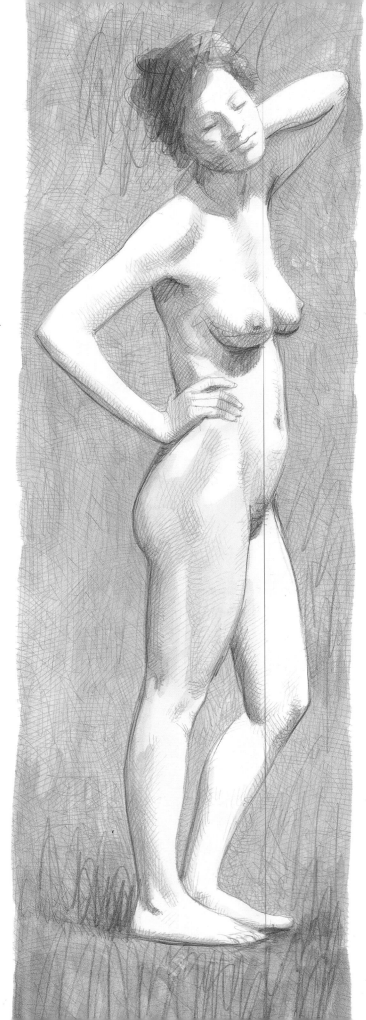

DRAWING 2

There is a very clear display in this model's posture of the contrasting directions of tilt in the transverse axes running through shoulders and hips. Also noteworthy are the differences in level between the two knees and the displacement in the heights at which each hand hangs relative to the thighs.

Whether these 'akimbo' postures are studied from the front or from behind, the carriage of the pelvis plays a crucial role, as does the sideways curve this imparts to the spinal column and the position taken by the head as a consequence.

Counterpoising doesn't just happen at the level of the skeleton: it is also to be seen in the outlines of other bodily contours. Looking at the model's trunk in this picture, you can easily see how her left side follows a line that tends to jut outwards in a convex curve, while there is a contraction in the concave profile of her right flank. The opposite is happening to the profile running down from the pelvis to the feet: on the model's left-hand side, for example, the long outward bow seems to be an extension of the related curve on her right flank as it 'crosses through' the body and continues on the other side.

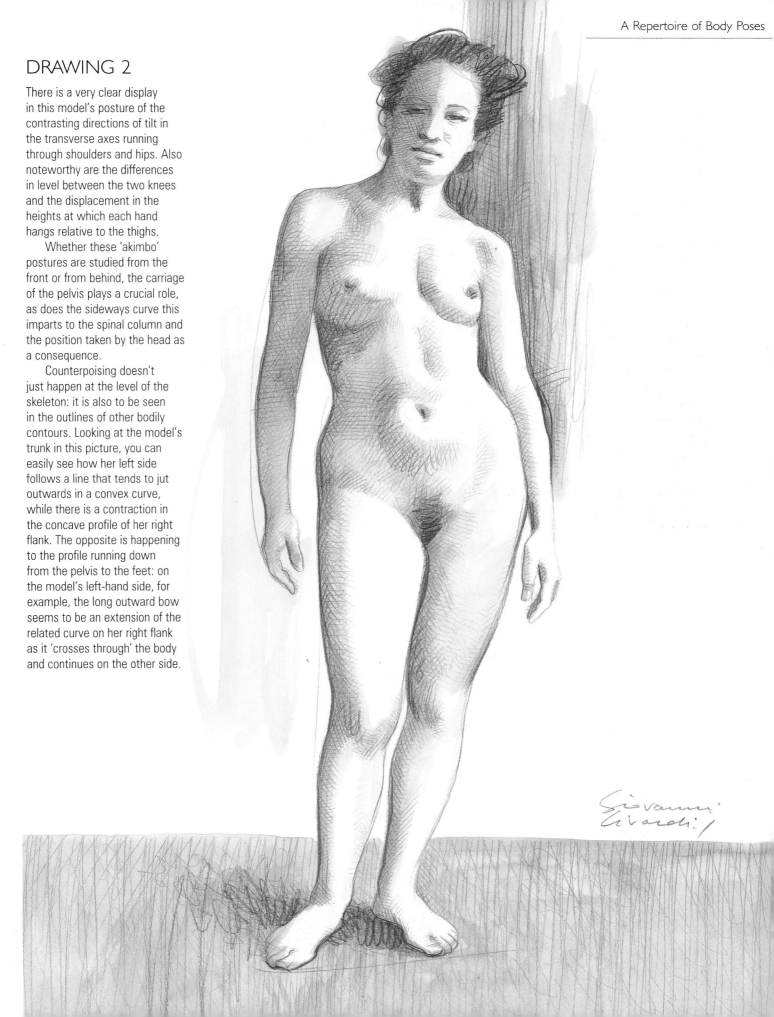

DRAWING 3

The body of the model portrayed in this drawing has
a very different structural configuration to that of the
preceding model, whose softer, gracefully conjoined
forms have an almost adolescent look. In this case, the
opposing forces in the posture – which are pushed to
an extreme – accentuate the curvilinear continuity and
contrast between the body segments and stress the
model's athletic qualities. The raised arms enhance the
convex curve of the right flank, bring the lightly tensed
abdominal muscles into relief and emphasise the iliac
crests hipbones sharply, especially on the left-hand side.

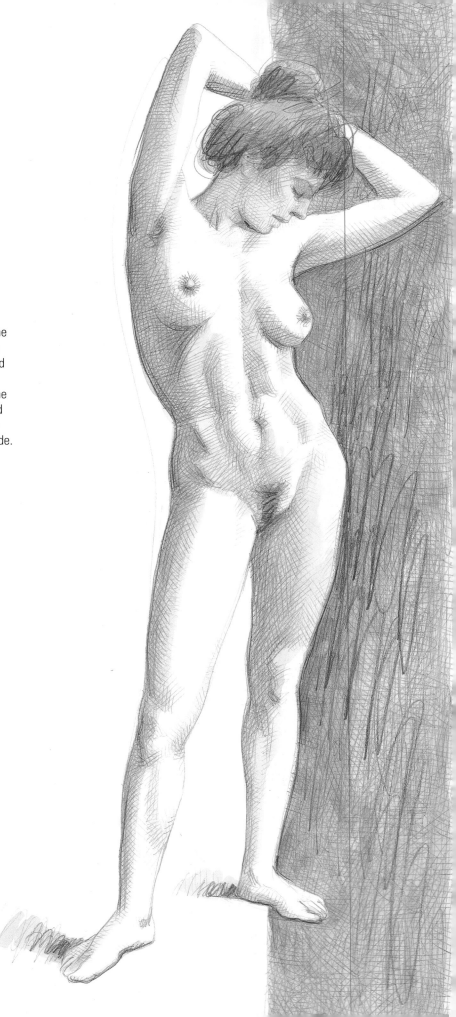

DRAWING 4

This drawing is taken from the same model in the same pose as in the previous study, but here viewed from behind. In addition to the comments made about the frontal view, it can here be added that in this kind of position the spinal furrow is nearly always a clear depression, whose depth will depend on the extent to which the model's back muscles are developed. This furrow extends from the base of the neck down to the sacral bone. Indeed, at neck height, it is always possible to make out the protuberances formed by the seventh cervical and first thoracic vertebrae, which are made to jut out further here by the forward poise of the head – induced and aided by the pushing action of the arm. The furrow stops suddenly at the lumbar level of the back and turns into a flat surface, which is somewhat broader in women than in men.

This dorsal view of the nude contains many more details worthy of comment. For example, the folds in the skin on the contracted left-hand side of the trunk have been indicated clearly in this drawing, although without making the mistake of over-emphasising them. Note also the differing heights of the shoulder blades and the unequal extent to which each juts out: while the innermost edge of the left shoulder blade is very close to vertical, that of the right shoulder blade has been drawn up sharply by the arm so that it appears at an oblique angle. The fold below the buttock muscle of the left (load-bearing) leg makes a deep horizontal cut across the top of the thigh and only merges with it towards its outer edge, while the right-hand fold is indistinct and fades smoothly into the thigh's hind surface.

The counter-opposition of the different parts of the anatomy is made more evident by the simple application of opposite tones: the strongly lit half of the body stands out clearly against a shaded background, while the shaded part of the body is silhouetted by a white ground.

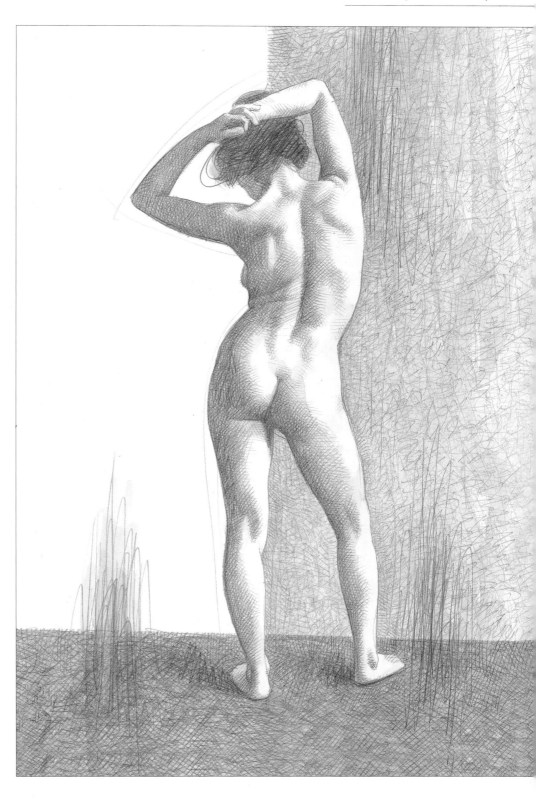

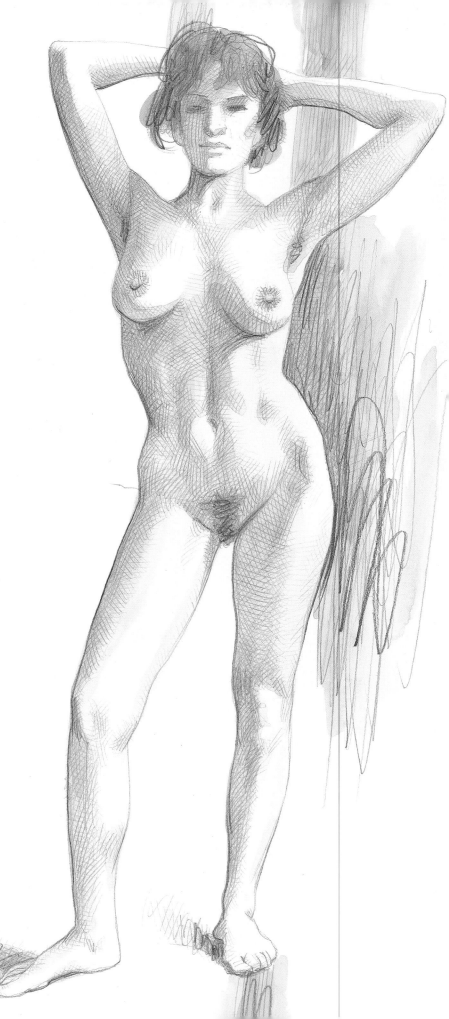

DRAWING 5

A little more spontaneity and a little less muscular tension suffice to make the difference between this posture and the one in drawing 3. The differences are to be found above all in the chest: the model's right breast is raised a little higher than the left due to the higher extension of the arm and the slight pull on the chest away in the other direction. The stomach muscles are only slightly contracted and the deepened appearance of the vertical furrow formed down the middle of the abdomen by the linea alba is more an effect of the side-on direction of the incident light rather than arising from any anatomical origin such as an athletic build.

The marked outward bow to be seen at the top of the model's left thigh is caused by the greater trochanter of the thigh bone in combination with a typically feminine layer of adipose fat in this area.

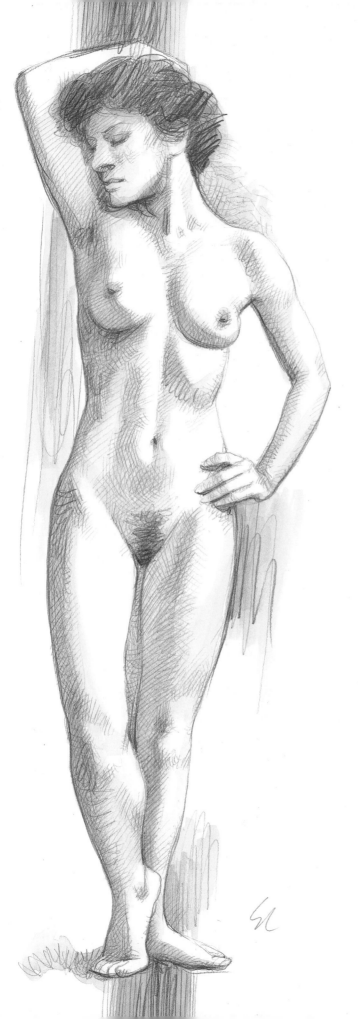

DRAWING 6

The typical shifting of the body's axes of equilibrium, usually seen in counterpoised positions, is displayed only to a minimal extent by the posture depicted in this drawing. The pelvis maintains a horizontal carriage here because the leg doing most of the work (the left one) has not been tensed enough to lift it and the bending of the right leg is not sufficient to cause a noticeable lowering of the pelvic girdle on that side. The counterpoised stance is also disguised by the positioning of the upper body. While the lifted position of the right arm draws up the shoulder and with it the right breast, their elevated position is made less noticeable by the raising of the left shoulder as the hand rests on the hip. The overall balance of the body remains stable even though the line of gravity falls within a very restricted base of support.

DRAWING 7

The posture depicted in this drawing should be compared with those shown in drawings 5 and 6 in order to compare the similarities and differences each position imposes on the anatomical form.

 The characteristics of a naturally counterpoised posture may be changed by deliberately exaggerating or by compensating for its effects. This is what is happening here: the model is intentionally lowering the left-hand side of her pelvis by bending the leg on that side but is at the same time holding the line of her shoulders level, keeping her breasts on a horizontal plane. In fact, the skeletal frame is adjusting itself to counterbalance for a shift in the supporting base, but these adjustments are almost indiscernible in this picture, being masked by the regular vertical lines of the arms, head and neck. The costal arch – the lower opening formed by the ribcage – hardly betrays its slight lateral twist in the opposite direction to the turn of the hipbones, but its true position is revealed by the curve this posture induces in the linea alba running down the centre of the abdomen, which, by contrast, is straight and perpendicular in drawing 6.

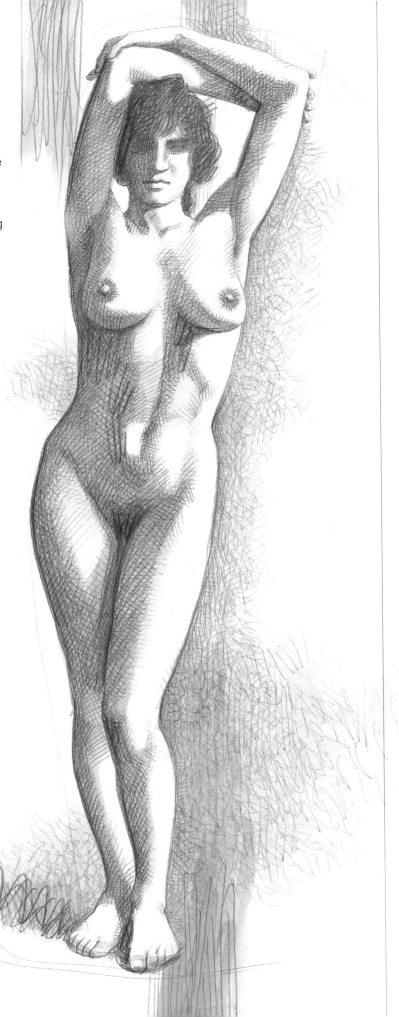

DRAWING 8

This drawing, which came midway between the preparatory sketch shown in plate 16 and the coloured pencil and watercolour drawing in plate 14, is of interest because it shows a body shape that was often selected for female models by the classical schools of art. According to this classical tradition of the 'typical feminine form', these softly rounded shapes, devoid of any sharp, bony protuberances or highly developed musculature, lend themselves ideally to an earnest study of the subtle merging of tones as they fade into each other across the body's smooth, undulating surfaces. Also of note in this study is the shapely structure of the left arm: the area between shoulder and elbow, below the deltoid (shoulder) muscle, stands out partly because of the contraction of the triceps and partly due to the presence of adipose tissue behind the deltoid – present in many women. The accentuated extent of the inward bend (overextension) of the elbow joint on this arm is also a typically female characteristic.

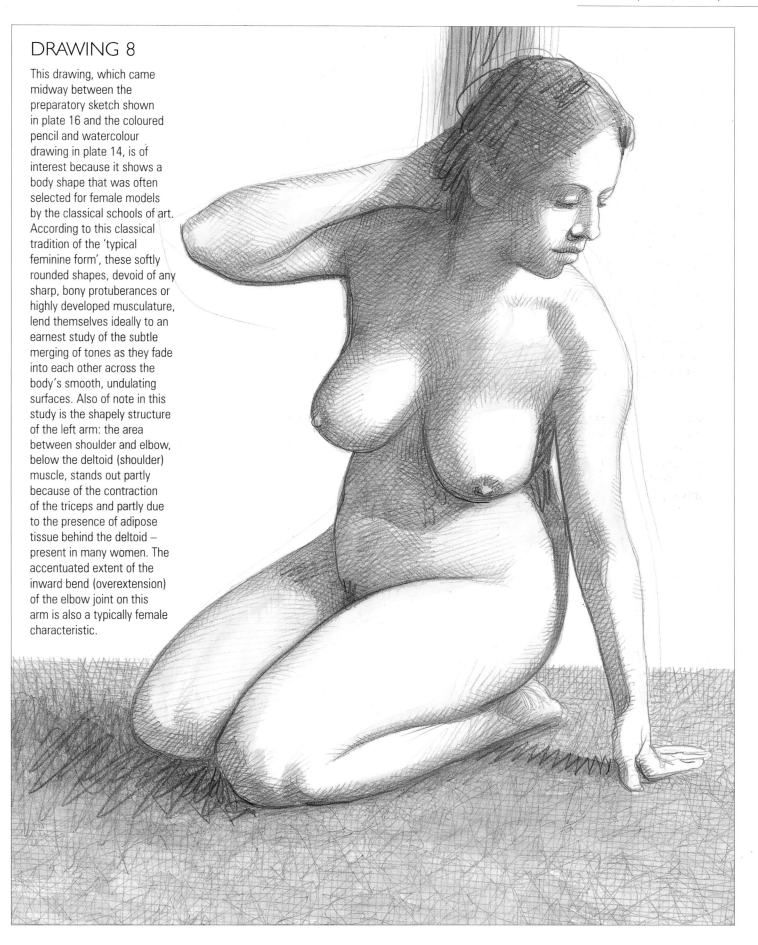

DRAWING 9

In this drawing I have portrayed a model of around sixty years of age. Maturity is in no way to be considered detrimental to a model's interest for nude study: on the contrary, more mature or elderly models present an opportunity for anatomical and aesthetic observation which can only deepen that kind of understanding of what it means to be human which is to be acquired through our gaze. The individual history within the physique before us can be a source of intense aesthetic feelings.

The aging process brings with it changes to the bodily form, some of which may be obvious at first glance and well noted: greying hair, the accumulation of areas of fat, shortening of stature, folds in the skin, etc, while others are subtler and can only be appreciated through the study of the naked body. Among these are changes in the proportions between the different parts, the tendency for models to assume certain postures, changes in skin coloration or in the fineness of the skin in some body zones, as well as a more limited, but nonetheless expressive, repertoire of movements.

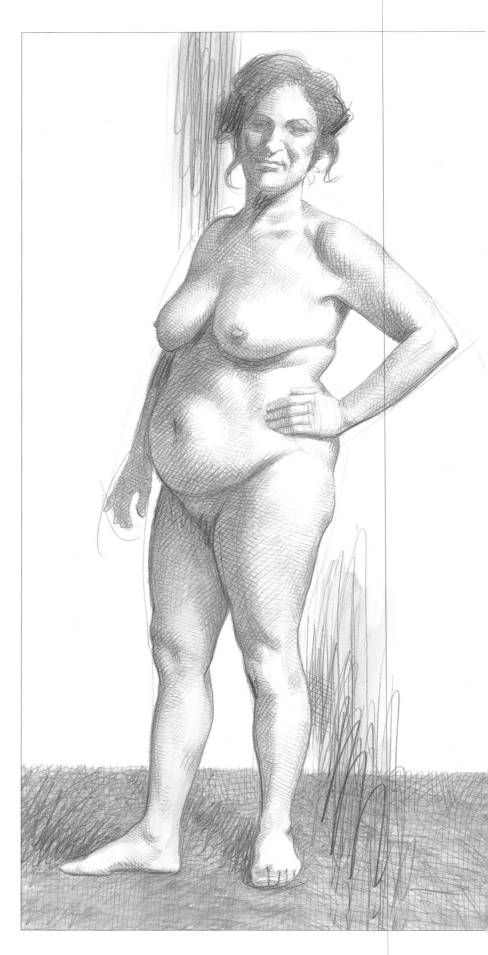

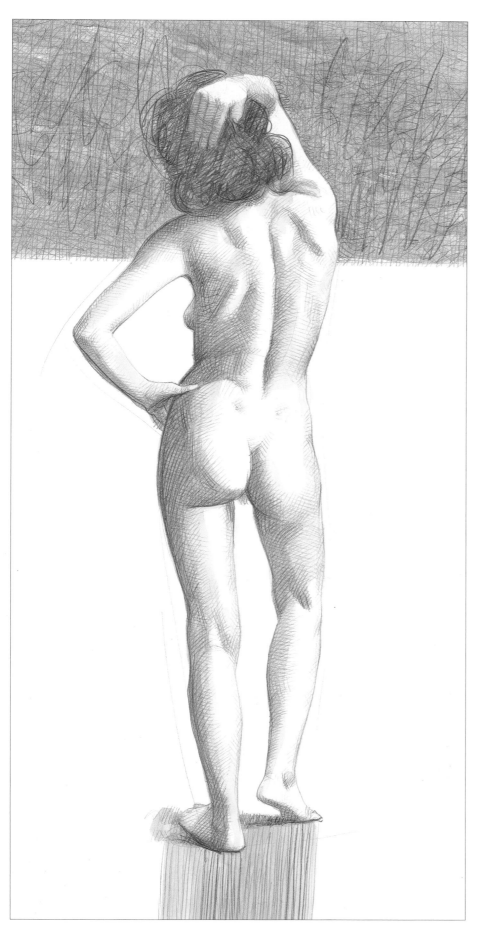

DRAWING 10

This drawing should be compared to drawing 4, which is very similar. It is clear, however, that these are two separate models who differ in their physical builds, ages and degrees of muscular development, as well as in the ways they 'go into' the pose, and so on.

It is always useful and instructive to compare a number of models in the same pose and to take careful note of how anatomical features and shapes collate. It is also often noted how some models are able to inspire artistic and compositional interest more than others, or are able to suggest particularly interesting postures. So when you study each individual model, you should bring to them the full engagement of your artistic feelings and curiosity, viewing them from different distances and angles to gather an impression of their specific characters and create a portrait of each body 'in the round'.

DRAWING 11

Poses in which models are seated or drawn-up into themselves are of interest because, unlike upright postures, these positions bring a degree of calmness to the composition and allow both artist and model to work in an unrushed way. They thus promote our contemplation of aspects of form (e.g. how closed forms differ from open ones), of anatomical proportion and of composition.

In this study I investigated the contrast between the axes of the body's separate segments, many of which form something approaching a right angle between them: between the upper arms and the forearms; between the thighs and the lower legs; between these and the feet; between head and neck and the shoulders, etc. The collarbones take on a sculptural importance in this composition as their snaking progress, seen here from above, bridges the plane between breast and shoulders and places the necessary stress on the volume of this area. In this drawn-up position the body's masses squeeze into each other – the calves into the thighs, the forearms into the shins etc; it is important to look out for the new shapes that are formed when this happens, while bearing in mind the presence of the skeleton underneath and the volumes occupied by the muscles. It will sometimes be necessary to make allowances for the surprising, not altogether pleasing, visual effects that such positions may create. In this drawing, for example, is a faithful, proportional rendition from life and this gives the lower legs a wide and flattened appearance as they squash against the thighs, while the feet look somewhat oversized. Nonetheless – used in a measured way – such apparent deformations can be turned to advantage to emphasise the foreshortening effect of perspective and to add an element of solidity to the form.

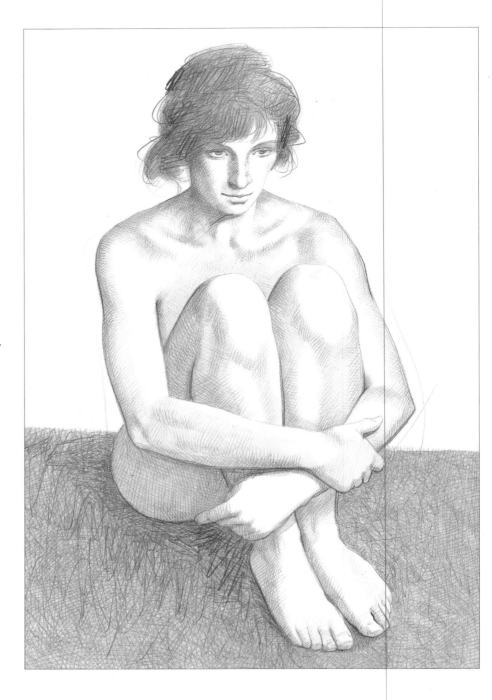

DRAWING 12▷

The forward lean of the upper body cancels out the usual curvature of the spine, replacing it with a regular bow, concave towards the front. In order to get comfortable in the pose shown here, the model has wrapped her forearms around one knee, thus bringing her shoulders forward with the result that the shoulder blades are drawn out sideways and the collarbones are made to stick up markedly at the top of the plane formed by the chest. Each collarbone is bordered by two sharp dimples, one above and one below, of unequal area and depth. The right foot is in pronounced plantar flexion, which brings the pointed ridge of the lateral malleolus bone out into sharp relief.

In this kind of complex position, in which various parts of the body intertwine and overlap each other, a good tip is to mark out each part as a separate volume and create depth in perspective by paying careful attention to the shadows cast by one part of the body on to another – as here with the shadows cast by the upper arm and forearm on the model's right calf and thigh – careful attention should also be paid to any shadows cast on the floor.

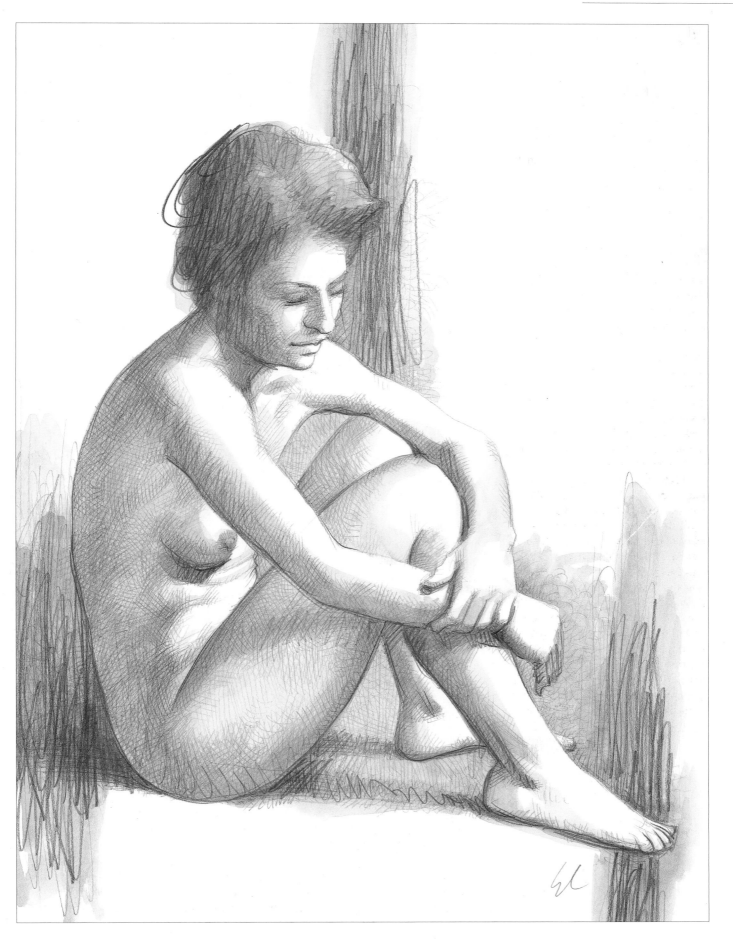

DRAWING 13

Poses assumed by models are not always
aesthetically pleasing or attractive at first
glance, but this does not always mean
they cannot turn into interesting studies
in anatomy and composition. I noticed the
model take this rather unusual position
during a short break in a life session and I
thought it would make an almost abstract
composition. The 'abstract' pattern is defined
by the perpendicular position of the trunk, the
horizontality of the right thigh and the oblique
stance of the left leg – all clasped together
by the crossing of the hands.

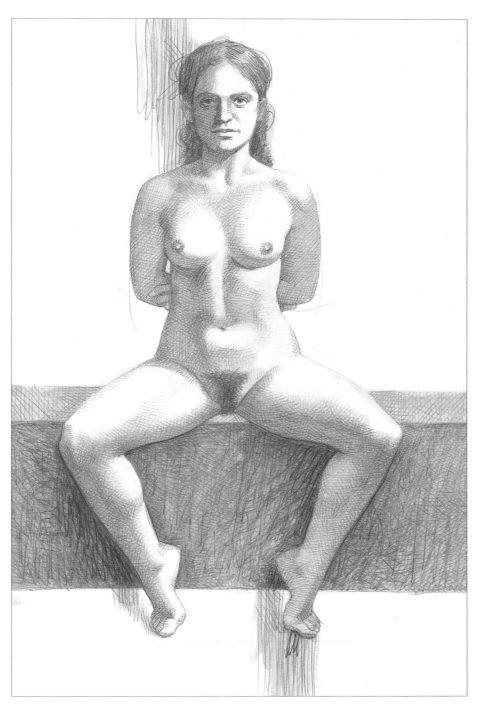

DRAWING 14

In this drawing, too, what attracted me was the compositional pattern of the pose, rather than particular anatomical features. The mirror-like symmetry lends solidity to the body's structure and gives it a veneer of Egyptian sacredness. But the static look is tempered by a series of contrasts between the body's lines of axis: the thighs, the lower legs, the trunk and the arms which are brought out by the horizontal rake of the bench on which the model is seated.

In order to cross the forearms behind the back, it is necessary to lean the shoulders forwards a little, which makes this portion of the body wider than it would otherwise have been. Although this change in proportion, along with the smallness of the breasts, combine to detract from this young model's typically feminine looks, it was on the whole worthwhile sacrificing spontaneity of pose to the demands made by the composition.

DRAWING 15

Kneeling positions are especially suited to producing postures that are interesting both for their sculptural qualities – the positioning of the forms in space, depths and volumes – and from the compositional point of view – the arrangement of tonal masses, the projections of shadows, etc. However, it is necessary to work quickly when a model is in these types of position as they can be quite uncomfortable and hard to hold for very long – it can be difficult to keep your balance when the main support is the knees, the bridge of a foot, or even the side of a leg.

The model in this drawing is in a decidedly static position although – paradoxically – it contains a hint of movement, a dynamic tension suggested in the lean of the trunk, the turn of the head and the parallel but counterpoised positioning of the right arm and left thigh. The backward placement of the right arm highlights the deltoid muscle, which covers the head of the humerus and deepens the clear depression separating it from the larger chest muscle. This same region below the model's left shoulder is much flatter as the various planes come together in a much gentler way.

The squeezing of the thigh as it rests on the lower part of the leg, more pronounced in the left leg, forces the large muscle groups of these two body segments to flatten and spread out sideways. It is advisable, however, to concentrate carefully on how you draw individual regions in this type of situation, noting how forms are changed under pressure, while keeping in mind the fact that bodily forms can only be compressed within the very definite limits imposed on proportion and articulation by the underlying framework of bones.

DRAWING 16

The light shining from the top right-hand side of this picture rakes across the surface of the model's form and throws even the smallest prominences and depressions into relief. This helps us see, starting from just below the model's left armpit, how the light swelling which marks out the lateral continuation of the breast is interrupted at one level by the edge of the large back muscle and, lower down, by the fold of the abdomen.

The left arm, stretched out with an inward turn, has the forearm in a prone position which gathers one or two folds of 'excess' skin at the elbow. Always visible at the wrist, the distinctive ovoid protuberance of the styloid process at the end of the ulna is particularly in evidence here. This bony reference point is very useful when it comes to ensuring that the rotation given to the hand looks right, as well as for giving clear expression to the angular junction between the centre-line of the hand and that of the forearm, when they are viewed side-on.

Also detectable beneath the skin here, due to the bending of the leg, is the bony structure of the knee joint. To appreciate this structure fully, it is necessary to be aware that the medial and lateral epicondyles of the femur, the protuberance of the tibia and the head of the fibula as well as the kneecap and each bone's covering of tendon, contribute to make up the external structural configuration of the joint, and how this varies with the degree to which it is bent.

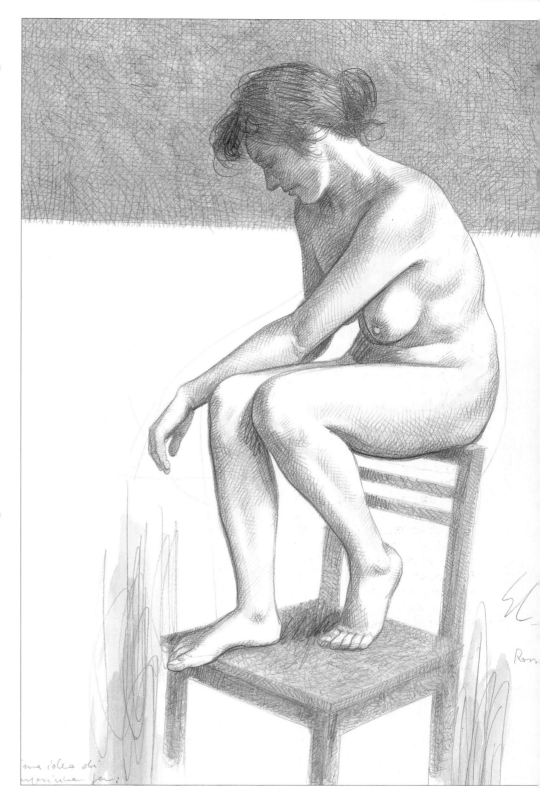

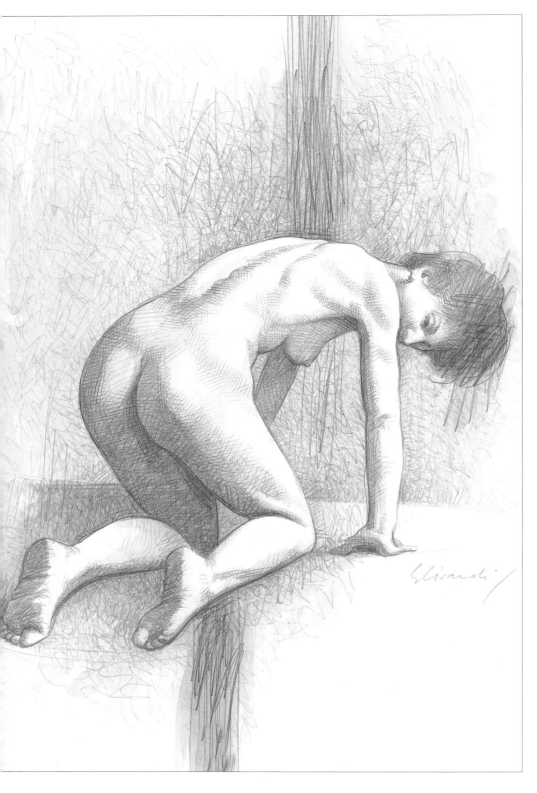

DRAWING 17

The pose I asked this model to assume may seem a little odd, but I thought it a suitable way to demonstrate that looseness of movement, agility and muscular definition that dancers so often possess. The upward bending of the spinal column causes it to lose its alternating physiological curvature (lordosis and kyphosis) and to take on a continuous regular bow. This movement also raises the spine along its furrow, revealing a regular row of one vertebral process after another, while the back muscles spread and flatten themselves against the ribcage. At the base of the spinal furrow, on the pelvis, can be seen the flat, triangular area of skin which covers the sacrum, whose upper angles are always marked out by two fine dimples corresponding to the posterior superior iliac spines.

The drawing also highlights some anatomical details of the shoulder blade region: the inner edge, the lower angle and the ridge of the right shoulder blade, the large tube-shaped muscle, the small tube-shaped muscle (teres major and teres minor) and the lateral edge of the large back muscle.

When the trunk leans forward like this, the force of gravity pulls the breasts away from the ribcage and they take on an elongated, conical shape as they stretch downwards, making the habitual skin-fold beneath the breasts disappear. Lastly, the soles of the feet are cut across with many deep creases, resulting from their extreme plantar flexion in this pose.

DRAWING 18

It is a good idea to observe – and to draw – the posing model from more than one viewpoint: only by changing perspectives can you fully evaluate all the compositional and anatomical/morphological aspects of the subject which become salient during a nude study. This is the process of investigation typically followed by the sculptor – who is interested above all in the body's actual volumes in space – but it can also be of great utility to painters. This drawing should therefore be compared with drawing 24 in order to note their similarities and differences, going beyond their immediately apparent likenesses.

In drawing 18 the sitter's pose has an overall conical or pyramidal tendency: i.e. the projection of the thigh towards the viewer gives the body a depth and volume which is in contrast with the flatness of the shoulders as they turn to face the front fully. The overall form in drawing 24, on the other hand, is more of a two-dimensional triangle, as if laid out flat on the paper. This impression is not altered by the partial foreshortening of the shoulders, but by way of compensation greater prominence is given by this viewpoint to the rotation of the trunk, the forward jut of the breasts and the extensive surface of the left thigh.

In both these drawings the pronounced angle between upper arm and forearm has been made clearly evident: the overextended bend on this joint can be greater in women than in men. Emphasis has also been given to the rather dominating proportions of the left leg and foot: this play on perspective is partly real and partly the result of artifice on my part.

In short, while I sought in drawing 18 to capture the sculptural, volumetric aspect of the model's body, in drawing 24 I concentrated on the graphic aspects of outline and the model's static balance.

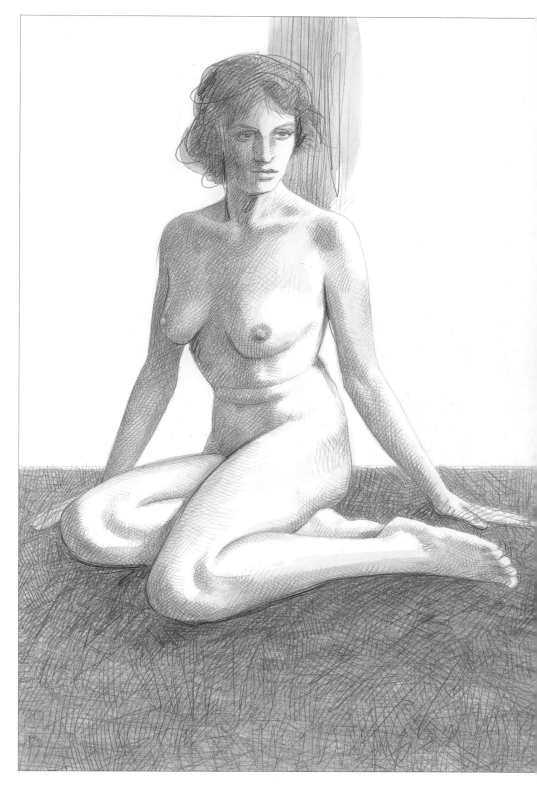

DRAWING 19

The model posing for this study is the same
one as in drawing 16, and the posture
represents a variation of the one examined
there. The body is again seen from side-on
and the legs are bent in the same way: here,
however, the trunk is unmistakably upright
and the support of the model's left arm adds
to the sense of stability conveyed, a feeling
only slightly disturbed by that bending of the
left leg, as if suggesting a gesture – or at
least an intention – of movement.

The light from the upper right does not
pick out any particular details of surface
relief on the skin; this obviously means that
there is only a slight amount of tension in
the muscles and that the skin has not been
compressed or folded. We do, however, once
more see the fold of the abdomen at the level
of the navel, indicating the slight forward
bend of the chest on to the abdomen. In
this drawing the right hand appears both
drawn and positioned in an awkward way;
perhaps it would have been better to leave
it out completely. But these are studies,
made with a view to helping the artist
become aware of the various and complex
aspects of the figure and for this very reason
such studies are very rarely complete and
valuable works in their own right. It is via
this process of observation, trial and error,
evaluation, discovery and selection that one
arrives at a more carefully formulated and
thought-through work – a more eloquent act
of expression.

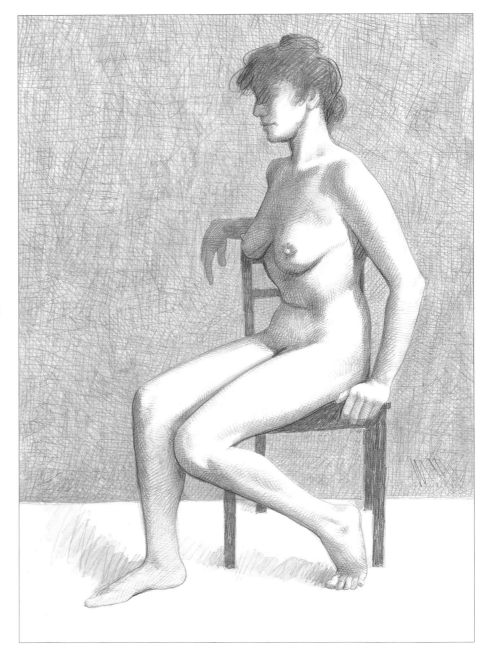

DRAWING 20

Seldom do I tell a model precisely what pose to go into, but prefer to suggest an attitude, a position or a movement which may turn out to be germane to studying shapes and researching compositional possibilities. So I encourage models to position themselves with freedom, limiting myself to observing them and to gathering the more stimulating and inspiring aspects as they arise – including those I come across by chance. Even in the art college, during life-class sessions, a keen and attentive draftsman or woman can derive much of value from those spontaneous positions models adopt during their breaks between one sitting and another, while they are getting dressed or undressing (see drawing 13).

In this drawing I was trying to explore the positional relationships between the individual parts of the model's body as she holds this compact position in which the axes of each limb are either running parallel with each other or in opposite directions across the body's sides. For example: the model's right forearm and upper arm reflect the same positional relationship as the two parts of her left leg, whereas – albeit to a lesser extent – the left arm contrasts in its cocked position with the straight up-and-down lines of the right leg. The rotation given to the head, followed in turn by the twisting in the trunk, is in a counter-spiral to the positioning of the thighs: a counter-movement which imparts a dynamic note to what is essentially a rather static posture.

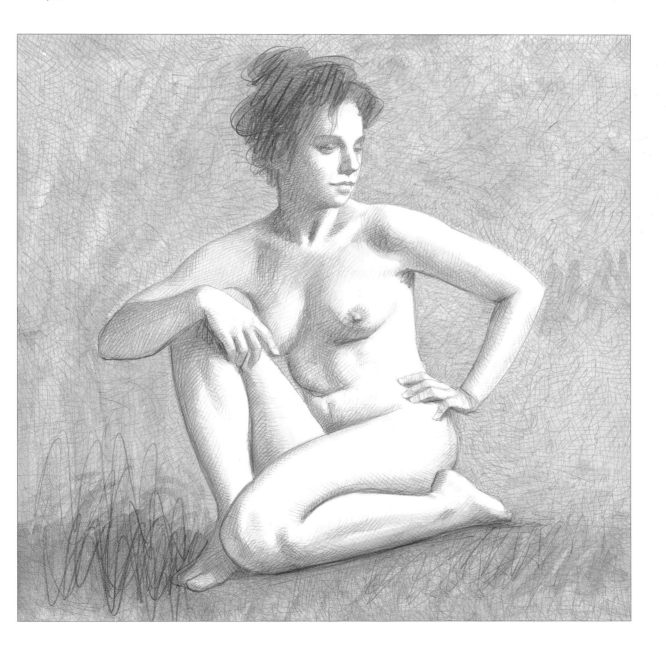

DRAWING 21

The position here also points in common with that shown in drawing 13. Yet the attitudes of the two models differ radically. Obviously, this difference is perceived not just from the morphological point of view, but also from the psychological one, of inferred character. Whereas the frame of mind conveyed by the study in drawing 13 is calm, familiar, demure, in this study I have emphasised an aspect I perceived in the model of self-assured defiance – almost bordering on playful 'offer'. The absence of any visible support to hold the model's weight – just the mere suggestion of one made by a vertical shadow – adds to the figure's detachment from its environment, concentrating the viewer's attention on the anatomical and gestural details of the nude. The stretching of the chest, for example, partly as a result of the backward shifting of the left arm, throws the collarbones into relief as well as the furrows on the breastbone. The raising of the left shoulder draws up the breast on that side so that the shoulders and the nipples make two transverse lines diagonally crossing the vertical line formed by the head, chest and abdomen.

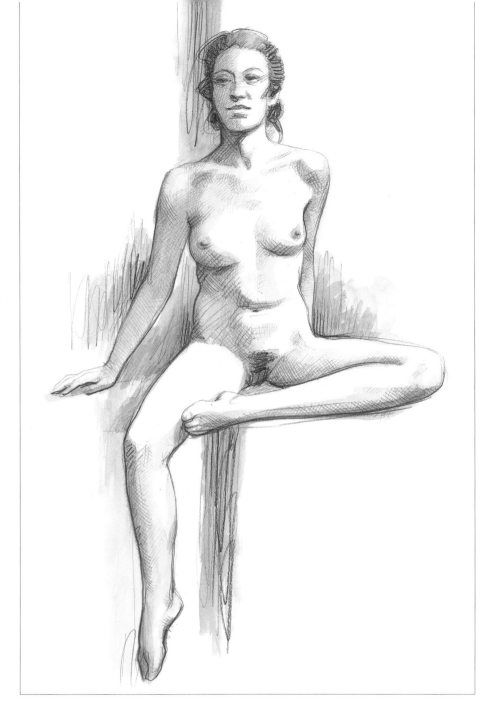

DRAWING 22▷

This drawing was done as a preliminary study for the monochrome painting reproduced in plate 8 (page 21) and I also used this same pose for the sketch demonstrating oil technique in plate 2. The marked tonal contrast between those parts of the body in strong light and those in shade – which nonetheless receive a fair amount of reflected ambient light – combine to give the figure its solidity and three-dimensional quality. What caught my attention here was an oddly mirror-like aspect of the positioning of the limbs: the forearms reflect the positioning of the lower legs; the hands are a mirror-image of the feet and on each side the upper arms and thighs meet in the same way. Sometimes, if you carefully follow your rational curiosity, it can come to the assistance of your emotional expressiveness; at other times it can lead to tragic results.

The raking light picks out undulations on the surface of that slender portion of abdomen visible above the model's right thigh. These depressions are not due to muscle or bone-structure, but bending has formed subtle ripples or rises and depressions in the skin and adipose tissue.

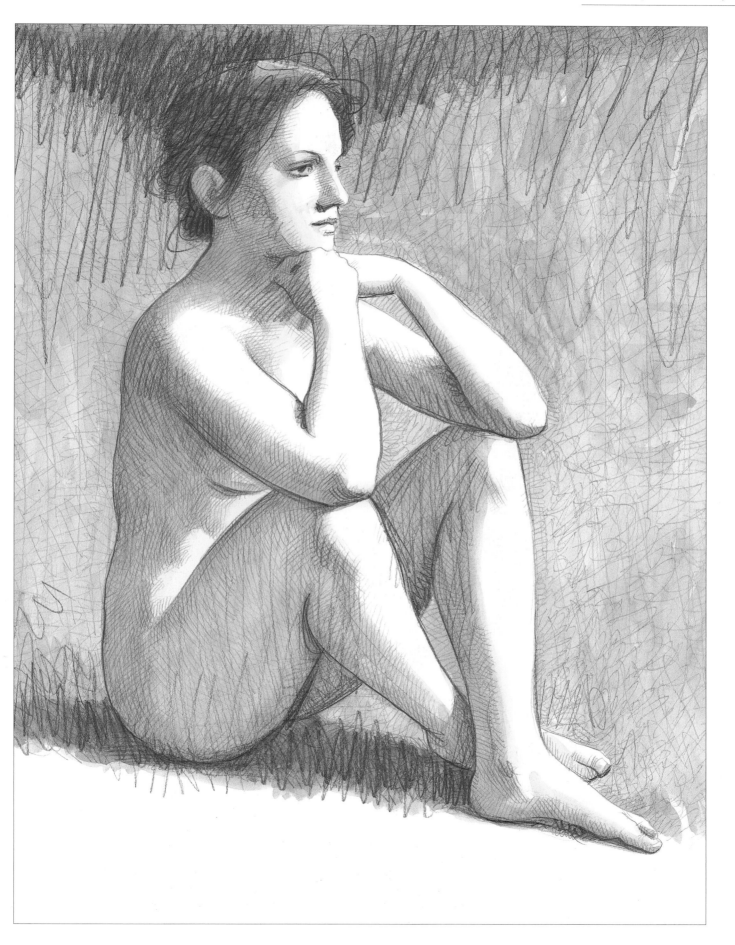

DRAWING 23

A drawing taken from this study was used to illustrate charcoal drawing technique (plate 17) and this same model also posed for plate 14, plate 16 and drawing 8. When a model is particularly suitable and a particular posture appears especially interesting, I tend to repeat the subject in several different versions, varying the technique or the dimensions of the study to see if it holds water when different implements and pictorial techniques are used. It sometimes happens that certain body images seem to suggest a specific technique or a method of execution of choice, but then prove awkward when you try to achieve the same impression using other implements, yielding less successful results.

The ample dimensions of the pelvis compared to those of the shoulders are clear in this frontal standing pose: a characteristic typical of some female anatomies, and as I have noted in my comments for drawing 8, this model's looks are especially suited to displaying the classical feminine form. The navel, for example, is set deep in the middle of an abdominal region which is a little more protuberant and globular than would typically be the case with a man and at the sides of the thighs, at the height of the greater trochanter of the thigh bones, there is an adipose deposit not often seen in men. Female models with different builds may display similar morphological features although in less-evident ways.

In this drawing the model's right leg, held tautly forwards, has a slender look that contrasts a little with the apparent squatness of its neighbour, with its imposing masses of muscle and adipose tissue. A final remark: the left arm, held behind the back, would have benefited from more careful observation and treatment of the visible parts of the forearm to avoid giving the impression that it has been cut off at the elbow.

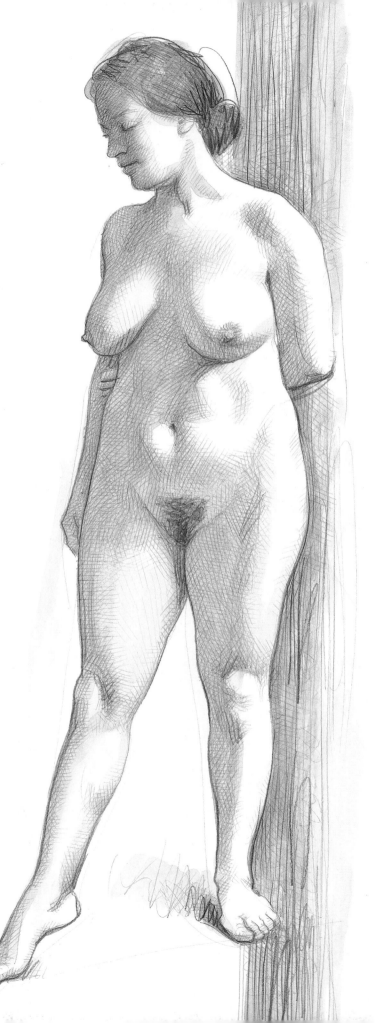

DRAWING 24

Please refer to my comments about drawing 18.

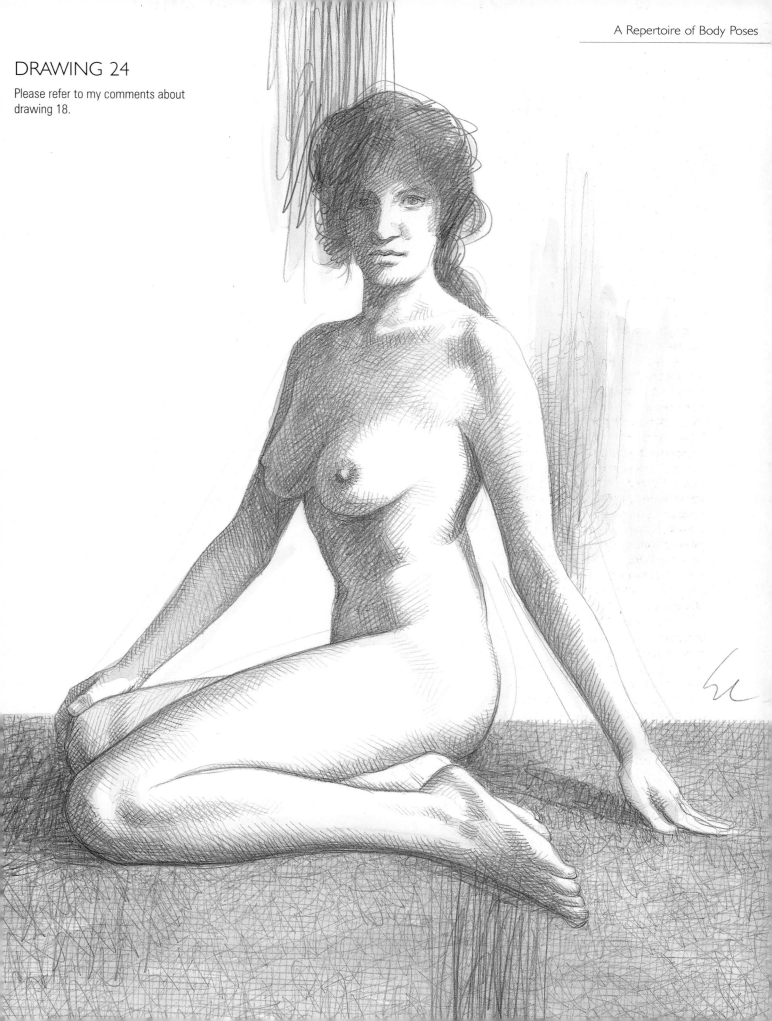

DRAWING 25

The opposing directions followed in this posture by the transverse axes passing through the shoulders and the hips bring us back to the characteristics of counterpoised stances, which we have already spoken about in connection with the drawings depicting standing poses. The displacement appears strongly accentuated in this case by the tension in the model's right arm, which functions as the load-bearing column for the back and which, in doing so draws the model's right breast up a little. As a result, the collarbones change their angle and hollows of differing depths are formed above and below each one.

The horizontal line of the plank on which the model is seated emphasises the counterbalanced position and forms a contrast to the perfectly vertical left leg.

It is always difficult to draw a limb, either in its entirety or in part, when it is in a very sheer perspective view: in such circumstances it is a good idea to compensate for any excessive foreshortening of one limb by presenting its partner in a more extended and recognisable way.

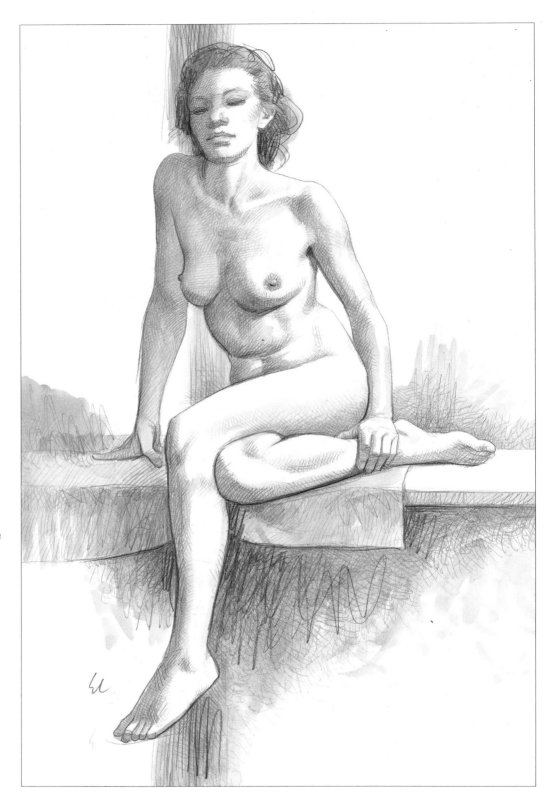

DRAWING 26

In order to 'anchor' this figure to its surroundings and to counteract the impression that it was floating freely in space, or around the paper's surface, I placed some fairly dark tonal masses in the background with loose, parallel pencil marks and some brushstrokes of highly diluted gouache. These areas use tonal contrast to bring the strongly lit parts of the body into relief and to make visible the cross-shaped arrangement which links the model's body to the cube form on which she sits, extending out to the edges of the paper.

The twist in the body is made more conspicuous by the placing of the model's right hand on her left thigh, by the shadow the forearm casts across the tops of both thighs, and by the swelling of the triceps muscle of the left arm. The size of this muscle is further strengthened by the layer of adipose tissue behind the deltoid muscle of the shoulder.

The surfaces bordering the ankles are dominated by the presence of the malleoli or the end segments of the fibula and tibia bones of the calf. The lateral malleolus (on the outside of the ankle), which marks the end of the fibula, is pointed and clearly visible beneath the skin, while the medial malleolus marking the end of the tibia (inside leg) is broader, protrudes less and is positioned further forward and further up the leg. The inner profile of the foot has a slightly concave curve, while its outer edge is characterised by a regular if slight convex swerve.

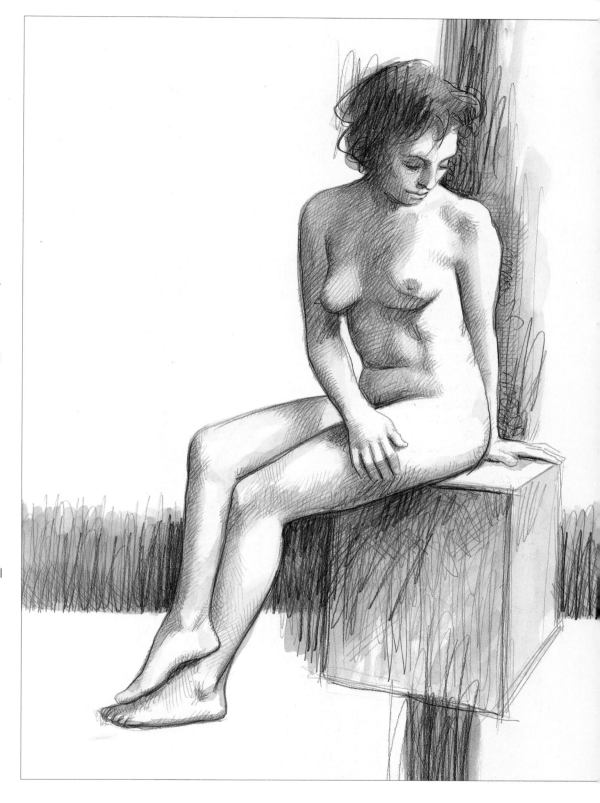

DRAWING 27

The male body can make a perfect subject for anatomical study as its external forms may often be of solid construction and clearly defined. Also, with thinner layers of adipose fat, the outlines and volumes of the superficial muscles, tendons and some bony processes are apparent beneath the skin. For these reasons, and for the impression of strength these features can evoke, the male nude has long been an object of study in the studio and a source of inspiration. This fact is evident from any consideration of the artistic tradition spanning from ancient Greece to the Renaissance, with the continuation of an academic tradition of the male nude necessitated by the depiction of historical and mythological subjects almost up as far as the end of the 19th century. This tradition of study has, of course, paralleled that of the female nude, whose popularity as an object of study, (no doubt due to its great symbolic, gestural and suggestive power), gradually increased until it was given the position of near monopoly it occupies in modern and contemporary figurative art. Studying and drawing the male nude from life is a practice which continues today mainly in colleges and academies of art and is far less widespread than its importance for the observation and analysis of human anatomy would justify.

The counterpoised stance depicted in this drawing brings to attention the greater width of this model's shoulders compared to his hips, and the sideward bend of the trunk provides a visual echo of the line followed by the linea alba, that longitudinal furrow running between the two upright muscles of the abdomen, which can be a very pronounced feature of the sculpted bodies of some sporting types (the vertical centre line of the six pack). Well-developed muscles, especially of the arms, can reinforce the angular look of a body's profile.

When drawing a male nude it is often a good idea to indicate the areas of body hair, which are distributed differently and often more densely than those on women: typically on the chest, the face, the legs, forearms and encircling the genital organs, extending up to the navel.

The lower arch of the ribcage often has a more acute angle in men and is quite clearly defined under the layer of muscle. There, the external oblique muscle on the model's left side, partially covers the iliac crest (hipbone).

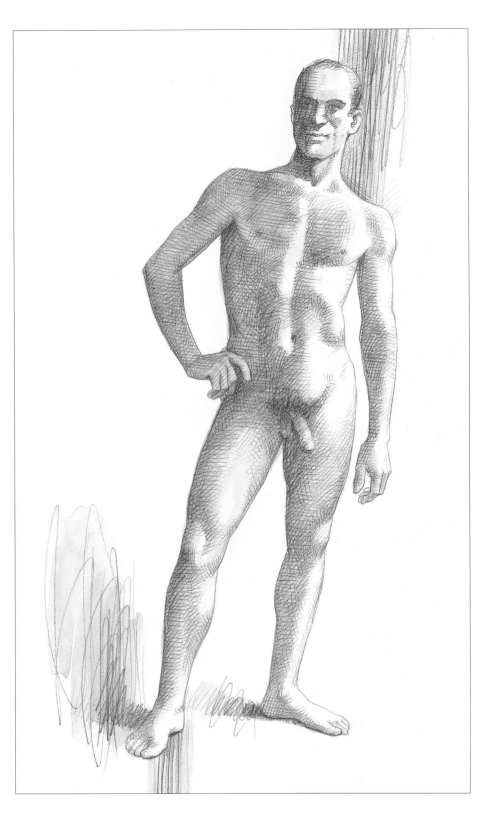

DRAWING 28

This drawing uses the same model as is depicted in the previous study, as well as in others scattered throughout this book: it is, indeed, no easy matter – in Italy – to find suitable male models that are prepared to pose naked, although female models are comparatively easy to find.

The posture shown here brings the course of the spinal column into relief as well as the change in position of the right scapula (shoulder blade) when the arm is raised to a sharp angle. Concentrating on the region of the right shoulder blade, we see the modifications induced in the position of the scapula and the forms of the back muscles by the arm's movement. We can clearly see, for example, the outline of the trapezius muscle and how the deltoid muscle forms a cushion around the acromion. Being jointed with the collarbone, the shoulder blade is drawn upwards and sideways by the arm's movement, bringing its inner (or medial) edge to a diagonal position in relation to the median line of the body. In the standard anatomical position, with the arms hanging parallel at the sides, this edge of the scapula is parallel with the spine.

Inside the vertebral furrow, which is here formed by the flexing of well-developed back muscles, there is no sign of the points of each vertebra, as these only appear when the spinal column is bent outwards (see drawing 17) although the bony point of the 7th cervical vertebra is always visible at the base of the nape of the neck, and this may sometimes be joined by the first thoracic vertebra.

There is a slight contraction to the muscles of the right thigh, although this model's habit of frequent exercise means these are unusually large: the quadriceps muscle of the thigh is situated at the front and is separated from the biceps femoris – which is situated at the back of the thigh – by a flat line running down the outer side of the thigh, known as the fascia lata.

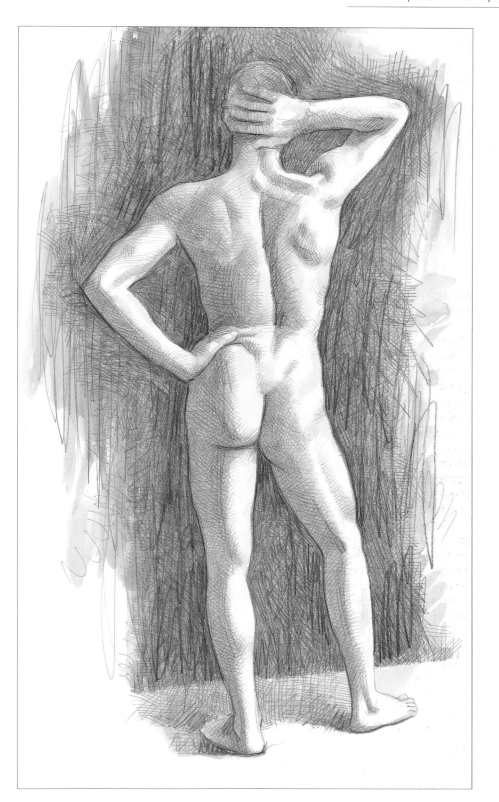

DRAWING 29

The position I asked the model to adopt here contrasts a little with the vigorous impression male nudes are often supposed to inspire – whether out of tradition or convention. Be that as it may, my interest here was to highlight the proportional relations between the different segments of the body, along with some anatomical characteristics which are easier to see when the body is viewed from the side and in a relaxed pose. Looking at the side of the torso and down the back from this position, one can see the spinal ridge on the back surface of the shoulder blade and the raised lateral outline of the large back muscle. As the light comes from above and almost skims the surface of the model's body, it accentuates the divisions between the different muscle volumes at the back of the arm: the rear side of the triceps is in sharp profile, even though it is slightly contracted here, while the tendon of this muscle creates that typical flattening of the surface as it reaches down to the elbow.

The skeletal structure of the knee joint is for the main part just beneath the skin and I have indicated on the right leg the dip to the side of the patella or kneecap and the protuberance formed by the upper expansion of the tibia and the head of the fibula as well as the flattened band made at the front by the tendon attached to the kneecap. Also clearly evident in this drawing is the side of the tendon reaching down from the biceps femoris – the large muscle at the back of the thigh – to the head of the fibula. When the leg is bent to some extent, this tendon tightens like a rope and raises that triangular sheet of tissue which forms the outer wall of the popliteal fossa, the hollow behind the knee.

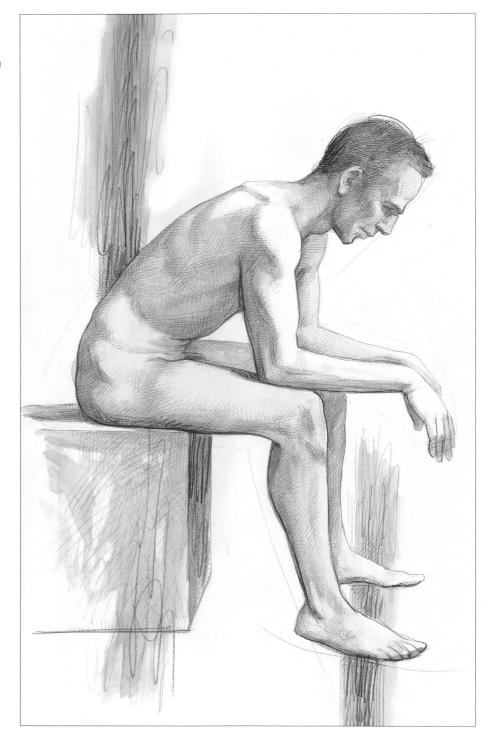

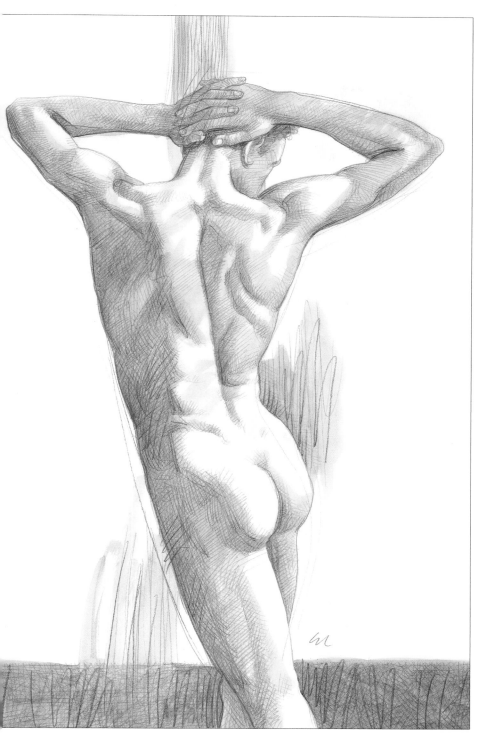

DRAWING 30

The twist given to the trunk and the emphasis made by the lighting angled across the skin combine in this drawing to demonstrate the massive bulk of this model's dorsal muscles. So here we see the raised deltoids and the trapezium muscle on the right side, the large back muscles in the depths of which the spinal musculature forms the raised ridges running parallel to the spinal column. But some bony parts are also clearly in view, as they are covered by skin and not by muscle: the spine of the shoulder blade, for example, but most of all its outermost extremity at the tip of the shoulder (the acromion) as well as the shoulder blade's medial (innermost) rim and lower angle. Another easily identifiable bony part is the tip of the ulna, the olecranon, which gives the elbow its sharp curve.

The nape of the neck has a furrow which runs down it, formed on each side by the descending parts of the trapezium muscles which are contracted here to counteract the flexing action of the hands interlinked behind the head.

Of note at hip level is how men's buttocks may be leaner than women's and often have a flattening at the sides which is due to the arrangement of the tendons on the large gluteus muscle and the protruding of the thigh bone's greater trochanter.

DRAWING 31

When a model is seated on a spacious floor surface, she is free to arrange her body into a great variety of positions, many of which make fascinating compositions. In almost every case, the overall form can be compared to a cone or a pyramid, or sometimes a triangle, as can be seen in drawing 33. In the position studied here, the embracing movement of the arms brings the upper back forward, but this also has an effect on the arms. On the model's left arm – which is the only one visible from this viewpoint – the deltoid muscle is faintly contracted, while its front portion and the biceps below it are being squeezed against the left thigh, with the result that the forms of the upper half of the left arm are flattened out sideways.

Looking down at the left leg, we can see how the tendon of the biceps femoris juts out like the sharp edge of a ribbon as it emerges from the thigh to meet the knee. As it rests on the front of the left leg, the left hand follows the calf's curved form, which causes the fingers to bend, each to a differing degree, with the little finger bending the least – being stretched out almost straight here – in accordance with the lengths of the individual fingers and the angle of the lower leg. This last observation may appear like stating the obvious, but I take pains to point it out because I very often see figure drawings which fail to take account of the thickness of each body part when one is placed on top of another – usually the result of a mistake, I am sure, and not an intentional effect.

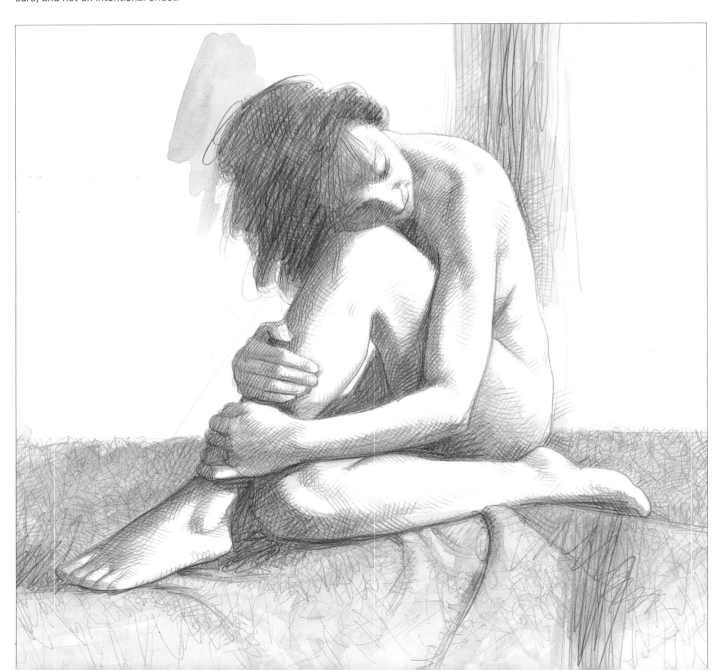

DRAWING 32

Leaning your upper body on one elbow when you are partially reclined may not be uncomfortable, but it is a position that can be held only for a fairly limited amount of time. The twist and sideways bend thus imparted to the spinal column contracts some muscle groups and strains others, which rapidly leads to tiring. In the position shown in this drawing, the stiff support of the model's right arm is pushing the right shoulder forward up towards the neck and thus bringing out the collarbone and the front side wall of the armpit, which is made up of the edge of the large pectoral muscle as it reaches across to its anchoring at the head of the humerus.

The muscles running up either side of the neck to hold the head up and prevent the force of gravity from making it loll downwards, the sternocleidomastoid muscles, have tendons that reach down to anchor themselves on what is known as the manubrium at the top of the breastbone or sternum. Here they stand out sharply as they contract to bring the head towards an upright position.

On the subject of keeping position, while this posture of reclining along one side of the body appears stable, it is in fact a rather precarious one: the base of support – it is true – extends along a fair area, but it is really quite narrow and elongated and this model could easily roll over on to her back if she were not gripping on to the edge of the bench with her hand and splaying out her right thigh as a counterbalance. Indeed, on the inner side of the right thigh you can see the ridge raised by the adductor muscles (above all the adductor longus) as they partly contract to help the body keep its balance.

The female breast comprises the mammary gland and its envelope of adipose tissue and breasts may vary widely in volume, shape and consistency. The fine, slightly conical form of this model's breasts is distorted a little by the sideways pull of gravity and the lateral bend of the trunk: the right one is thus flattened and extends down towards the side of the chest and it is a little thicker on its outer side, where a faint furrow is formed. The left breast, on the other hand, appears less stretched and forms a more regular hemisphere resting on the side more compressed by the chest, although here, too, the effect of gravity is visible as it becomes thicker on the side nearer the breastbone.

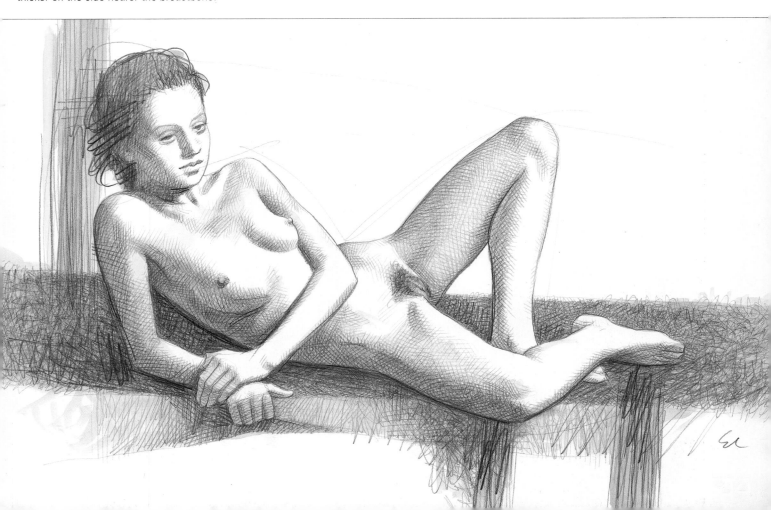

DRAWING 33

Apart from squashing her breast against her thigh, the forward bend of this model's upper body also has interesting effects visible in her back. From the viewpoint shown by this drawing, for example, which shows the model side-on and without any foreshortening, we can see how the forward rotation of her right shoulder blade is clearly indicated by the raised position of some of its parts: its spine, lower angle and its inner or medial ridge. A large part of the rear surface of the shoulder blade is covered by the infraspinatus, teres major and teres minor muscles, which reach over towards the shoulder to connect it to the humerus, the bone of the upper arm. In the other direction, the lower angle of the shoulder blade emerges just below the large dorsal muscle which, together with the large serratus anterior muscle and the external oblique muscle (obliquus externus), cover a large part of the ribcage. The teres major muscle also contributes, along with the long head of the triceps and the large dorsal muscle, to forming the posterior side wall of the armpit, which in this drawing has a sharper and finer profile than it would have in the standard anatomical position.

Being squeezed against the drawn-up thigh, the right breast spreads out sideways, increasing the extent of the fold beneath it. As I have already pointed out elsewhere (see drawing 26), a conspicuous feature of the ankle is the lateral malleolus (at the bottom end of the fibula), which has a rather pointed form and is bordered at the front by the tendon of the descending peroneus longus muscle.

For comparison, the length of the foot is slightly greater than the height of the head, while the length of the hand from base of palm to fingertip corresponds to the height of the face from chin-tip to hairline.

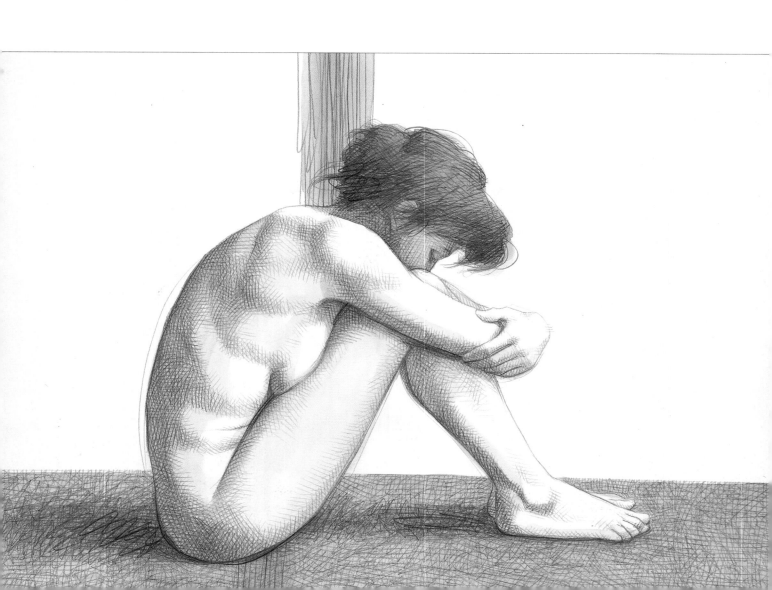

DRAWING 34

This position is a variation of the one shown in drawing 31, from which it diverges only in the upright bearing of the trunk. When a person is in this pose, some difficulties arise in assessing the proportions of the individual parts of the body. For example, it is not possible to compare the width of the pelvis with that of the shoulders and for this reason the shoulders tend to appear too broad when compared to what the study of anatomy tells us. This tendency is accentuated here by the raising of the shoulders due to the supporting function of the straightened arms, which also has the effect of making the collarbones protrude. Another effect of this position is to emphasise the bulge of the sternocleidomastoid muscles of the neck and of the left deltoid (shoulder) muscle – an effect which some may find too strong to be aesthetically pleasing. In this drawing I have also emphasised the extent of the elbow's hyperextension (a typically female ability), which works to the detriment of the drawing as an 'artistic' study, while confirming its faithfulness to what is seen and its mainly anatomical interest.

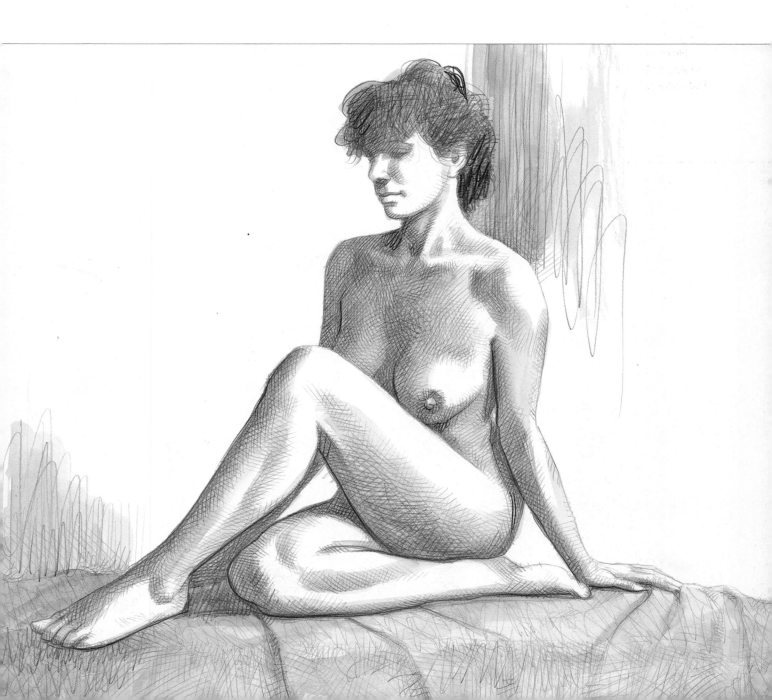

DRAWING 35

Reclining poses are especially favoured in portraying the female nude and they have several advantages to recommend them: they promote a balanced composition; they allow a broad scope for the variety of positions in which the bodily masses may be arranged and – not a minor consideration – they are none too strenuous for models to hold for the time required by a slow painting technique. However, compared to upright, seated or kneeling postures, which are those preferred by sculptors and are traditionally more often used with male models, lying positions bring with them a specific series of drawbacks. One is that when the model is lying down, the assessment of the body's overall proportions becomes a relatively awkward operation; another is that gravity acts in a markedly different way on a reclined body, changing the shapes of various parts, especially along the length of the supporting base as it is pressed against the surface beneath it, whether this be a hard or a yielding one.

And it is specifically these changes that interested me in this drawing. The profile of the trunk, for example, begins with the pelvis, which here appears full and prominent, and the trunk's outline then progresses up to the model's right shoulder, rising and dipping as it traces the sequence of gentle undulations formed by the ribcage as well as the teres major, teres minor and deltoid muscles of the upper back and shoulder.

The model's right breast sags downwards, although it is supported to some extent by the crook of the right forearm. The sharply bent right thigh appears somewhat flattened out by the force of gravity, although this flattening is limited by the structure of the large muscle groups around the femur, whose greater trochanter raises a dimple at the hip. The overhead lighting creates shadows on the thighs, the lower leg and face, easing the viewer's task of reconstructing a three-dimensional image from the two-dimensional drawing.

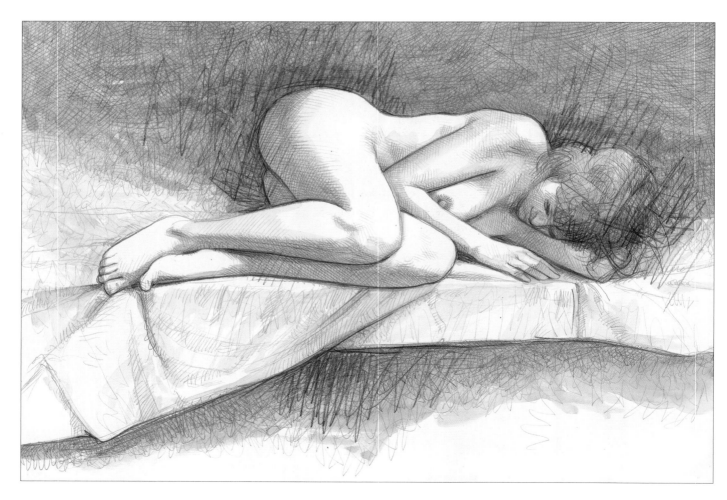

A Repertoire of Body Poses

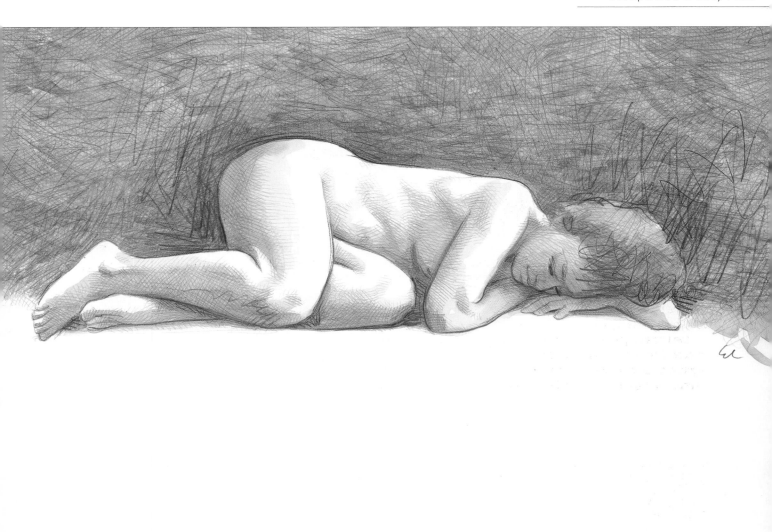

DRAWING 36

This study shows a position very similar to the one portrayed in the previous drawing.
However, differences between the models in terms of age, height and build provide
interesting points of comparison not just in the particular shapes, but also in the contrasting
ways these two models 'go into' the pose. The attitude of the model in this drawing appears
more relaxed, almost more familiar, an effect that provides the composition with a deeper
access of meaning.

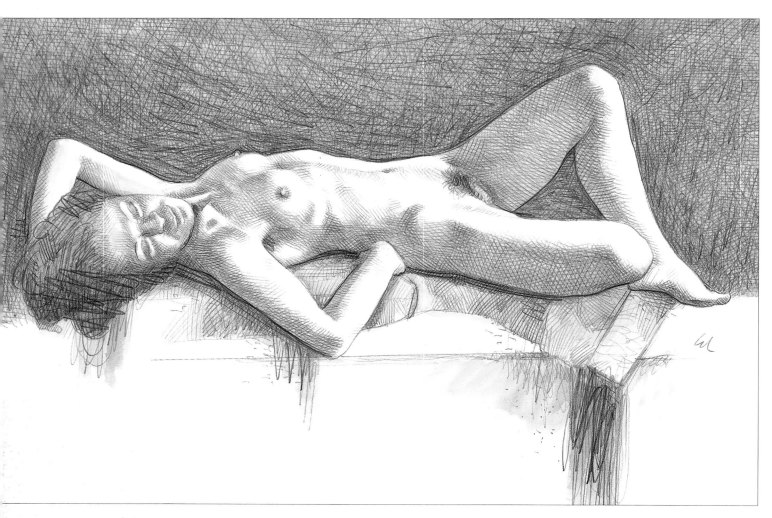

DRAWING 37

The source of illumination in this study is direct and trained on the model horizontally: the light skims across the body, showing up every single prominence, every dip and dell, every harsh detail. This kind of lighting can emphasise surface characteristics and irregularities of the skin in excessive detail, calling for the exercise of careful aesthetic judgement. This issue is forced by situations, such as the one created for this drawing here, where the illumination strays drastically from the natural light we are used to viewing people in, i.e. the light-source coming more or less from one side and mainly top-down. The unnaturalness of the lighting in this drawing is immediately apparent in the model's face, where the bottom-up illumination displaces shadows to parts we are used to seeing as reflectors of light: the forehead, the ridge of the nose, the top of the bottom lip, etc. This photo-negative effect is also visible on the chest, in the surface of the breast bone, at the tops and undersides of the breasts, as well as on the shoulders and the thighs. Such dramatic lighting should be used with caution and in moderation because it can be difficult to give an effective interpretation of its effects on the body's forms, although it can sometimes be very useful and instructive to be forced to look at and perceive anatomical shapes and characteristics under non-habitual lighting conditions. Some examples: in this drawing it is easy to see the ridge of the iliac crest of the right hip, the furrows between some of the ribs, the longitudinal depression of the linea alba and the clear hollow of the jugular cavity.

A supine figure – a person lying on their back – has some characteristic morphological details with which we are all familiar: the abdomen and belly flatten out or even become hollows; the points and some portions of the iliac crests emerge; the lower arch of the ribcage appears; female breasts rest back on the chest, enlarging in circumference and reducing in depth, and muscles on the limbs and any adipose deposits succumb to some extent to the force of gravity, spreading their masses downwards.

DRAWING 38

Closed forms – those in which models fold in on themselves and concentrate their body mass, so to speak, into a spherical, cuboid or ovoid form – are seldom used in paintings of the nude, but are very frequent in life studies done in the studio, as well as in works of sculpture. They offer an opportunity to study the anatomy of the human figure in unusual configurations, produced by the tensing of muscles, the compression of skin and the full flexion of the joints.

The model depicted here has gone into a position of isolation, of concentration and of dependency highly reminiscent of the typical foetal position. Leaving symbolic associations to one side, an eye for anatomical analysis will note, for example, the raising of the vertebral spinal processes in a regularly spaced line, their pointed crests peeping above the rim of the backbone's furrow; the protruding of the left iliac crest; the sideways rotation of the left shoulder blade; the stretching and flattening of the back muscles; the acute angle of the left elbow and its sharp sculpting into counterpoised planes. Also catching the eye is the way the left breast bulges out laterally under compression – as noted in my comments on drawing 33 – and the raised form made by the greater trochanter at the hip, as well as its associated layer of adipose tissue. Lastly, along the side wall of the thigh, it is possible to discern the longitudinal flattening made by the fascia lata.

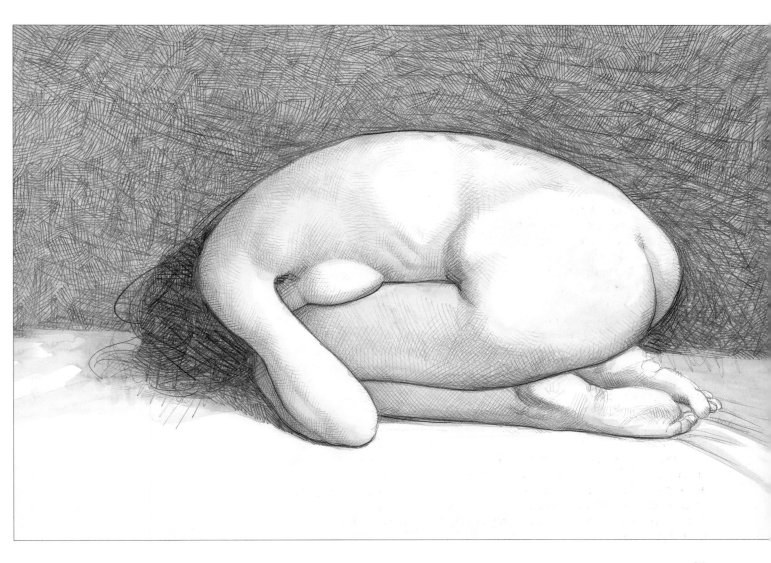

DRAWINGS 39–42

Study of the completely naked human body may be supplemented by studies of the draped figure, or by portraits in which the full figure of the sitter is shown only partially clothed, revealing a part of the anatomy or, alternatively, by portraits that concentrate on some anatomical aspect to make a striking composition. Studies of people in semi-clothed poses may offer great visual richness and variety as well as depths of symbolic and aesthetic meaning. Such studies tend to depict women, who may be young, but more mature subjects are not uncommon.

The four drawings reproduced here are studies in preparation for portraits which were later executed as commissions for the sitters featured in them. I have stressed the contrast between a limited exposure of nudity and the apparel worn, playing on the alluring aspect of what were quite spontaneous poses, suggested by the sitters themselves. The idea was to have the whole figure 'arranged' in an unusual and striking way across the surface of the canvas, but at the same time to isolate it from its surroundings in order to concentrate the observer's attention on the body before them and the psychological dimension of the pose adopted by the individual sitter.

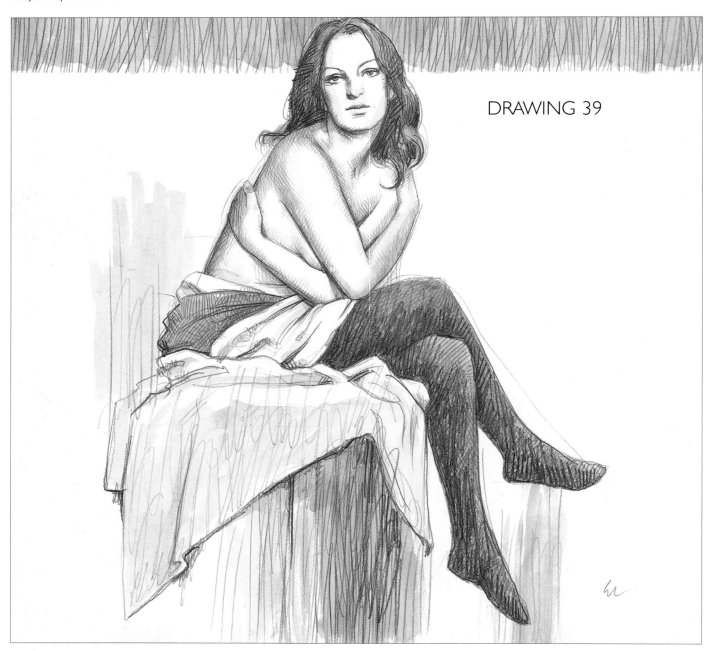

DRAWING 39

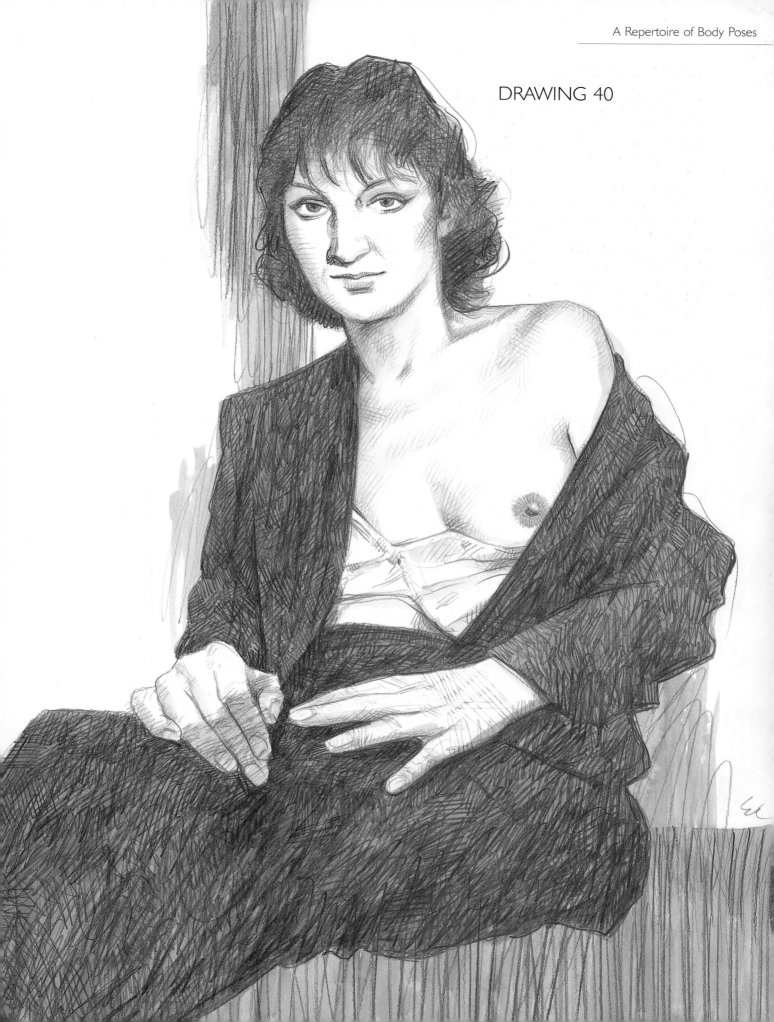

DRAWING 40

DRAWING 41

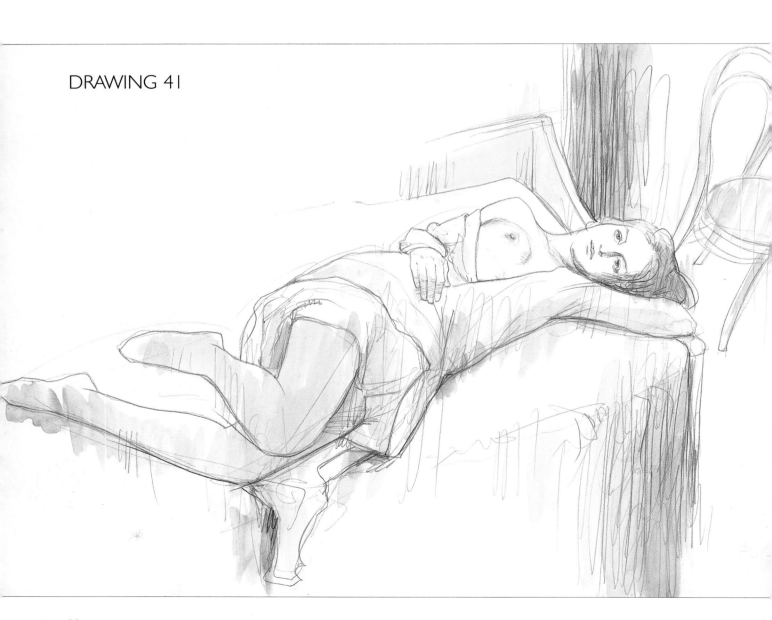

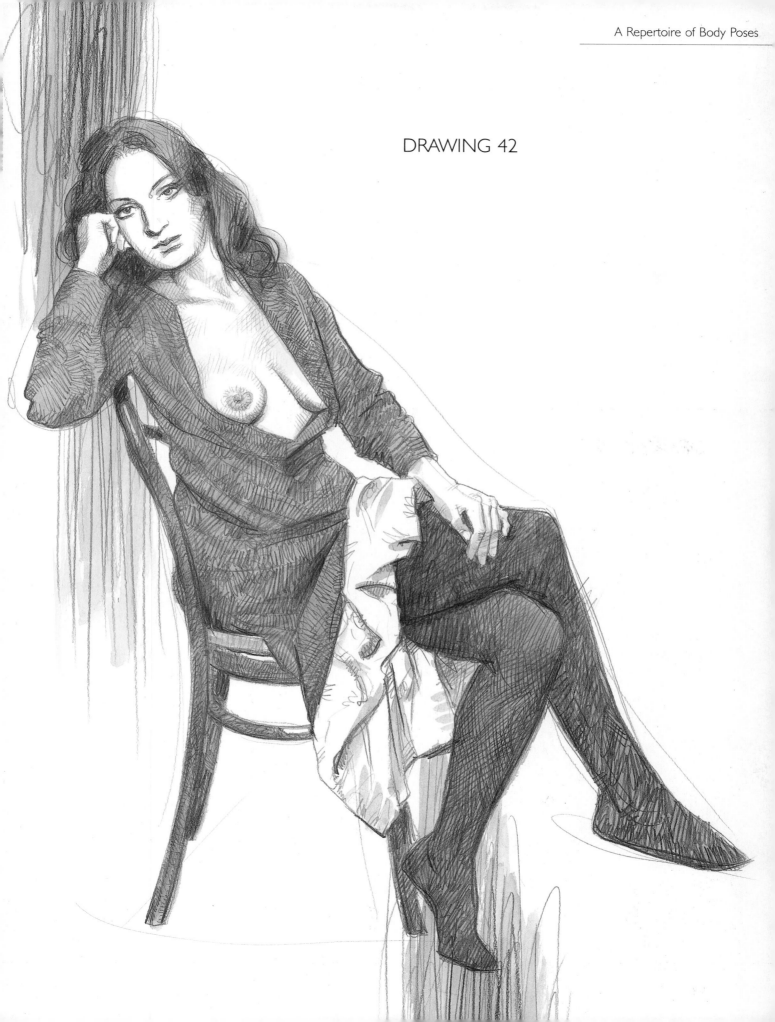

DRAWING 42

DRAWINGS 43–46

The study of a person's head will, for any artist, soon turn into a portrait because, while carrying out the study, one is forced to explore the anatomical and morphological proportions of the features which comprise the head's outward aspect and these are linked to subtle, fine, emotional and psychological impressions bound up with the subject's personality. Of course, the same could be said about the study of any part of the body – just think of the power of expression invested in the hands, for example.

The morphology of the human head is principally determined by the bone structure of the cranium, which in part lies just below the skin. Over this structure is laid the highly complex arrangement of the many small facial muscles – the muscles that move the skin and produce the visible expressive signals of the face – as well as some sturdier muscles, such as the masseter, which has the function of moving the jaw bone.

Even the head's more salient features, i.e. the eyes, nose, lips and earflaps, are closely linked to the underlying bony structures, constituting as they do the 'inward paths' of our primary senses. Careful observation of the many variations in forms of the human head – between female and male, between different ages, under different genetic influences – will enable you to compare various specific characteristics of morphology, but these will all be retraceable to a basic common layout. For example, it will be found that the overall height of the face from the chin to the hairline can be divided into three equal sections corresponding to the forehead, the nose and the distance from the bottom of the nose to the chin; also that the distance between the eyes equals the width of one eye, or the breadth of the nostrils; that the height of the ear is the same as that of the nose, and so forth.

The portraits reproduced here were made as preparatory studies for more highly finished works in different paint media, created in various dimensions and in some cases using the aid of photographs taken at the same time as these preparatory sketches were made.

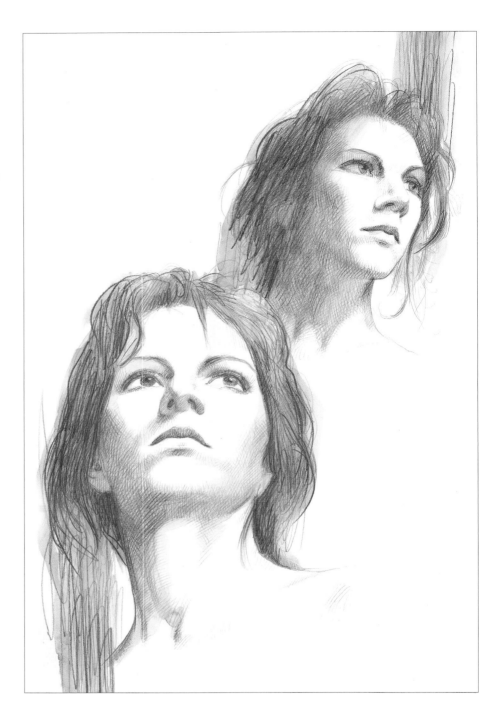

DRAWING 43

This drawing illustrates a portrait-making procedure I almost always follow, that is of drawing a series of portraits of the same sitter from different viewpoints and with slight variations in their expression as a means of 'getting to know' the person portrayed.

DRAWING 44

This is a portrait of a middle-aged woman, (who also appears in the nude study, drawing 9), whose attractive face also shows the passage of time. In such cases, it is very important for the artist to pay a lot of attention to 'self-created' features of the face – lines of age, creases created by characteristic expressions, skin coloration, etc – assigning to each its appropriate weight and without overemphasising any of them, which would easily result in a falsification of the sitter's authentic physiognomy. The same amount of attention should be paid to the neck, the shoulders and any other anatomical particulars that are included.

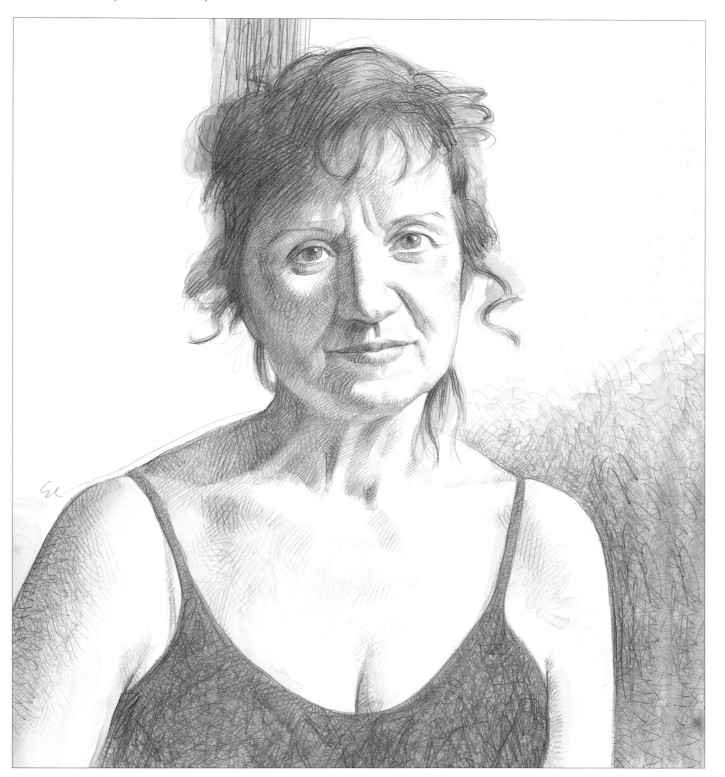

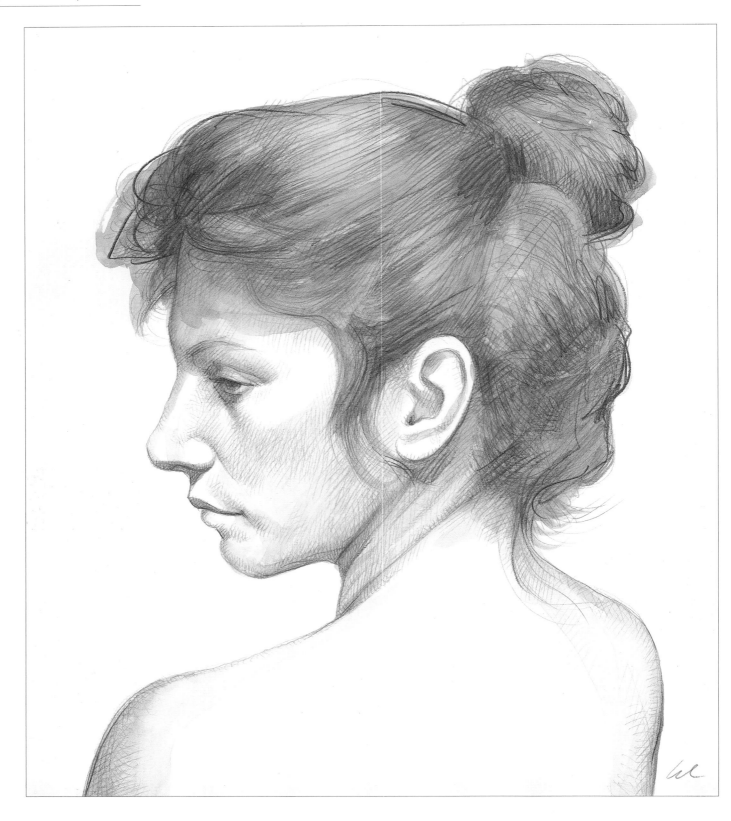

DRAWING 45

This is an example of an informal portrait that strays somewhat from the traditional canons.
A facial profile always makes a very characterising and expressive image, especially if – as
here – it is accompanied by a partial turn of the neck and shoulders, emphasising its three-
dimensional aspect. It is better to treat the hair using broad tonal masses, indicating individual
hairs only here and there to convey its soft and finely fringed quality.

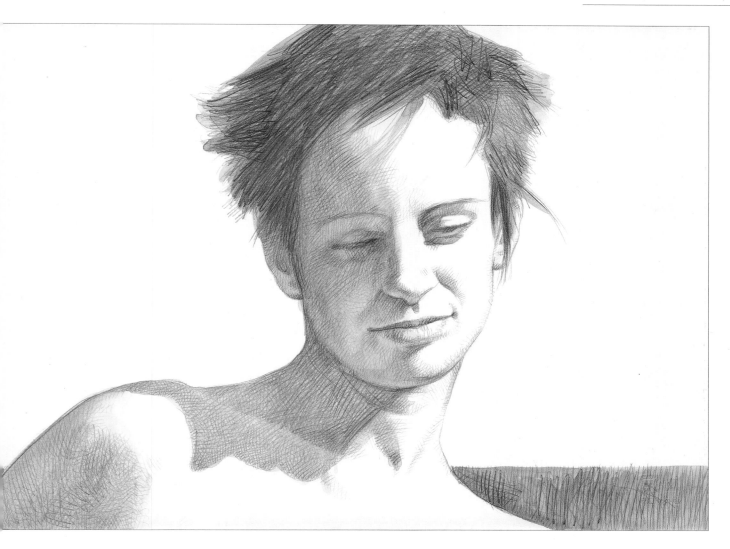

DRAWING 46

In this drawing, the sitter's relaxed, critical expression is underscored by the shadow cast down her neck and across her right shoulder. The side lighting casts shadows which help to define the nose and provides bright highlights which counterbalance the dark mass of wind-tousled hair.

FROM DRAWING TO SCULPTURE

Credo, perché solo la fede, come l'arte, parla allo spirito.
I believe, because only faith can speak to the spirit the way art does.
…
Quell'amaro sogno ogni volta infranto, mai posseduto, forse irrangiungibile di reinventare con forme nuove la figura umana.
That bitter, perhaps unreachable dream, which turns to dust and eludes our grasp each time it arises: to re-invent the human figure in pristine forms.

Mario Negri

Le corps humain a des profils à l'infini.
The human body has profiles unbounded in number.
…
Dans une belle sculpture on devine toujours une puissante impulsion intérieure.
One can discern, within any beautiful sculpture, a powerful interior force.

Auguste Rodin

Ever since its origins, sculptural art has had one central interest: the representation of the human figure. The human body, expressed as a volume occupying space, has been a bottomless well of inspiration for artists both as a source of aesthetic forms and as a conduit for meanings: meanings which may be deeply symbolic, or forms which may be celebratory or simply decorative. Although contemporary sculptural art now seeks its inspiration far from naturalistic sources, its search for abstract plastic forms is still anchored to a sense of structure and of relations between parts which derives from millennia of contemplating the world of living forms and especially the richest, fullest and most evocative manifestation of that world in the human body.

If an understanding of drawing is of crucial importance in studying the techniques of painting, it is an even more basic part of the process of sculptural representation. Here, drawing becomes a tool for seeking synthesis, for arriving at the essence of complex volumetric and spatial factors.

The subject, you will appreciate, is a vast one, and the way I have chosen to scratch its surface and maybe to whet your artistic appetite for expressing yourself in three-dimensional form, is to show a few pictures of some of my early sculptures. These sculptures were made many years ago now, and perhaps because they were my first attempts, they remain close to representations taken 'from life' and therefore to the practicalities of this craft; practicalities which are closely intermeshed with the study of the naked human form.

SCULPTURE 1

'Solitude'
Terracotta, 30cm/12in high

Clay is the ideal material for modelling forms. By modelling I mean the method suited to wax, clay or embossing work, which the artists of the Renaissance called laying on (per via di porre) which involves adding further material to what is already there. This is, in fact the technical and conceptual opposite of what is properly called sculpting, which follows a process of taking away from the material you start with (per via di levare). When modelling clay, then, the final form is attained through the addition of layers of material, starting with small hand-moulded balls of clay and building them up gradually, pressing each one on to the inner form until the desired sculptural volume is reached. In the case of sculpting, on the other hand, the desired form is reached by using suitable tools to remove excess material, working from the outside inwards.

I fashioned this figure, whose posture occupies a pyramid-shaped space, in a relatively small format because soft, wet clay has a tendency to cave in under its own weight, which makes it unsuitable for creating very large-scale forms or shapes involving long overhangs. Of course, it is possible to use various interim dodges to hold up the weight of the drying clay: internal steel-wire reinforcing, wooden props and wedges, etc.

However, if you wish to let the clay figure cure by drying in air before firing it in a furnace to turn it into terracotta, as was done with this figurine, no foreign bodies should be left inside the drying clay as these will not yield evenly during the clay's gradual process of drying and shrinking, leading to cracks and eventual shattering.

The model's posture and body forms were given slight anatomical exaggeration, making them appear more expressive and anguished. To add to this effect, the whole surface was slightly roughened by patting it gently with a stiff-bristled brush.

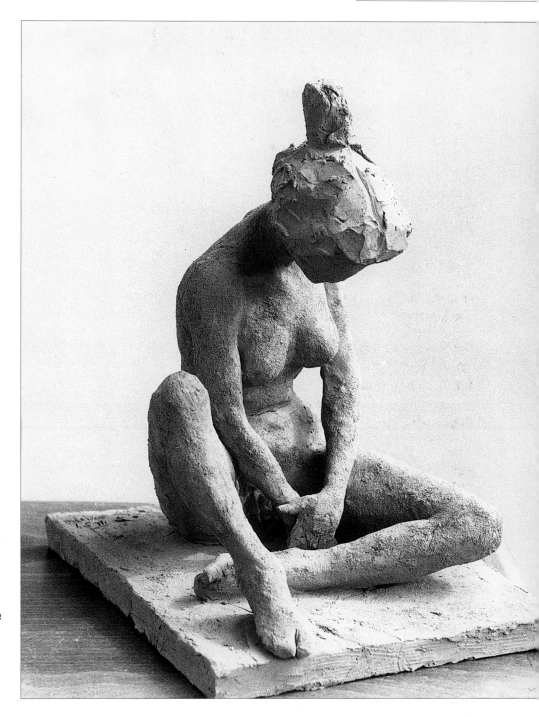

SCULPTURE 2

'Dancer'
Bronze, 50cm/20in high

Dance is a theme that has often been used in sculpture because it allows the sculptor to combine the dynamic sensation that derives from catching a movement 'in the act' with the tensions concentrated in the dancer's limbs as they move through space in search of balance.

When you are engaged in the necessarily lengthy work processes of creating a sculpture, the need to keep costs down and the important consideration of not over-trying other people's patience mean that it is best to learn to work from memory. By this I mean to limit your reliance on a posing model to the preparatory phases – during which reams of exploratory drawings may be made – when the initial framework is being set up and the figure's main areas of mass are being roughed out. After this, the model's services may be dispensed with until the checking stage when the final touches are being given to the anatomical forms.

I modelled this figure on to a skeleton framework of wire bent to form the essential bodily posture. The wire was itself supported by wooden shuttering fixed to a workbench which functioned in turn as a base. Instead of clay, I used Plasticine, a material that can be modelled in a way similar to clay and which has the additional advantage that it does not dry out and shrink. Having finished the phase of forming a positive mould of the figure, I made a cast of this in plaster, a material tough enough to withstand the pouring of the bronze.

The view of the statue captured in this photograph is one that reveals the way that different segments of the body are on alternating axes: some segments continue in the same direction where they meet, while others are at right angles to each other. Thus the figure's left arm and leg are roughly parallel with each other and with the right forearm but these body segments are all at right angles to the trunk and the right leg: the overall combination gives the form an open character.

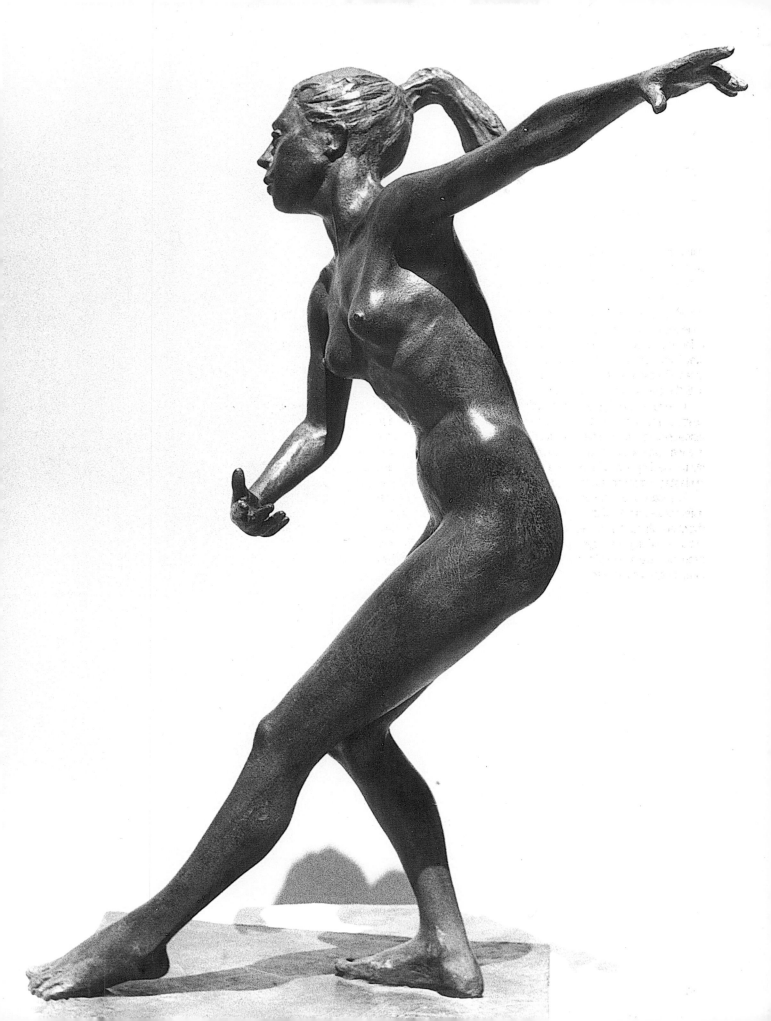

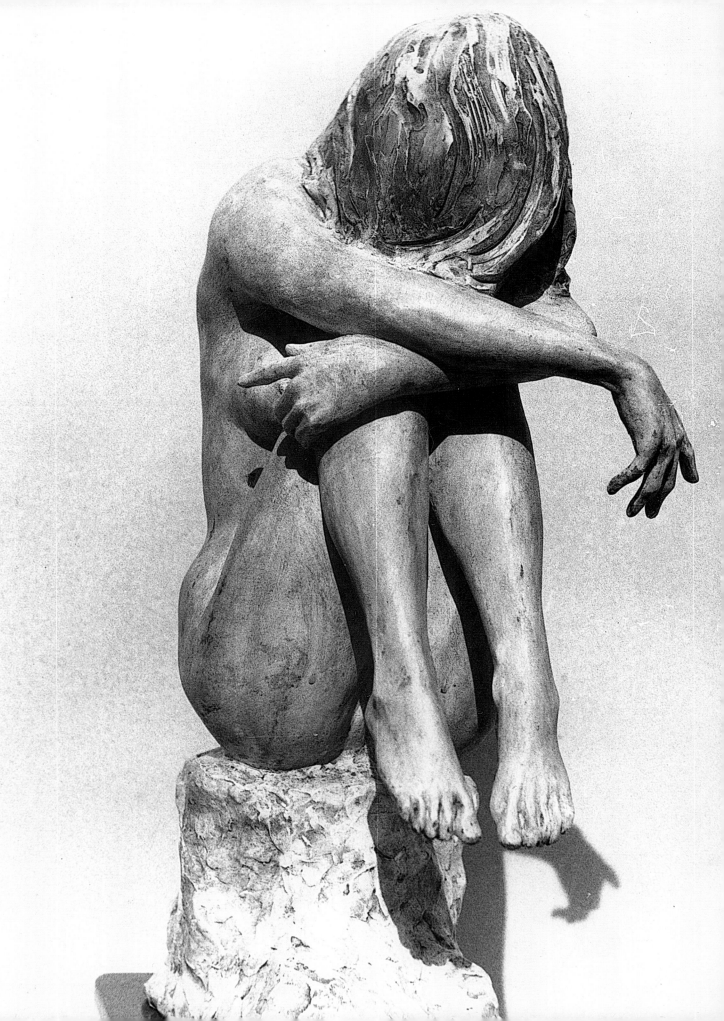

◁SCULPTURE 3

'Meditation'
Plaster, 57cm/22in high

The overall form here, by contrast with the foregoing statue, is a closed one: rather than radiating out into space, the model's body is here gathered and held in a compact ovoid form. All of the power in the pose, all the lines of force appear to be centre-seeking, as if trying to pack all the body's energies into its deepest core – into the soul. Nonetheless, I made an attempt to introduce a touch of visual dynamism in that I asked the model to cross her forearms over each other, thus bringing them slightly away from the rest of the body. In this way, I thought, the impulses towards reflection and introspection would not appear to be completely excluding the world in egoistical solipsism, but prying outwards, too, with a faint gesture towards hope and encounter.

When the work was finished, the cast plaster surface was smoothed down using fine-grade sandpaper and then given a patina in the form of a coat of oil paint (raw umber), highly thinned with turpentine essence. A protective sheen was then applied to the whole sculpture using a little beeswax.

SCULPTURE 4▷

'The Temple'
Bronze, 80cm/31in high

This crucifix was made in memory of my father; it is now to be found in a church which is very close to my heart. Almost resembling a god in the Greek tradition, the body – the word made flesh in the form of the letter 'Y' – is pierced through more by the suffering of despair than by any pain inflicted by nails: without a cross, then, but with arms outspread in hope of an embrace …

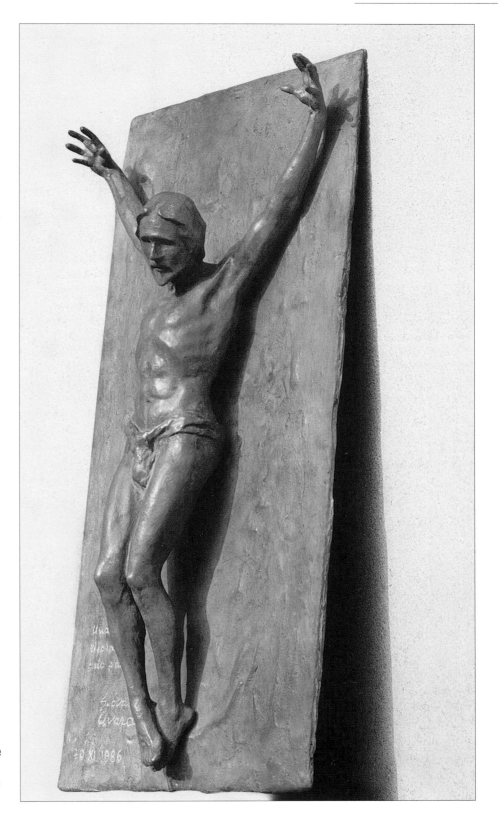

SCULPTURE 5

'Large Dancer'
Bronze, 110cm/43in high

The human form can suggest abstraction or formal synthesis: this happens when contemplation of the body provides a spark which leads towards a free discourse of forms. Unless it has been intentionally contrived to do so, a well-executed sculpture should not offer one 'side', one viewpoint, that is privileged above all others, by which I mean one aspect of the work that is more complete and more laden with meaning than any other. It should be possible, in other words, to walk around the work without discovering any views that are artistically weak or lacking in formal significance. This rarely happens because, as we are all aware, we have an instinctive tendency to perceive some aspects of the body better than others: the face or the body seen from the front, for example. We feel that certain aspects and movements are especially rich in meaning at the expense of others, to which we assign a secondary value. So it is that when this sculpture is viewed from a little to the right of front-on, its profiles flow together to present its ogival form in the most complete and effective way. The view from behind, on the other hand, seems to contain less meaning, although its overall form is more charged with tensions, being cut through by lines and axes in counter position to each other – the position was, indeed, a difficult one for the model to hold for more than a few minutes at a time.

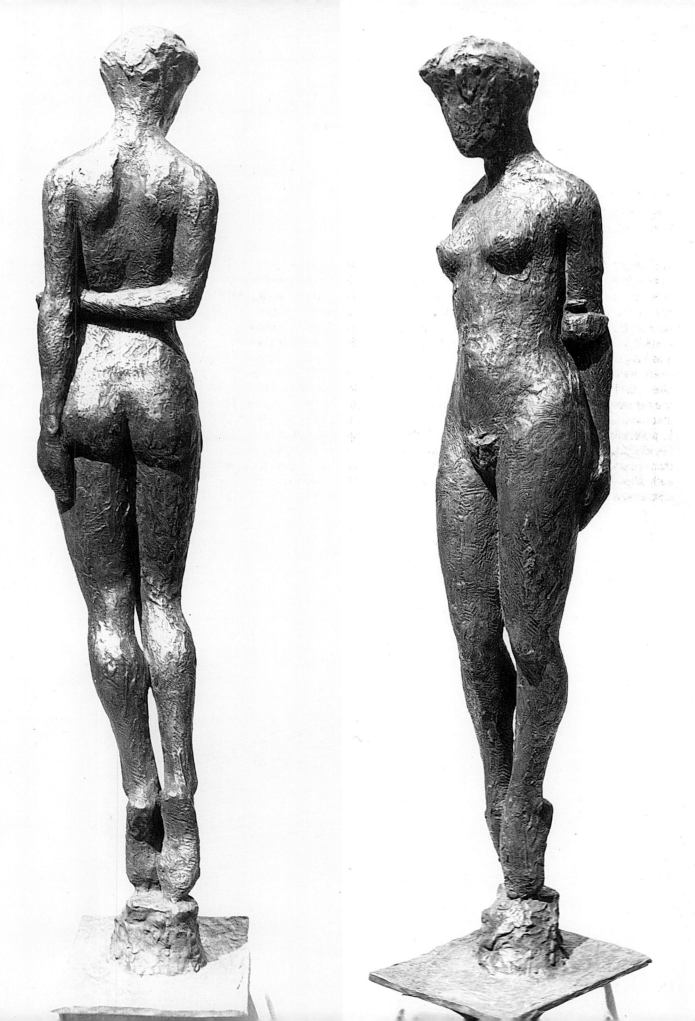

BIBLIOGRAPHY

Bammes, Gotfried, 'Figurliches Gestalten', Volk und Wissen Volkseigener Verlag, Berlin, 1978

Cennini, Cennino, 'Il libro dell'arte', (sec. XIV), Ed. moderna: Neri Pozza, Vicenza, 1982

Civardi, Giovanni, 'Anatomia artistica', Il Castello, Milano, 1994

Civardi, Giovanni, 'Il nudo maschile', Il Castello, Milano, 1991

Civardi, Giovanni, 'Il nudo femminile', Il Castello, Milano, 1992

Civardi, Giovanni, 'Introduzione alla pittura ad olio', Il Castello, Milano, 1991

Civardi, Giovanni, 'Gli strumenti e le tecniche', Il Castello, Milano, 1992

Clerin, Philippe, 'La sculpture, toutes les techniques', Dessain et Tolra, Paris, 1987

Constance, Diana, 'An introduction to Drawing the Nude', Quintet Pub. Ltd., London 1993

Corrain, Lucia, and Valenti, Mario, (Eds.), 'Leggere l'opera d'arte – dal figurativo all'astratto', Soc. Ed. Esculapio, Bologna, 1991

Doerner, Max, 'Mahlmaterial und seine Verwendung im Bilde', Enke Verlag, Stuttgart, 1954

Graves, Douglas, R., 'Life Drawing in Charcoal', Dover Publications, 2003

Graves, Douglas, R., 'Figure Painting in Oil', Pitman, 1973

Kunde, Wolfgang, 'Akt in Farbe', Otto Maier GmbH, Ravensburg, 1989

Lagrifford, Henri, 'Conseils practiques sur le modelage, le moulage et la sculpture', Bornemann, Paris, 1972

Lanteri, Edouard, 'Modelling and Sculpture', Vol. 1, Chapman and Hall, London-New York, 1902

Loomis, Andrew, 'Creative Illustration', The Viking Press, New York, 1947

Maltese, Corrado, (Ed.), 'Le tecniche artistiche', Mursia, Milano, 1998 (1973)

Negri, Mario, 'All'ombra della scultura', All'insegna del Pesce d'oro, Milano, 1985

Nicodemi, G.B., 'Dizionario delle tecniche pittoriche antiche e moderne', Il Castello, Milano, III ed. 1993 (1977)

Piva, Gino, 'Manuale pratica di tecnica pittorica', Hoepli, Milano, IV ed. 1971 (1951)

Prette, Maria Carla, - De Giorgis, Alfonso, 'Leggere l'arte', Giunti, Firenze, 1999

Previati Gaetano, 'Della pittura: tecnica e arte', F.lli Bocca, Torino, 1905

Raynes, John, 'The Figure-drawing Workbook', Collins and Brown, London, 1997

Ronchetti, Giuseppe, 'Manuale per I dilettanti di pittura', Hoepli, Milano, XVI ed. 1960

Rosa, Leone, A., 'La technica della pittura dai tempi preistorici ad oggi', S.E.I. Milano, 1937

Rudel, Jean, 'La technique de la peinture', Presses Universitaires de France, Paris, 1969 (1950)

Rudel, Jean, 'La technique du dessin', Presses Universitaires de France, Paris, 1979

Rudel, Jean, 'La technique de la sculpture', Presses Universitaires de France, Paris, 1980

Rudel, Jean, (Ed.), 'Les techniques de l'art', Flammarion, Paris, 1999

Rush, Michael, 'New Media in Late 20th Century Art', Thames and Hudson, London, 1999

Slobodkin, Louis, 'Sculpture, Principles and Practice', World Pub. Co., New York, 1949

Smith, Ray, 'The Artist's Handbook', Dorling-Kindersley Ltd., London, 1987

Smith, Ray, 'How to Draw and Paint What You See', Dorling-Kindersley Ltd., London, 1984

Smith, Stan and Wheeler, Linda, 'Drawing and Painting the Figure', Phaidon Press, London, 1983

Smith, Stan, (Ed.), 'The Artist's Manual', Macdonald Educ., London, 1980 (Italian edition, Zanichelli, Bologna, 1985)

Speed, Harold, 'The Practice and Science of Drawing', Seeley, Service and Co. Ltd., London, 1917

Speed, Harold, 'The Science and Practice of Oil Painting', Chapman and Hall Ltd., London, 1924

Teissig, Karel, 'Le techniche del disegno', F.lli Melita Ed., La Spezia, 1991, (orirginal edition: Prague 1983)

Toney, Anthony, 'Creative Painting and Drawing', Dover Pub. Inc., New York, 1966

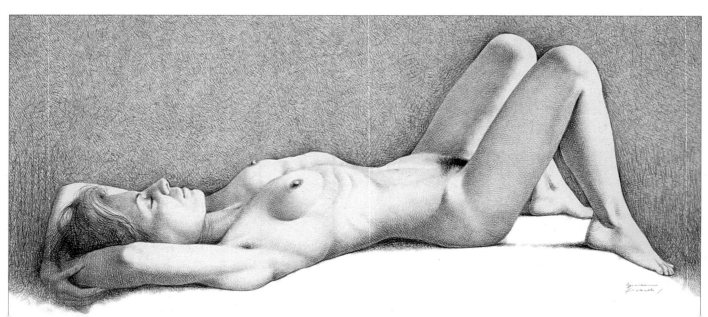